TREASURES

— FROM THE —

ROYAL
ARCHIVES

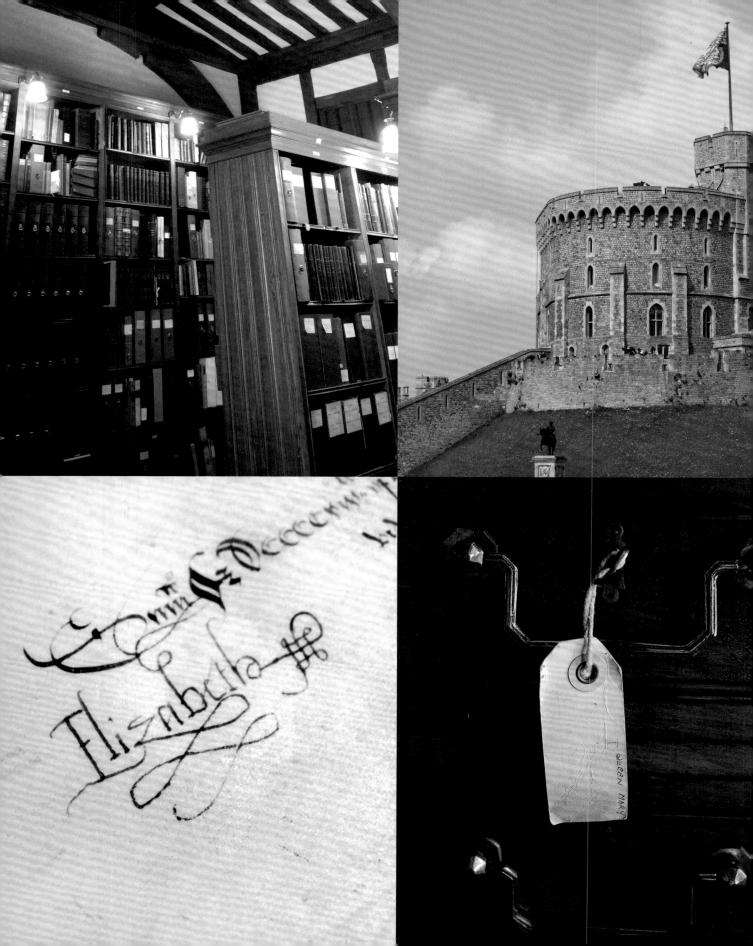

TREASURES

FROM THE

ROYAL

ARCHIVES

PAM CLARK JULIE CROCKER ALLISON DERRETT
LAURA HOBBS JILL KELSEY

Royal Collection Trust

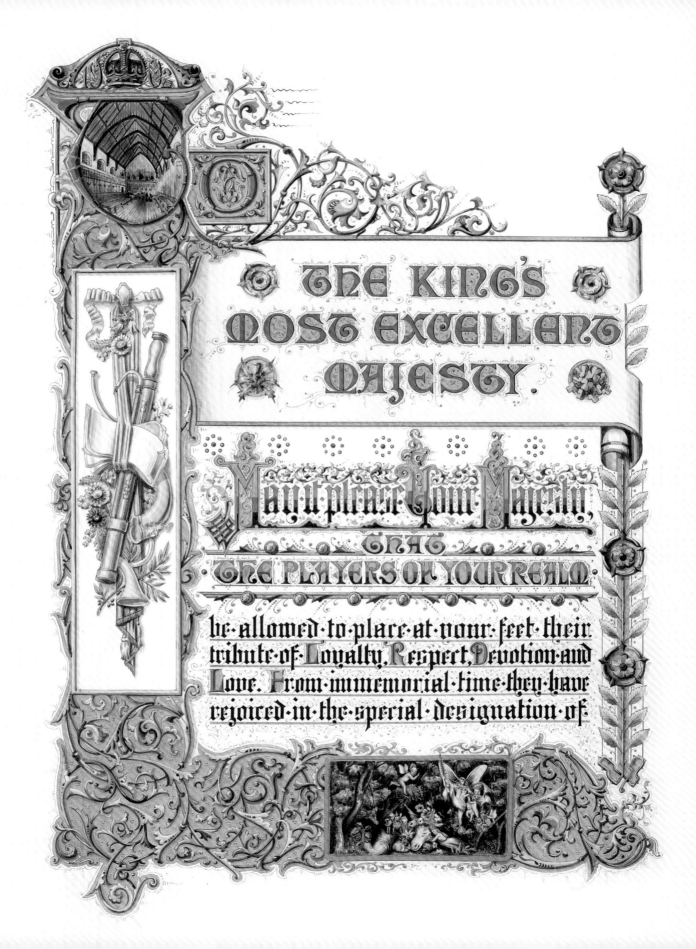

THE KING'S MOST EXCELLENT MAJESTY.

May it please Your Majesty,

THAT THE PLAYERS OF YOUR REALM

be allowed to place at your feet their tribute of Loyalty, Respect, Devotion and Love. From immemorial time they have rejoiced in the special designation of

CONTENTS _____

 *When you see this symbol, our Royal Archives website **www.royalcollection.org.uk/exhibitions/treasures-from-the-royal-archives** will have further information on the treasures featured in this book, including more illustrations and the complete text of some of the historical documents. You will also be able to access a website version for the animation of Major John Chard's plans and timeline of events at the Battle of Rorke's Drift in 1879.*

FOREWORD

WINDSOR CASTLE

The centenary of the Royal Archives, celebrated in this new history, provides an opportunity to reflect on the stories told in the collections stored within the Round Tower. For the first time, a fascinating selection of treasures spanning nearly five hundred years, each one illuminating a different facet of the lives of monarchs, the Royal Family and their Households, is available for the general reader.

From Tudor times to the industrial revolution, and onward through the Victorian age and the twentieth century, the chapters illustrate the sometimes turbulent times they describe. Yet occasions of day-to-day pastimes and family life are also highlighted in the book's wide-ranging selection of material.

I am pleased that this work can show what a wonderful resource has been collected in the Royal Archives, a resource which is now increasingly being made available for all to enjoy.

Sir Christopher Geidt
Keeper of The Queen's Archives

OPPOSITE *The new flagpole being hoisted to the top of the Round Tower, Windsor Castle, 1892.*
RA VIC/MAIN/R/41/57/6

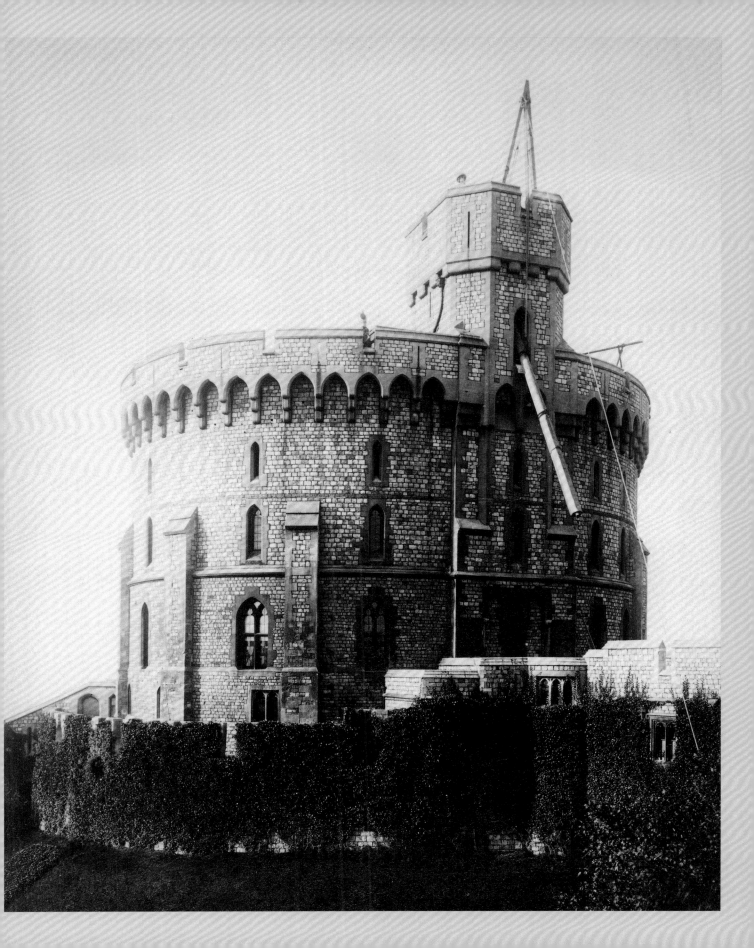

INTRODUCTION _____

The Round Tower, standing proudly on its chalk mound, with the flag – the Royal Standard or the Union Flag, depending on whether or not the Sovereign is in residence – fluttering above it, is probably the best-known image of Windsor Castle. Perhaps less well known is the fact that, since 1914, the Round Tower has housed the Royal Archives.

With the benefit of hindsight, it may seem surprising that before that time there had been no appointed place in which the Royal Family and the Royal Household could store their historic records; nor had there been any person whose particular role it was to look after them. Kept in tin trunks, boxes, folders and volumes, they were instead often lodged in cupboards or storerooms in the various royal residences – although some of the larger groups of papers did find a home in the Royal Library, which had been established at Windsor by William IV in the 1830s.

It was the death of Queen Victoria, in 1901, which brought about the need for the creation of a proper archive in which to store the Royal Family's papers. The Queen, who had reigned for 63 years, had corresponded copiously with her ministers, senior members of the Armed Forces and of the Church, ambassadors, heads of state, members of the aristocracy, artists, and her own extensive family in Britain and throughout Europe. These letters had, for the most part, been carefully preserved.

Queen Victoria's official correspondence was filed in a subject-based system devised by her husband, Prince Albert, with categories for 'Changes of Government', 'Ireland', the 'Army', the 'Church', 'Foreign Affairs' and so on. The papers, which often included drafts or copies of the Queen's outgoing letters made by the Prince (who acted as her private secretary), were bound in volumes, with the writer and addressee of each item identified by him on the mount. The industrious Prince Albert even went to the trouble of prefacing the volumes with a summary of the contents. This system of arrangement was continued 'most carefully' after the Prince's untimely death in 1861, and its effectiveness can be judged by the fact that very similar filing systems were adopted by the private secretaries of the Queen's next two successors, King Edward VII and King George V.

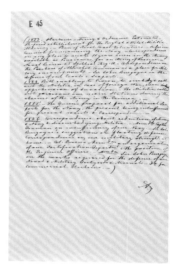

ABOVE *Summary written by Prince Albert for the file in Queen Victoria's official correspondence relating to the National Defences, 1853–6. RA VIC/MAIN/E/45*

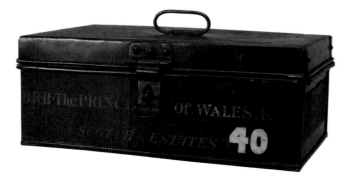

LEFT *Trunk formerly used to store records relating to the Scottish property owned by King Edward VII as Prince of Wales. RA PS/RA/TRUNK*

In contrast, as her Assistant Private Secretary recalled, some years after her death, 'Queen Victoria's [private] papers at the end of her reign … were … in hopeless confusion'. Nevertheless, she had been keen to ensure that these were preserved. As she herself explained in 1874, in response to her eldest daughter, who had asked for permission to burn the letters she had received from her mother, to avoid their falling into the wrong hands after her death, 'I am not for burning [such letters] except any of a nature to affect any of the family painfully … all the papers and letters I have are secured … I am much against destroying important letters, as I every day see the necessity of reference.'

In fact, the Queen went a step further in ensuring the preservation of her correspondence, by requesting the return of letters from herself or her family, after the death of the recipient. Thus, for instance, her letters to her first Prime Minister, Lord Melbourne, and those to her favourite uncle, King Leopold I of the Belgians, ended up in her possession. In some cases, though, she would return the letters, after having looked through them, with the request that they be kept as family heirlooms.

Queen Victoria's papers also included the detailed diary, or Journal, of her life, which she had kept from the age of 13 almost up to the day of her death. Throughout her life she was a great writer, with a vivid style, acute powers of observation and a prodigious memory. This account of 68 years of the life of the person after whom the Victorian age is named is thus a rich resource, notwithstanding the fact that, for the last 60 years of it, all that survives is the expurgated version dutifully copied out after the Queen's death by her youngest daughter, Princess Beatrice. Such an apparent act of sacrilege was, in fact, done on the instructions of Queen Victoria herself. Despite her awareness of its potential importance – as early as 1843, she had written, 'I am vain enough to think [my Journal] may perhaps some day be reduced to interesting Memoirs' – the Queen clearly considered that some entries in this private diary might indeed 'affect … the family painfully'.

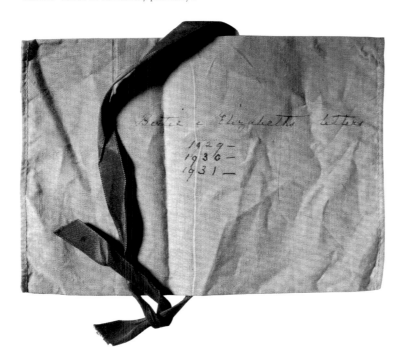

LEFT *One of the cloth envelopes in which Queen Mary carefully kept her private correspondence, in this case letters from 1929 to 1931 written by her son and daughter-in-law, the Duke and Duchess of York, later King George VI and Queen Elizabeth.*
RA QM/PRIV

These, then, were the records with which King Edward VII was confronted. Within a few weeks of his mother's death, the King had accepted the offer of Lord Esher (1852–1930), a civil servant who had played a key role in organising the celebrations for Queen Victoria's Diamond Jubilee, to collect and arrange the late Queen's papers. This led subsequently to Esher's appointment as the first Keeper of the Royal Archives. Esher also persuaded the King to agree to his publishing selections from Queen Victoria's letters and Journals, as a memorial to her and to demonstrate the role of the monarchy, and the first volume came out in 1907.

Distracted by this publishing project, it was inevitable that by the time King Edward VII died, in 1910, Lord Esher had not put in place a plan to unite the Queen's papers in a dedicated archive space, and it was left to King George V to bring this to fruition. In this he was almost certainly aided by his wife, Queen Mary, who had a particular interest in the history of the royal family, and who, like Prince Albert before her, valued the efficient organisation of records and also of the objects in the Royal Collection. She had already set aside a room in the Round Tower at Windsor Castle as a family museum (later transferred to Frogmore House in the private grounds of Windsor Castle), and in 1912 King George V decreed that 'All the Royal Archives shall be kept in a Strong Room or Rooms in the Round Tower'.

The Round Tower, built on the mound that was the site of William the Conqueror's original castle, dates largely from the fourteenth century, when it had been rebuilt to provide a suite of rooms for Edward III, while the main royal apartments, on the north side of the Castle, were themselves being reconstructed. The Tower was in the form of a two-storey shell keep with an open courtyard. In the early nineteenth century, as part of his 'gothicisation' of Windsor Castle,

George IV doubled the height of the Tower, to give the impressive skyline that is seen today. It was in the top half of Edward III's medieval Great Hall (later used as a guard chamber) that work began on creating the Muniment (from the Latin word for 'defence') Room, in which to preserve the papers of both Queen Victoria and King Edward VII (though many of the latter's private papers had been destroyed after his death by his Private Secretary, Lord Knollys). In 1914 the transfer of the records to their new home began.

Soon, two other collections, which had previously been kept first at Cumberland Lodge, in Windsor Great Park, and later in the Royal Library at Windsor Castle, were also moved to the Round Tower. These were the papers of William Augustus, Duke of Cumberland (1721–65), and those of the exiled Stuarts. The Cumberland Papers comprise the Duke's correspondence as Captain-General of the Army and as Ranger of Windsor Great Park, as well as records reflecting his interest in horse racing. The Stuart Papers consist of the correspondence of James II after he had gone into exile in 1688, and of his descendants, Prince James Francis Edward Stuart (1688–1766), Prince Charles Edward Stuart (1720–88) and Cardinal Henry Benedict Stuart (1725–1807). This latter collection – a remarkable survivor in the Royal Archives, especially as it includes much material concerning the Stuart pretenders' attempts to regain the British throne in the eighteenth century – was purchased in Italy for George IV after the death of Cardinal Stuart.

The rapid expansion of the Royal Archives continued apace in the early years, first with the discovery in 1912 of more than thirty large boxes of the papers of George III and George IV in the basement of the Duke of Wellington's London home, Apsley House. This important collection had been quite forgotten since George IV's executor, the first Duke of Wellington, had placed it there, labelled 'To be destroyed unread'. Luckily, this instruction was not carried out and the papers were presented to King George V by the fourth Duke. George III is thus

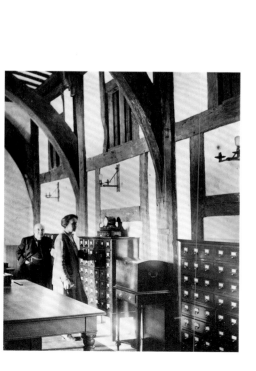

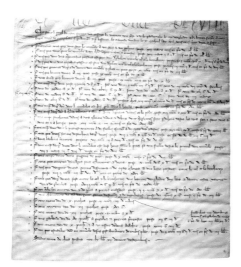

the first Sovereign whose papers are preserved in the Royal Archives. He was probably the first monarch who corresponded regularly with his government, as his immediate predecessors, George I and George II, were not native English speakers, while prior to that ministers had been closely embedded in the Court and so were in constant contact with their Sovereign. As a result, the official papers of earlier monarchs, such as survive, are mostly to be found in government records in The National Archives.

Two years' later, in 1914, the Duke of Buccleuch presented a series of warrants, bills and receipts kept by his ancestors, the Dukes of Montagu, as Masters of the Great Wardrobe. This department of the Royal Household had dealt with the supply of furniture and furnishings for royal palaces, and of royal liveries and ceremonial robes. These volumes, covering the period 1660–1749, still form the earliest series of records held in the Royal Archives.

The first people appointed to care for the Royal Archives were thus presented with a wealth of material. At first they elected to sort and calendar the papers (that is, summarise them in detailed lists), then bind them in series of volumes of related documents. Within a few years, though, it became apparent that it would take too long to calendar everything, so it was decided to concentrate on indexing the records. It was also realised that binding the papers made them far more unwieldy for users. And it was not long before academic researchers began to request access to these historic records – the first researcher recorded in the Royal Archives' Visitors' Book is Sir Sidney Lee (1859–1926), in 1920, for his official biography of King Edward VII. By 1929 Lord Stamfordham (1849–1931), Private Secretary to King George V, was reporting to the Keeper of the Privy Purse that 'Every year more people apply to examine the records.'

Stamfordham had been given the additional appointment of Keeper of the Royal Archives, in succession to Lord Esher, in 1919 or 1920, thus beginning the tradition, which has continued ever since, of the Private Secretary to the Sovereign, one of whose duties is being responsible for record-keeping throughout the Royal Household, being also ex-officio Keeper of the Royal Archives.

Lord Stamfordham was in no doubt about the importance of the Archives, firmly dismissing the complaint of the Keeper of the Privy Purse at having to continue paying his small staff of four: 'The Archives "have come to stay" and time will not bring less work.'

He was quite correct, for the collections continued to grow, particularly, in the early years, with the support of Queen Mary, who wrote to various relatives to encourage them to deposit their papers in the Royal Archives. Some other records, notably various lists of Royal Household staff from the sixteenth century onwards, were acquired by purchase; these included a list of jewels belonging to Edward I, dated 1297, which is the oldest document held in the Royal Archives. Gradually the Archives spread out from the Muniment Room into other rooms in the Round Tower.

Donations also carried on, sporadically, including two important acquisitions in the reign of Queen Elizabeth II: the political papers of Lord Melbourne (1779–1848), Home Secretary 1830–34 and then Prime Minster 1834 and 1835–41; and the letters from William IV and his Private Secretary to his

Prime Minister, Lord Grey (1764–1845). Each collection was presented to The Queen by a descendant of the respective politician, and together they help to fill part of the gap left by the destruction of most of the papers of William IV by his surviving executor, Sir Herbert Wheatley, to prevent their 'fall[ing] into other people's hands'.

The Royal Household, too, now had its own repository for its historic records, which had previously been sent to the Public Record Office (now The National Archives) for want of a better home. The twentieth-century, and later, papers of the Sovereign's Household, together with those of the Households of other members of the Royal Family, and of the private royal estates, are now routinely received in the Royal Archives. For the past 15 years this has been done using a records management system, to ensure that the appropriate records are archived and that other items are kept no longer than is necessary for business purposes.

The last 35 years have seen other developments in the care of these royal records. These have included the appointments of two dedicated conservators, who are able to clean and repair bindings, paper, parchment and seals, not to mention the other media occasionally encountered in the Royal Archives. There is an increasing emphasis on pre-emptive conservation, and the work of the conservators is complemented by storing the records in inert polyester sleeves or conservation-grade folders and boxes. In addition, climatic controls have been introduced, to provide stable temperature and humidity in the storage areas. This facility was made possible when, in 1993, following a major project to underpin and renovate the Round Tower, most of the collections were moved to a brand-new storage area, built within the Georgian two-storey extension to the Tower and covering the open courtyard. A subsequent enhancement has been the introduction of mobile shelving into one storage room, maximising the use of the available space.

Modern technology is similarly being employed to improve access to the collections, as far as possible, bearing in mind that the Royal Archives remains a private family archive. Cataloguing has been done on computer for more than 25 years, commencing with the Private Secretary's papers from the reign of King George VI and moving on to include various other series of records, both private and official, from the last two hundred years. Now, in addition to the more traditional ways of giving access to documents in the Royal Archives, such as exhibitions (internal and, occasionally, external) and microfilm copies, material is being made available online. Entire series of records, beginning in 2012 with the whole of Queen Victoria's Journals (www.queenvictoriasjournals.org), and selections of items on particular themes, such as Queen Victoria (www.queen-victorias-scrapbook.org), are being presented in this way.

However, technology also raises challenges, as thought must increasingly be given to how to preserve for the future the records that the Royal Family and the Royal Household are creating today using computers, smart phones and so on. Although the archival treasures of the future may well look very different from those currently stored in the Royal Archives, it is certain that their content will be as important and fascinating as that of the ones presented in this book.

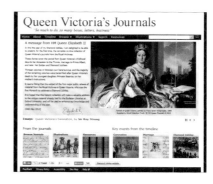

ABOVE *Home page for the website for the online edition of Queen Victoria's Journals, 2012.*

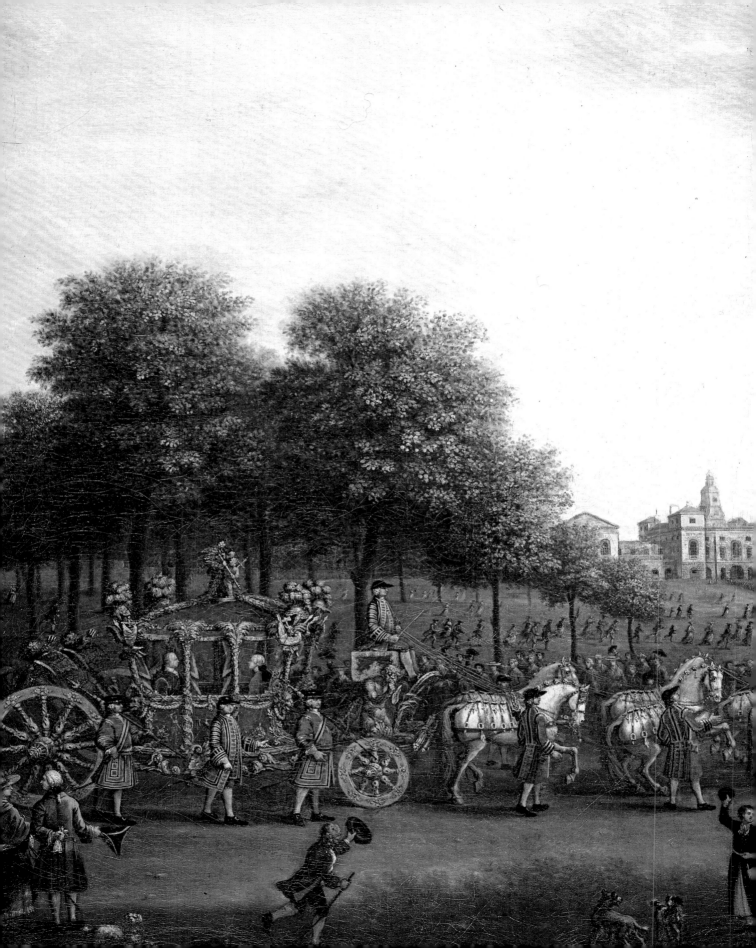

ONE POMP & CIRCUMSTANCE

'Today was indeed a great & memorable day in our lives & one which we can never forget ...'

KING GEORGE V'S DIARY ACCOUNT OF HIS CORONATION, 22 JUNE 1911

INTRODUCTION _____

Ceremonial and pageantry are, for many people, synonymous with the Royal Family, which is not surprising: landmark royal events, such as coronations and jubilees, and important constitutional occasions like the State Opening of Parliament, are all marked by formal procedures which, in most cases, have been developed and fashioned over centuries. The British monarchy is not, of course, alone in its use of colourful spectacle. The displays marking such occasions enable the public to witness and share in the events, and thus strengthen the relationship between Sovereign and people. Records relating to and illustrating these ceremonies are to be found throughout the Royal Archives.

The most important event in a Sovereign's official life is the coronation. The solemn religious ritual and surrounding ceremonial elements are rooted in tradition; but while the anointing, by which the Sovereign is consecrated, is still regarded as an essentially private moment, the coronation as a whole is a major public event, celebrated in magnificence. This was particularly obvious with the coronation of George IV (p. 22). Celebrations for jubilees often include elements similar to coronations, such as processions, as well as other, more public, events (p. 28); both occasions offer opportunities for the public to send in expressions of loyalty (p. 32).

Ceremonial also attends the public investiture of the Sovereign's eldest son as Prince of Wales (p. 43) and inevitably plays its part, albeit more soberly, in the arrangements for a Sovereign's state funeral (p. 30).

British pageantry is frequently a colourful affair: uniformed troops, bands and fanfares, processions of horses and carriages, crimson robes and coronets, the glittering crown jewels: all play a part. The appearance of the magnificent Gold State Coach (p. 20) graces many of the most important of these ceremonial occasions. Liveried Mews staff (p. 26) and the Heralds in their uniforms of centuries-old design (p. 19) are also familiar figures and regular participants in such events. All these elements contribute to the visual richness and splendour marking British royal ceremonial.

But a more personal aspect of these great public events is also revealed in the Royal Archives. After Queen Victoria's accession, her uncle, King Leopold of the Belgians, wrote offering advice to assist the young Sovereign in her new role (p. 24). A newly crowned King George V recorded his own coronation in his diary (p. 34), while a king's daughter and future queen described the crowning of her parents in 1937, an event foreshadowed in a decorated letter from one of Queen Elizabeth's acquaintances (p. 37). Thus both the public and the private sides of these great ceremonial occasions are reflected in royal records, providing evidence relating to the national celebration of these events and also to the personal impact they have on the principal participants.

Copy receipt for tabards for officers in the College of Arms, with coloured drawing of the tabard, bearing the Royal Arms, March 1717

RA GEO/MAIN/87910–87910A

The College of Arms is the Sovereign's heraldic department. Its 13 members are styled 'heralds in ordinary', and form three groups: kings (for example, Garter King of Arms), heralds and pursuivants. They are members of the Royal Household, directly appointed by the Sovereign. Heralds have existed in England since at least 1170. Their chief function initially was to proclaim and organise tournaments. Although many of their ceremonial duties have since disappeared, the College of Arms is still responsible for the arrangement of state ceremonials.

On these occasions the heralds wear their medieval uniform, including a tabard embroidered on the front, back and sleeves with the Royal Arms. This document of 1717, signed by Charles Mawson (Chester Herald), records the receipt of coats (i.e. tabards) for Clarenceux and Norroy Kings of Arms, five of the heralds and two of the pursuivants. Richard Mawson (Portcullis Pursuivant), Dudley Downes (Rouge Dragon Pursuivant) and Thomas Wightwick (York Herald) also signed to indicate receipt of their tabards. Clarenceux King of Arms at this time was Sir John Vanbrugh (1664–1726), the celebrated architect and dramatist.

As this document dates from the reign of George I, the Royal Arms depicted incorporate German arms in the lower right-hand quarter: Brunswick (two golden lions), Lüneburg (a blue lion) and Hanover (a white horse). The crown in the centre of this quarter is the badge of the Arch-Treasurer of the Holy Roman Empire, an office held by George I as Elector of Hanover. The other arms represented are those of England (three golden lions), Scotland (a red lion) and Ireland (a harp), along with France (three fleurs-de-lis), which had been part of the Royal Arms since Edward III claimed the French throne but which were finally removed after 1801, when this version of the Royal Arms ceased to be used.

This receipt is in a volume of Great Wardrobe accounts, the earliest series of papers in the Royal Archives, covering the period 1660–1749. The accounts consist of three parallel series – warrants, bills and receipts – which cover the provision of royal liveries and ceremonial robes (as here), and also relate to the supply of furniture and furnishings for royal palaces. These accounts are, therefore, an important and valuable record for the royal residences during this period.

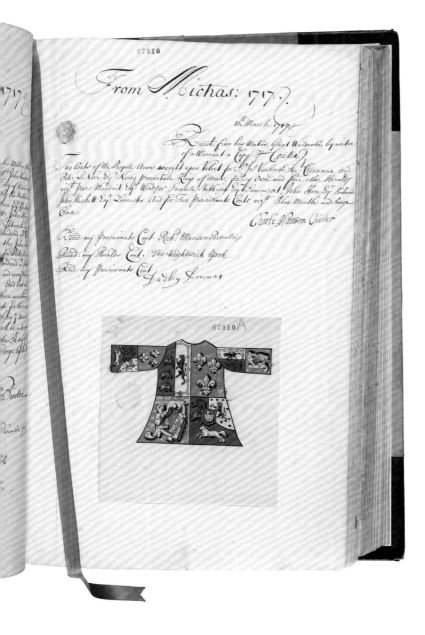

Entry in a journal of daily occurrences in the Royal Mews recording the delivery of the Gold State Coach and its cost, November 1762

RA MEWS/DIARY/MOH/1A

One of the best-known symbols of British ceremonial, the Gold State Coach was built for George III and first used by him to open Parliament on 25 November 1762, the day after its delivery to the Royal Mews. Designed by the famous architect William Chambers (1722/3–96), it was built by the coach maker Samuel Butler, whose name is recorded in this Mews journal along with the other craftsmen who contributed to its creation. As its name implies, the coach is gilded all over (by Henry Pujolas) and decorated with symbolic paintings and carvings. Among the paintings (executed by Giovanni Cipriani), for example, the front panel depicts Victory presenting a laurel garland to Britannia, who is holding a staff of Liberty and is attended by figures representing Justice, Wisdom, Commerce and Plenty, amongst others; St Paul's Cathedral and the river Thames are in the background.

As can be seen from the journal, the greatest expense was the carved decoration by Joseph Wilton, costing £2,500 (around £187,000 in modern currency). This decoration is also heavily symbolic, including three cherubs on the roof representing the genii of England, Scotland and Ireland, which support the Imperial Crown of Great Britain; the four trees at the corners of the framework of the

coach are decorated with trophies symbolising Britain's victory in the Seven Years' War (1756–63). The body of the coach is slung by braces of morocco leather 'held' by four Tritons, two of which appear to be pulling the coach and announcing the arrival of the Monarch of the Ocean with their conch shells. The wheels imitate those of an ancient triumphal chariot; the interior is lined with crimson satin.

The coach is 24 ft (7.3 m) long, 8 ft (2.4 m) wide, 12 ft (3.7 m) high and weighs 4 tons (4064.2 kg); it can proceed only at a walking pace, and is drawn by eight horses.

It is no wonder that such a magnificent coach is reserved for the most important royal occasions. It has been used for every coronation since that of William IV in 1831 and was formerly used for the State Opening of Parliament. It was also used by Queen Elizabeth II for her Silver and Golden Jubilees. This rather humble entry in a Mews journal records the delivery of probably 'the most superb & expensive' coach 'ever built in this Kingdom', and perhaps one of the most famous in the world.

BELOW *The Gold State Coach in the State Coach House at the Royal Mews, Buckingham Palace.*

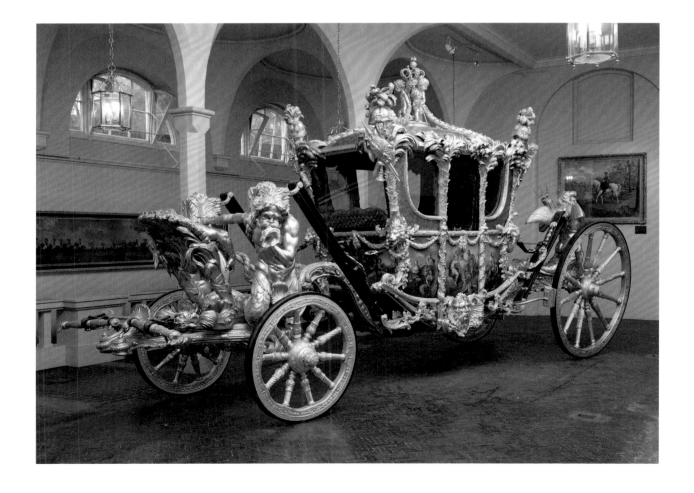

Cloth fragments from textiles used in the Coronation of George IV and menu book for the Coronation Banquet in Westminster Hall, 19 July 1821

RA GEO/ADD3/85 and

RA MRH/MRHF/MENUS/MAIN/MIXED

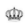

The coronation service, with its rich symbolism, consecrates the Sovereign. It is basically a religious ceremony but provides an occasion for great pomp and celebration; it remains a central and crucial feature in the ceremonial life of the British monarchy.

Not surprisingly, in view of his love of opulence, probably the most flamboyant coronation was that of George IV in 1821. It was also one of the most expensive, costing around £240,000 (about £10,000,000 in modern currency), compared with that of his father, George III, which cost less than £10,000 in 1761, and that of his brother, William IV, which cost just over £40,000 in 1831. Those in the procession wore Elizabethan and Jacobean costumes; the King's own robe was modelled on that of Napoleon and included a 27ft (8.2m) long velvet crimson train, decorated with gold stars, which required eight train bearers to carry it.

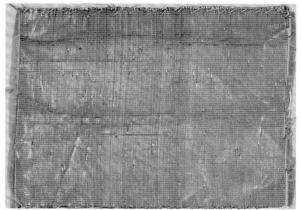

The whole effect must have been dazzling, the painter Benjamin Robert Haydon observing: 'all that was rich in colour, gorgeous in effect … English in character or Asiatic in magnificence, was crowded into this golden & enchanted hall!'

The year 1821 was the last time a coronation banquet, which had been part of coronation celebrations since the medieval period, was held in Westminster Hall. 23 temporary kitchens provided 160 tureens of soup and similar numbers of dishes of fish, joints and vegetables, amongst many others; it has been estimated that there were 3,271 cold dishes alone.

There are few textile examples in the Royal Archives; fabrics often prove extremely fragile, so it is particularly pleasing to have some swatches from a nineteenth-century coronation. The menu book is one of the earliest from a series in the Royal Archives recording royal meals, and is particularly valuable as a record of what was almost certainly the most extravagant coronation banquet ever held.

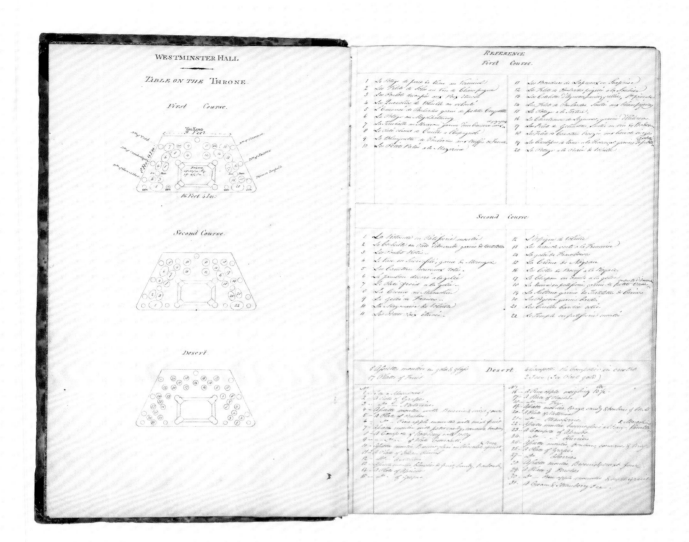

OPPOSITE TOP & CENTRE
These cloth fragments indicate something of the magnificence of the textiles used at George IV's Coronation: the yellow and gold floral material was part of the cloth of gold covering of the canopy held behind the King as he processed to and from Westminster Abbey, with the 'Silver Tissue' as its lining, while the gold textile was part of the covering of St Edward's Chair, in which the King was crowned.

OPPOSITE BOTTOM *George Jones (1786–1869),* The Banquet at the Coronation of George IV, *1822. Oil on panel RCIN 404463*

ABOVE *The Coronation menu book gives table plans for Westminster Hall on the left and the proposed menus – divided into first course, second course and dessert – on the right; the opening shown here is for the royal family's table.*

LEFT *Letter from King Leopold I of the Belgians to Queen Victoria, 23 June 1837.*

Queen Victoria's accession speech to the Privy Council, 20 June 1837, and a letter from King Leopold I of the Belgians to the young Queen, offering advice on her new position, 23 June 1837

RA VIC/ADDA27 and RA VIC/MAIN/Y/63/47

On the death of William IV on 20 June 1837, his 18-year-old niece came to the throne as Queen Victoria.

On the day of her accession, she was woken at 6 in the morning to receive the news of the King's death, and five hours later the new Sovereign held her first Privy Council, at which her first act was to read this declaration. It had been written by the Prime Minister, Lord Melbourne, and Victoria described it as 'very fine'. The diarist Charles Greville (1794–1865), Clerk of the Privy Council, noted on the document's title sheet: 'this is the speech which Queen Victoria read in Council upon the day of her accession … and I took this paper from Her Majesty's hands after she had read it'. Few speeches by Queen Victoria survive in the Royal Archives.

Young and inexperienced, the new Sovereign was guided in this, her first official duty, by her Prime Minister; but she had been prepared for her new role by her beloved uncle, King Leopold of the Belgians.

Uncle and niece corresponded for many years (the Royal Archives holds over fifty volumes of their letters); and once Victoria ceased to be a child, Leopold's letters frequently offered advice on suitable studies and activities and, later, on political matters.

This letter is of particular interest in being advice to a new young Sovereign from an older one. Writing a few days after Victoria's accession, King Leopold emphasises the political importance of affirming her English birth, of praising Britain and its people, and of supporting the established Church. The King also advises her that it might be 'politic' to associate herself with the country's fond memories of Princess Charlotte, heir of George IV and Leopold's first wife, who had died in childbirth in 1817 before she could succeed to the throne, as this 'can only revive a good feeling in the hearts of the people for You'.

ABOVE *Magdalena Dalton (1801–74), Leopold I, King of the Belgians, 1840. Watercolour on ivory laid on card RCIN 420875*

RIGHT *Covering note and first page of Queen Victoria's accession speech to the Privy Council, 20 June 1837.*

BELOW RIGHT *James Brooks (1825–1901), The First Council of Queen Victoria, 1891. Oil on canvas RCIN 407146*

Declaration
of Her M. the Queen

this is the speech which
Queen Victoria read in
Council upon the day of
her accession Tuesday June
20th 1837, and I took this
paper from Her Majesty's
hand, after she had read it

Greville

1

The severe and afflicting
loss, which the Nation
has sustained by the
death of his Majesty,
my beloved Uncle has
devolved upon Me
the duty of administering
the Government of
this Empire — This
awful Responsibility
is imposed upon Me
So suddenly and at
So early a period of
my Life, that I should

Transcript of Queen Victoria's accession speech, 20 June 1837

Declaration of Her M. the Queen,
this is the speech which Queen Victoria read in Council upon the day of her accession Tuesday June 20th 1837, and I took this paper from Her Majesty's hands after she had read it

C Greville

The severe and afflicting loss, which the Nation has sustained by the death of his Majesty, my beloved Uncle has devolved upon me the duty of administering the Government of this Empire – This awful responsibility is imposed upon me so suddenly and at so early a period of my Life, that I should feel myself utterly oppressed by the burthen, were I not sustained by the hope, that Divine Providence, which has called me to this work, will give me strength for the performance of it, and that I shall find in the purity of my Intentions and in my zeal for the public welfare that support & those resources, which usually belong to a more mature age and to longer experience.

I place my firm reliance upon the wisdom of Parliament and upon the loyalty and affection of my People.

I esteem it also a peculiar advantage, that I succeed to a Sovereign whose constant regard for the rights and Liberties of his subjects & whose desire to promote the amelioration of the Laws and Institutions of the Country have rendered his name the object of general attachment and veneration.

Educated in England under the tender and enlightened care of a most affectionate Mother I have learned from my Infancy to respect and love the Constitution of my native Country – It will be my unceasing study to maintain the reformed Religion as by Law established securing at the same time to all the full enjoyment of religious liberty, and I shall steadily protect the rights and promote to the utmost of my Power the happiness and welfare of all Classes of my Subjects.

Pictures of liveries worn by Royal Mews staff at the time of Queen Victoria's Golden Jubilee, 21 June 1887

RA MEWS/LIV/MISC

Queen Victoria celebrated 50 years on the throne in 1887; as the volume from which these images come is dated 21 June 1887, the fiftieth anniversary of her proclamation as Queen and the day on which the Golden Jubilee was celebrated, it was evidently produced as a record of that event. The volume depicts the different liveries worn by Royal Mews personnel for the various state events in which they participate, and includes descriptions of the liveries shown. Carriages, horses and liveried Household attendants are among the most recognisable and colourful aspects of royal ceremonial.

Mews liveries have their origins in the Georgian period and, apart from the change of royal cypher with the accession of each new Sovereign, they appear to have altered little since the eighteenth century. Different forms of the liveries are worn for state and semi-state occasions, and there are also Scarlet and Ascot liveries. The first illustration here depicts 'State Liveries with caps' for a postilion (who rides a carriage horse), coachman and footman; it has been estimated that the Coachman's Full State driving coat and waistcoat weigh around 16 lb

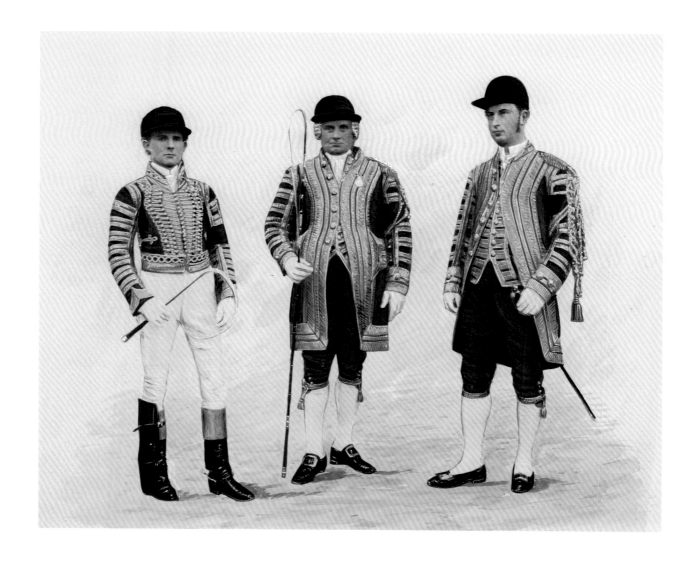

(over 7 kg). The second illustration, 'Scarlet Liveries with boots & leather breeches', shows one postilion in Ascot livery, another in the blue jacket worn with Scarlet liveries, and a footman and outrider (who leads a carriage procession) in Scarlet liveries with gold-laced top hats.

What is remarkable about this volume (which is unique in the Royal Archives) is that the images of these uniformed figures are photographic: they are hand-coloured (probably water-coloured) platinum prints. The liveries have been heavily painted and the faces have also clearly been coloured, although less thickly. The individuals are all identified in pencilled notes, and some appear in more than one illustration. The footman, James Wargent, appears in both these illustrations; he is shown with the state coachman, George Payne, and postilion Richard Woollven, in the first, and with outrider Henry Mould and postilions William Edser and Charles Smith in the second. George Payne had entered royal service in 1838, the second year of Queen Victoria's reign; in 1887 he received a bar to his Victoria Faithful Service Medal for his 49 years in the Royal Household, almost as many as the Queen he served had reigned.

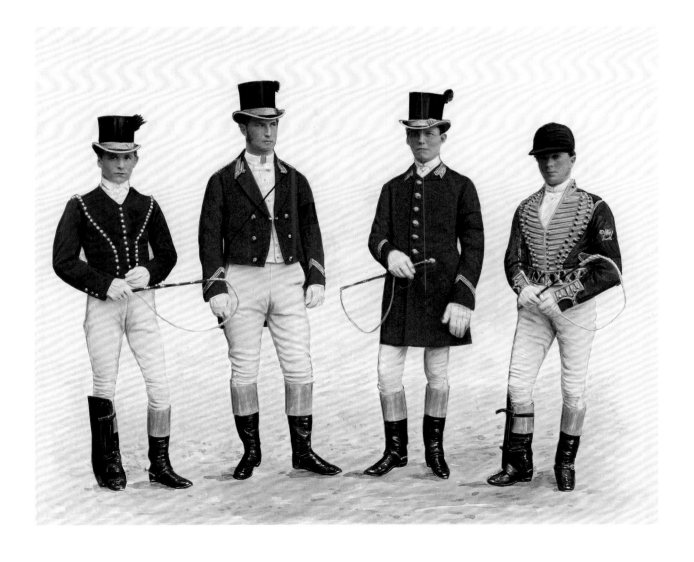

Items relating to Queen Victoria's Diamond Jubilee in 1897: carriage procession list for 22 June, pressed flowers from a jubilee bouquet, and Lord Chamberlain's Office memorandum for the garden party held on 28 June

RA MEWS/DIARY/PROCESSION, RA VIC/MAIN/QVFLB /7 and RA LC/LCO/CER/MEMO

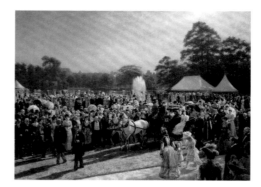

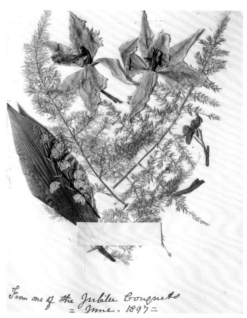

From one of the Jubilee Bouquets = June. 1897 =

Celebrations to mark the Sovereign's jubilee years have been held since the reign of George III, but it was not until the Victorian period that Sovereign and people started marking jubilees together, with the now-familiar processions and thanksgiving services in London as central elements.

In 1897 Queen Victoria became the first British Sovereign to have a Diamond Jubilee. The principal commemoration occurred on 22 June, with a procession to St Paul's Cathedral, where a short thanksgiving service was held outside (the Queen was too lame to climb the steps). This Royal Mews Procession Book lists the 17 carriages, with their occupants, horses and attendants, which formed this procession to the Cathedral. In the final coach was the Queen, with her daughter Helena, Princess Christian, and the Princess of Wales (the future Queen Alexandra). This semi-state landau was pulled by eight horses ridden by four postilions (of whom two, Edser and Woollven, appear in the 1887 Mews Livery Book, p. 27) and attended by eight grooms and two footmen. This volume is one of a series detailing the royal carriages, horses and personnel employed for official events from 1813 to 1939.

Another event marking the Diamond Jubilee was a garden party held at Buckingham Palace on 28 June; from this memorandum it seems to have been the last of the festivities. The account was written by Sir Spencer Ponsonby-Fane (1824–1915), Comptroller of Accounts in the Lord Chamberlain's Office from 1857, and is remarkably candid. Despite the general success of the event, he clearly did not enjoy it, as he concludes: 'I trust never again to have to go through such a business'. Such a personal account of proceedings is invaluable in enlivening the bare facts of an official event; it appears in a

series of Private Memoranda Books which include similar descriptions of royal events from 1858 to King Edward VII's Coronation in 1902.

A different aspect of the Jubilee is illustrated by the pressed flowers. Fastened into one of Queen Victoria's flower books, these are identified simply as being 'From one of the Jubilee bouquets' and presumably came from a bouquet given to or carried by the Queen herself. There are eight albums of Queen Victoria's pressed flowers in the Royal Archives, covering 1834–1900; these fragile plants commemorate special occasions, visits, or sometimes simply walks she took with Prince Albert, and many of them are annotated by the Queen herself. They are a charming personal record of both the official and the private life of Queen Victoria.

LEFT *Laurits Regner Tuxen (1853–1927),* The Garden Party at Buckingham Palace, 28 June 1897, *1897–1900. Oil on canvas RCIN 405286*

BOTTOM LEFT *Pressed flowers from a Jubilee bouquet. Although the flowers are, inevitably, much faded, it appears that the bouquet would have included irises, lily of the valley and fern.*

OPPOSITE FAR RIGHT *The Royal Mews procession book, listing the carriages which formed the procession to St Paul's Cathedral on the occasion of Queen Victoria's Diamond Jubilee.*

Transcript of Lord Chamberlain's Office memorandum

Jubilee
Garden Party
Monday June 28/97

6500 appns
5000 present

This was a very heavy business but was a day of rejoicing as we fondly hoped it was the end of the Jubilee Festivities –

The applications were so numberless that we were obliged to put in an announcement that we could not answer the Letters – …

The Queen came soon after five, and drove twice round the grounds …

HM. then went into her Tent and had Tea – after which she received the Envoys … & all the Princes, & Princesses, also the Cengalese who created much interest –

There were Photographers in every Bush, & amongst others the Cinometograph which made a great noise but HM. was much amused when she learnt what it was –

The Party was on the whole most successful – The Queen liked it – and so did all who were present – but there were terrible heartburnings at "not being even included amongst 6500" –

Some of the H. of C. people were especially rabid – because we stuck as much as possible to the rule that no one should be invited who had not been to Court within 5. years. - & excluded wives not presented –

I trust never again to have to go through such a business –

SPF June 30/97

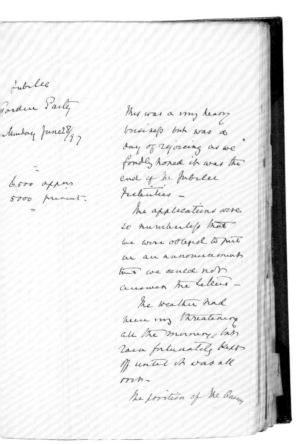

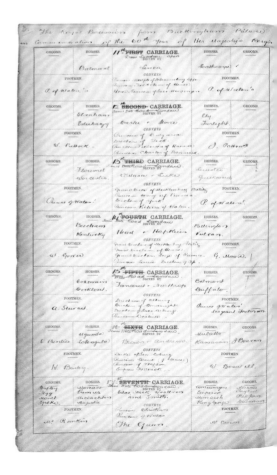

Entry in the Journal of Her Majesty's Yachts recording the journey of Queen Victoria's coffin from the Isle of Wight to Portsmouth, 1 February 1901

RA RY/DIARY/ADM

Just as at happier royal events, due ceremonial is incorporated into royal funerals, particularly state funerals for Sovereigns. Depending on where the Sovereign dies, additional processional ceremonies may be required to bring the coffin to Windsor, the burial place of all British Sovereigns since the funeral of George III in 1820.

This was the case for Queen Victoria, who died at Osborne House on the Isle of Wight on 22 January 1901, aged 81. Extraordinarily, no ceremonial had been planned for the Queen's funeral, so the journey to Windsor, as well as all the surrounding arrangements and the service, had to be planned from scratch in ten days. Somehow all was achieved by the time the coffin left Osborne House on 1 February.

After a short service, the first part of Queen Victoria's final journey began as her coffin was placed on a gun carriage pulled by eight horses of the Royal Horse Artillery, which was drawn in solemn procession to Trinity Pier at Cowes. At the pier the drums continued a muffled roll while the coffin was taken on board the Royal Yacht *Alberta*. This 160ft (50m) long paddle-wheel yacht with two funnels and three masts acted as a tender to the larger Royal Yacht *Victoria and Albert*.

This extract is from a series of Royal Yachts' Journals recording the use of the various royal yachts from 1837 to 1998. With its accompanying newspaper cutting, it describes the passage of the *Alberta* across the Solent, past the lines of the British and foreign Men of War moored there, each with a band playing funeral marches, and firing minute guns; the forts and ships in harbour then took up the firing until the *Alberta* arrived at Clarence Yard. Describing this impressive scene, one newspaper report commented: 'Has anything like it ever been seen in history?'

The following day, the coffin was placed on a train to London, drawn through the streets to Paddington station in a two-hour military procession, and eventually arrived that afternoon at St George's Chapel in Windsor Castle, where the funeral service was held. On 4 February, the Queen was finally laid to rest beside her beloved husband, Prince Albert, in Frogmore Mausoleum.

BELOW *Newspaper cutting from* The Times, *recording the passage of the royal funeral procession across the Solent.*

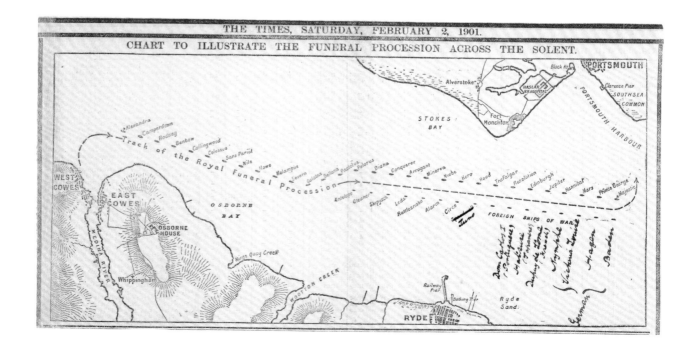

by the Royal Yachts "Victoria & Albert" and "Osborne", the German Imperial Yacht "Hohenzollern", the Admiralty Yacht "Enchantress" and the Trinity Yacht "Siren", and escorted by 8 Torpedo Boat Destroyers, proceeded in funeral procession through the lines of the British & Foreign Men of War moored in the Solent from Osborne to Spithead (as shewn in the attached chart) and to Clarence Yard, alongside which she was secured at 4.26 p.m.

The following crossed in the "Alberta" with the Royal Remains:- The Countess of Lytton, the Hon. N.L. Phipps, Major-General Sir John McNeill, Vice Admiral

Loyal address presented by the theatrical profession on the occasion of the Coronation of King Edward VII, 1902

RA ADDRESSES/MAIN/EVII/1902

Royal events frequently evoke a heightened regard for the Sovereign and the Royal Family, often marked by the sending of loyal addresses. A certain number of 'privileged bodies' (such as the General Synod, the Free Churches and Oxford and Cambridge Universities) enjoy an ancient right to present an address to the Sovereign in person on occasions such as coronations and jubilees; but other organisations may also feel inspired to create and send in their own expressions of loyalty. Occasionally, the address may come in the form of a volume, as is the case in this particular example.

In October 1901, the famous actor-manager Sir Henry Irving (1838–1905) reported to King Edward VII's Private Secretary, Sir Francis Knollys, that the actors of the United Kingdom wished to present a loyal address to the King to mark his Coronation. It was to be similar to the one presented by the theatrical profession to Queen Victoria on her Golden Jubilee in 1887 and would, Sir Henry noted, be 'a piece of work which will take a long time to prepare'. Indeed, it proved impossible to complete the address during the Coronation year and it seems that the volume was temporarily forgotten until it reappeared in August 1906.

It is immediately clear why this address took so long to prepare, for it is highly decorated, inside and out. The pages of the address are illuminated by different artists with various designs, but in an overall Art Nouveau style; a monogram apparently of the initials 'RPGJM' appears on 75 pages, while Agnes Jameson has signed 11 designs. After the written address and signatures of several theatrical professionals (including Irving, Sir Squire Bancroft and Irene Vanbrugh), each page is dedicated to a particular named theatre and signed by the members of the company there. In all 49 London theatres are listed, followed by 101 provincial theatres from 78 towns.

ABOVE RIGHT *Onlaid leather floral design on the inside front board of the volume, heavily decorated with gold finishing.*

OPPOSITE *Bound by the Zaehnsdorf company in pale blue morocco leather, the volume bears King Edward VII's monogram and crown on the front cover, surrounded by a wreath of green leaves and red berries. Even the fore-edges of the pages are decorated, in full gilt with goffering (indented tooling) in a floral and horseshoe motif.*

BELOW RIGHT *The page for the Lyceum Theatre, illustrated here, includes the signatures of Irving, who owned the theatre, Ellen Terry, who was its leading actress, and the author Bram Stoker, who was Irving's friend and the theatre's business manager.*

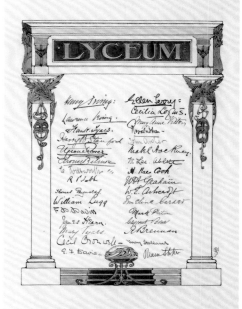

Thursday June 22nd. Our Coronation Day.
Buckingham Palace. It was overcast & cloudy
with slight showers & a strongish cool breeze,
but better for the people than great heat. Today
was indeed a great & memorable day in our lives
& one which we can never forget, but it brought
back to me many sad memories of 9 years ago
when the beloved Parents were crowned. May & I
left B.P. in the Coronation coach at 10.30. with 8
cream coloured horses. There were over 50,000
troops lining the streets under the command of
Ld. Kitchener. There were hundreds of thousands
of people who gave us a magnificent reception.
The Service in the Abbey was most beautiful
& impressive, but it was a terrible ordeal.
It was grand, yet simple & most dignified
& went without a hitch. I nearly broke down
when dear David came to do homage to
me, as it reminded me so much when I did
the same thing to beloved Papa, he did it
so well. Darling May looked lovely & it
was indeed a comfort to me to have her
by my side, as she has been ever to me
during these last 18 years. We left Westminster
Abbey at 2.15 (having arrived there before 11.0.)

1911
with our Crowns on & sceptres in our hands
This time we drove by the Mall, St James' Street
& Piccadilly, crowds enormous & decorations
very pretty. On reaching B.P. just before 3.
May & I went out on the balcony to show
ourselves to the people. Downey photographed
us in our robes with Crowns on. Had some tea
with our guests here. Worked all the afternoon
with Bigge & others answering telegrams & ...
of which I have hundreds. Such a large ...
collected in front of the Palace that I went ...
on balcony again. Our guests dined with us ...
8.30. May & I showed ourselves again to the
people. Wrote & read. Rather tired. Bed at 11.
Beautiful illuminations everywhere.
Friday June 23rd Dear David's birthday. Buckingham
Palace. Up early, showery & cloudy. We gave
his presents after breakfast. At 10.0. all the
members of the family (English) came to wish
joy, as we didn't see them to speak to yesterday
At 11.0. May & I started for our wonderful ...
through London, over 7 miles in length, the
the most beautifully decorated streets which
were crowded with people from top to ...
who cheered in a way I have never heard

King George V's diary account of his Coronation Day, 22 June 1911

RA GV/PRIV/GVD/1911: 22 June

On the death of his father, King Edward VII on 6 May 1910, King George V succeeded to the throne on. A bluff, down-to-earth man, his early naval training in log-keeping made him a conscientious recorder of facts, figures – and the daily weather – although he lacked his grandmother Queen Victoria's flair as a diarist. Whilst mostly brief and factual, his diaries, covering the years from 1878 until his death in 1936, occasionally reveal strong emotions. That is certainly the case here, when his own Coronation brought back 'sad memories' of 'when the beloved Parents were crowned'; and he 'nearly broke down'

when his son the Prince of Wales echoed his own act of homage of nine years previously.

While the central coronation service has remained largely unchanged, in the twentieth century there was perhaps more emphasis on the inner meaning of the ritual, and the general arrangements made for the 1902 Coronation of King Edward VII seem to have provided the template for those that followed. In 1911 a few changes were made to the form of the service: at the crowning a shorter, older form of words was restored to replace those used since 1689, and the anthem at the beginning of the communion service was replaced by one which had been part of the medieval rite. The service was, in the King's own words, 'beautiful & impressive … yet simple & most dignified'.

King George V's great affection for his wife, Mary, now Queen, who had shared this 'terrible ordeal' with him, is clear in his diary account, as he noted that 'it was indeed a comfort to me to have her by my side, as she has been ever to me during these last 18 years'. The grandeur of the occasion was not lost on the new Queen, who wrote to her aunt, the Grand Duchess of Mecklenburg-Strelitz (whose father was the seventh son of George III), that 'we felt it all so deeply ... taking so great a responsibility on our shoulders. To me who love tradition & the past ... the service was a very real solemn thing & appealed to my feelings more than I can express.'

The King also commented in his diary on the enormous crowds, the decorations and illuminations, and the appearances he and the Queen made on the balcony at Buckingham Palace; and while his description may not run to the length (over 2,000 words) Queen Victoria used to describe her own Coronation Day in 1838, it is nonetheless a distinctly personal account.

Transcript of King George V's diary entry for 22 June 1911

Thursday June 22nd Our Coronation Day. Buckingham Palace. It was overcast & cloudy with slight showers & a strongish cool breeze, but better for the people than great heat. Today was indeed a great & memorable day in our lives & one which we can never forget, but it brought back to me many sad memories of 9 years ago when the beloved Parents were crowned. May & I left B.P. in the Coronation coach at 10.30. with 8 cream coloured horses. There were over 50,000 troops lining the streets under the command of Ld Kitchener. There were hundreds of thousands of people who gave us a magnificent reception. The Service in the Abbey was most beautiful & impressive, but it was a terrible ordeal. It was grand, yet simple & most dignified & went without a hitch. I nearly broke down when dear David came to do homage to me, as it reminded me so much of when I did the same thing to beloved Papa, he did it so well. Darling May looked lovely

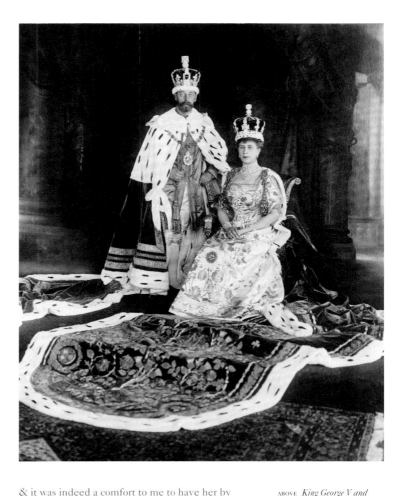

& it was indeed a comfort to me to have her by my side, as she has been ever to me during these last 18 years. We left Westminster Abbey at 2.15. (having arrived there before 11.0.) with our Crowns on & sceptres in our hands. This time we drove by the Mall, St James' Street & Piccadilly, crowds enormous & decorations very pretty. On reaching B.P. just before 3.0. May & I went out on the balcony to show ourselves to the people. Downey photographed us in our robes with Crowns on. Had some lunch with our guests here. Worked all the afternoon with Bigge & others answering telegrams & letters of which I have hundreds. Such a large crowd collected in front of the Palace that I went out on [the] balcony again. Our guests dined with us at 8.30. May & I showed ourselves again to the people. Wrote & read. Rather tired. Bed at 11.45. Beautiful illuminations everywhere.

ABOVE *King George V and Queen Mary in Coronation robes, 22 June 1911 RCIN 2926152*

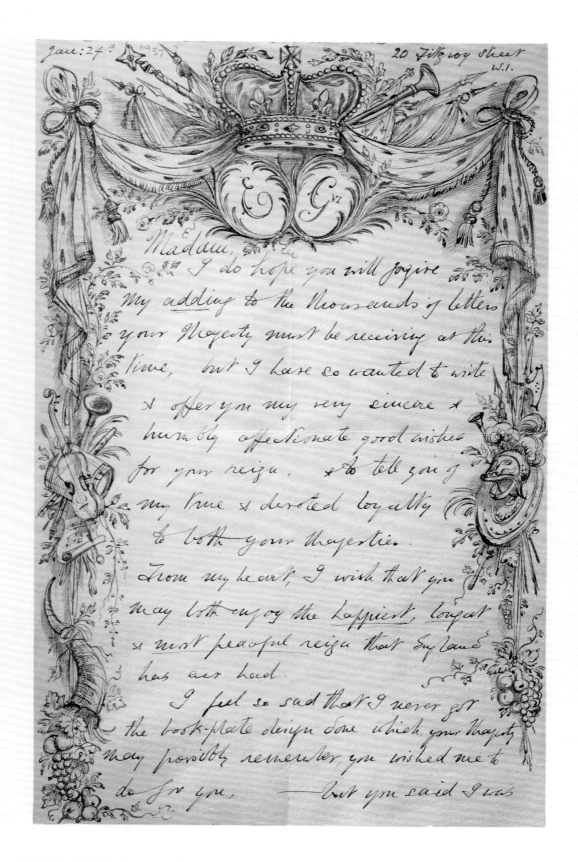

Jan: 24ᵗʰ 1937 20 Fitzroy Street
 W.1.

Madam,

I do hope you will forgive
my adding to the thousands of letters
your Majesty must be receiving at this
time, but I have so wanted to write
& offer you my very sincere &
humbly affectionate good wishes
for your reign, & to tell you of
my true & devoted loyalty
to both your Majesties.

From my heart, I wish that you
may both enjoy the happiest, longest
& most peaceful reign that England
has ever had.

I feel so sad that I never got
the book-plate design done which your Majesty
may possibly remember, you wished me to
do for you. —— but you said I was

Hand-illustrated letter from Rex Whistler to Queen Elizabeth, 24 January [1937], and Princess Elizabeth's handwritten account of the Coronation of her parents, King George VI and Queen Elizabeth, 12 May 1937

RA QEQM/PRIV/PAL: 1937.0124 and RA QEII/PRIV/PERS

As the second son of King George V, Albert, Duke of York, did not expect to become King; but when his elder brother, King Edward VIII, abdicated in December 1936, he succeeded to the British throne as King George VI. King Edward VIII is the only British Sovereign to have abdicated in modern times; although it is not uncommon in other European countries (particularly the Netherlands), abdication can be regarded as a threat to the institution of monarchy. In 1936, however, upheaval was averted and the British throne passed smoothly to the former Duke and Duchess of York, who were popular members of the royal family.

Messages of congratulation and support naturally follow an accession; some personal, from family and friends, others from well-wishing members of the

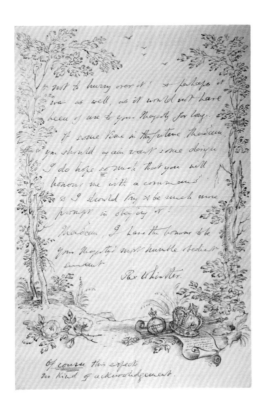

general public. One of those sending his congratulations to Queen Elizabeth was the artist Rex Whistler (1905–44); he was well known in London society and the new Queen liked him and his work. Whistler often illustrated his letters, including those to the Queen, and in this particular example he has created an exuberant celebratory design. Symbols of monarchy (crowns, orb and sceptre) are depicted alongside a trophy of war, a horn of plenty and other signs of fruitfulness, and musical instruments (presumably symbolising the arts and culture), to accompany his wishes that Their Majesties 'may both enjoy the happiest, longest & most peaceful reign that England has ever had'. Sadly, in less than three years Britain would be at war and Whistler himself would be one of the many casualties, being killed at Caen in July 1944. This letter is from the collection of the correspondence of Queen Elizabeth the Queen Mother and, as well as marking a particular event in royal history, it is an example of the wide variety of contacts and interests Queen Elizabeth enjoyed.

The Coronation of King George VI and Queen Elizabeth took place on 12 May 1937 in Westminster Abbey, the traditional location for such occasions. The Sovereign's family attended, of course; and on this occasion, as the new King and Queen were young parents, their 11- and 6-year-old daughters witnessed the ceremony. Princess Elizabeth (the future Queen Elizabeth II) wrote this account of the Coronation, 'To Mummy and Papa In Memory of Their Coronation', beginning from the time she was woken at 5 am 'by the band of the Royal Marines striking up just outside my window' until the time she went to bed that night. Naturally it is a very personal narrative but it is also unique, for it is not only an eyewitness account of a momentous occasion in her parents' lives by a young girl, but it is written by someone who would herself one day go through the same experience: 'I thought it all very, very wonderful and I expect the Abbey did, too.'

Transcript (part) of Princess Elizabeth's account of her parents' Coronation

An Account of the Coronation.

At 5 o'clock in the morning I was woken up by the band of the Royal Marines striking up just outside my window…

We went along to Mummy's bedroom and we found her putting on her dress. Papa was dressed in a white shirt, breeches and stockings, and over this he wore a crimson satin coat. Then a page came and said it was time to go down, so we kissed Mummy, and wished her good luck and went down …

[In Westminster Abbey] we went up the steps and into the box. There we sat down and waited for about half-an-hour until Mummy's procession began. Then came Papa looking very beautiful in a crimson robe and the Cap of State.

Then the service began.

I thought it all <u>very</u>, <u>very</u> wonderful and I expect the Abbey did, too. The arches and beams at the top were covered with a sort of haze of wonder as Papa was crowned, at least I thought so.

When Mummy was crowned and all the peeresses put on their coronets it looked wonderful to see arms and coronets hovering in the air and then the arms disappear as if by magic. Also the music was lovely and the band, the orchestra and the new organ all played beautifully.

What struck me as being rather odd was that Grannie [Queen Mary] did not remember much of her own Coronation. I should have thought that it would have stayed in her mind for ever.

At the end the service got rather boring as it was all prayers. Grannie and I were looking to see how many more pages to the end, and we turned one more and then I pointed to the word at the bottom of the page and it said "Finis". We both smiled at each other and turned back to the service …

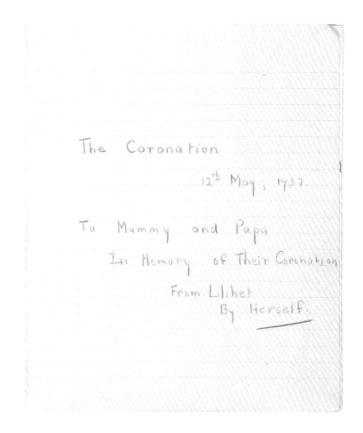

RIGHT *Dorothy Wilding (1893–1976)*, King George VI, Queen Elizabeth, Princess Elizabeth and Princess Margaret in their Coronation Robes, 12 May 1937. *Gelatin silver print RCIN 2999915*

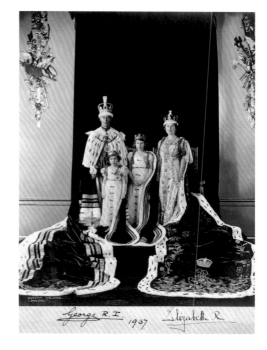

came to breakfast, was waiting there. We did not eat very much as we were too excited. After we had finished we looked out of the window until it was time to get dressed. We saw the Canadian Mounted Police in their red coats and once when a policeman went by on his bicycle, everybody cheered!

When we were dressed we showed ourselves to the visitors and the housemaids. Now I shall try and give you a description of our dresses. They were white silk with old cream lace and had little gold bows all the way down the middle. They had puffed sleeves with one little bow in the centre. Then there were the robes of purple velvet with gold on the edge.

We went along to Mummy's ... found her putting on her dress. ... shirt, breeches andtin

to go down, so we kissed Mummy, and wished her good luck and went down. There we said 'Goodmorning' to Aunt Alice, Aunt Marina and Aunt Mary with whom we were to drive to the Abbey. We were then told to get into the carriage. When we got in we still had to wait a few minutes and then our carriage moved from the door. At first it was very jolly but we soon got used to it. We went round the Memorial, down the Mall, through Admiralty Arch, along Whitehall, past the Cenotaph and the Horse Guards' Parade, and then Westminster Abbey. When we got out we were welcomed by the Duke of Norfolk, the Earl Marshal.

We waited in the little dressing-room until it was time to go up the aisle. Then we arranged ourselves to form the procession. First of all came two Heralds, then two Gentleman Ushers, then all in a line, Margaret, Aunt Mary and myself. When we got to the Theatre we sat down and waited for Queen

Mary's procession. Grannie looked too beautiful in a gold dress patterned with golden fflowers. Then we went up the steps and into the box. There we sat down and waited for about half-an-hour until Mummy's procession began. Then came Papa looking very beautiful in a crimson robe and the Cap of State.

Then the service began.

I thought it all very, very wonderful and I expect the Abbey did, too. The arches and beams at the top were covered with a sort of haze of wonder as Papa was crowned, at least I thought so.

When Mummy was crowned and all the peeresses put on their coronets it looked wonderful to see arms and coronets hovering in the air and then the arms disappear as if by magic. Also the music was lovely and the band, the orchestra and the new organ all played beautifully.

What struck me as being rather odd was that Grannie did not remember much of her own Coronation. I should have thought that it would have stayed in her mind for ever.

At the end the service got rather boring as it was all prayers. Grannie and I were looking to see how many more pages to the end, and we turned one more and then I pointed to the word at the bottom of the page and it said "Finis." We both smiled at each other and turned back to the service.

After Papa had passed we were all shivering because there was a most awful draught coming from somewhere, so we were glad to get out of the box. Then we went down the aisle, first a gentleman I did not know, then Margaret and myself and then Grannie. When we got back to our dressing-room we had some sandwiches, stuffed rolls, orangeade and lemonade. Then we left for our

Letter from George Lowe to Queen Elizabeth II's Assistant Private Secretary, Martin Charteris, reporting on the award of Coronation Medals to the Everest Sherpas, 8 December 1954, with photographs of some of the recipients

RA PS/PSO/QEII/PS /19/4/00/72/G

In 1953 the ninth British mountaineering expedition to attempt a first ascent of Mount Everest was organised by a joint Himalayan Committee of the Royal Geographical Society and the Alpine Club; the Duke of Edinburgh was its patron. The expedition was led by Colonel John Hunt and included 12 British and New Zealand mountaineers and 22 Sherpa porters led by Tenzing Norgay. Throughout April and May steady progress was made up the mountain; on 26 May the first of two selected climbing pairs made an attempt on the summit, reaching within 300 ft (91 m) of it before being forced to turn back. The following day the second team of New Zealander Edmund Hillary and Sherpa Tenzing made a further attempt; at 11.30 am on 29 May they reached the summit. The news of their

BRITISH MOUNT EVEREST EXPEDITION, 1953

(Himalayan Joint Committee of the Royal Geographical Society and the Alpine Club)

Patron: His Royal Highness the Duke of Edinburgh, K.G., K.T.

Telephone KENSINGTON 2172
Inland Telegrams OBTERRAS, SOUTHKENS, LONDON
Cables & Radio OBTERRAS, LONDON

ROYAL GEOGRAPHICAL SOCIETY
I KENSINGTON GORE
LONDON SW7

8th December, 1954.

Dear Colonel Charteris,

During November I had the honour of attending an investiture at Buckingham Palace and after that I thought that Her Majesty The Queen might be interested in an unusual investiture that was performed this year in Nepal.

Twelve of the Everest Sherpas who were awarded the Coronation Medal could not be located, and at the request of Her Majesty's Ambassador in Katmandu, the New Zealand Alpine Club Himalayan Expedition took the medals to the Sherpa villages near Everest, located the men and presented the medals.

The ceremony was carried out in Thyangboche Monastery by Mr. Charles Evans, F.R.C.S., deputy leader of both the Everest Expedition and the New Zealand Expedition. The enclosed photographs were taken inside the monastery during the presentation.

Yours sincerely,

George Lowe.

Member of the Everest Expedition and the New Zealand Himalayan Expedition.

Colonel The Hon. Martin Charteris, M.V.O., O.B.E.,
Buckingham Palace,
London, S.W.1.

success was received at Base Camp the following day and a coded message was sent by runner to the Nepalese village of Namche Bazaar, where a wireless transmitter forwarded it as a telegram to the British Embassy in Kathmandu. By a happy coincidence, the message reached London in time to be released on the morning of 2 June, the day of Queen Elizabeth II's Coronation, adding greatly to the celebrations and producing such headlines as the *Daily Mail*'s 'The Crowning Glory – Everest conquered'.

Honours were bestowed on the successful expedition party. At a private investiture during a reception for the expedition team at Buckingham Palace on 16 July, Colonel Hunt received a knighthood, Edmund Hillary was made a Knight Commander of the British Empire Order and Sherpa Tenzing was awarded the George Medal. Team members received Coronation Medals and it was agreed that these should also be given to the Sherpa porters who had not come to Britain. As this letter records, 12 of the Sherpas initially proved difficult to find, so the New Zealand Alpine Club Himalayan Expedition took the medals to the Sherpa villages near Everest and located the men. A special investiture was held in Thyangboche Monastery, as illustrated here.

The medals were presented by Charles Evans, Deputy Leader of the Everest Expedition, who is shown pinning a Coronation Medal on to Sherpa Pemba. Sherpa Annullu, described in the label of his photograph as 'one of the best of the Everest Sherpas', is shown wearing his Coronation Medal and the Tiger's Badge, which is awarded by the Himalayan Club to the best Sherpas. But by far the most charming image is that depicting Sherpa Gyaljen's family: the label on this photograph notes that he was away from the village so his medal was presented to his baby daughter, 'and this pleased everybody'.

The photographs illustrate a less well-known aspect of this mountaineering achievement. They were taken by George Lowe (born 1924), the other New Zealander in the expedition, and sent to Queen Elizabeth II with his letter. The last surviving member of this Everest-conquering team, George Lowe, died in March 2013, the sixtieth anniversary year of the Queen's Coronation.

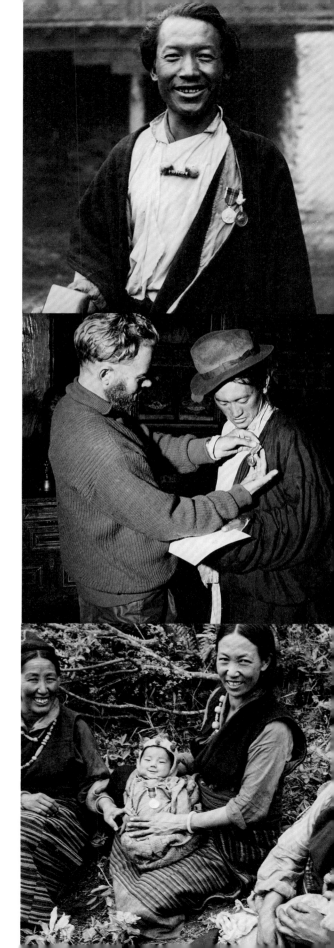

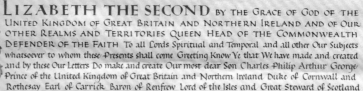

LIZABETH THE SECOND BY THE GRACE OF GOD OF THE UNITED KINGDOM OF GREAT BRITAIN AND NORTHERN IRELAND AND OF OUR OTHER REALMS AND TERRITORIES QUEEN HEAD OF THE COMMONWEALTH DEFENDER OF THE FAITH To all Lords Spiritual and Temporal and all other Our Subjects whatsoever to whom these Presents shall come Greeting Know Ye that We have made and created and by these Our Letters Do make and create Our most dear Son Charles Philip Arthur George Prince of the United Kingdom of Great Britain and Northern Ireland Duke of Cornwall and Rothesay Earl of Carrick Baron of Renfrew Lord of the Isles and Great Steward of Scotland PRINCE OF WALES and EARL OF CHESTER And to the same Our most dear Son Charles Philip Arthur George Have given and granted and by this Our present Charter Do give grant and confirm the name style title dignity and honour of the same Principality and Earldom And him Our most dear Son Charles Philip Arthur George as has been accustomed We do ennoble and invest with the said Principality and Earldom by girting him with a Sword by putting a Coronet on his head and a Gold Ring on his finger and also by delivering a Gold Rod into his hand that he may preside there and may direct and defend those parts To hold to him and his heirs Kings of the United Kingdom of Great Britain and Northern Ireland and of Our other Realms and Territories Heads of the Commonwealth for ever Wherefore We Will and strictly command for Us Our heirs and successors that Our most dear Son Charles Philip Arthur George may have the name style title state dignity and honour of the Principality of Wales and Earldom of Chester aforesaid unto him and his heirs Kings of the United Kingdom of Great Britain and Northern Ireland and of Our other Realms and Territories Heads of the Commonwealth as is above mentioned In Witness whereof We have caused these Our Letters to be made Patent Witness Ourself at Westminster the twenty-sixth day of July in the seventh year of Our Reign.

By Warrant under The Queen's Sign Manual

COLDSTREAM

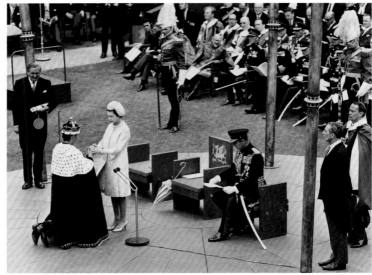

Letters Patent creating Prince Charles Prince of Wales, 26 July 1958

RA WARRANTS/CPW/1958

Letters Patent are one of the ways in which the Sovereign's will is expressed; they take the form of an open document to which the Great Seal is attached. The name derives from the Latin verb *pateo*, meaning to be open or accessible, and they are called 'letters' in a direct translation from the Latin *litterae patentes*, using a plural form in a singular sense. Among the various purposes for which Letters Patent may be issued is the grant of offices or titles, as is the case in this particular example.

While it has become traditional for the eldest son of the Sovereign to become Prince of Wales, there is no automatic succession to the title; once vacant, it becomes merged in the Crown and has to be granted anew by the Sovereign. The original Princes of Wales were, unsurprisingly, natives of that country; the last to have officially held this title, and to have been recognised as such by an English king (Henry III), was Llywelyn ap Gruffydd (died 1282). The first heir-apparent of an English Sovereign to be made Prince of Wales was the eldest son of Edward I; the future Edward II, he was born in Caernarvon and was invested by his father with the title in 1301.

As can be seen in this document, Prince Charles was created Prince of Wales on 26 July 1958, when he was only nine years old. This was announced at the closing ceremony of the Empire Games at Cardiff in a message recorded by The Queen (who was ill, and consequently unable to announce it in person): 'I intend to create my son, Charles, Prince of Wales, today. When he is grown up I will present him to you at Caernarvon.' The Prince's investiture duly took place in Caernarvon Castle on 1 July 1969; two Letters Patent were used during the ceremony, one in Welsh, which was read by George Thomas, the Secretary of State for Wales, and this one in English, which was read by the Home Secretary, James Callaghan.

This document was commissioned by the Crown Office; it is written on fine parchment in ink, with an illuminated first letter 'E' for The Queen's name. The Great Seal is blue, as this is the colour used for sealing all patents relating to close members of the Royal Family. As is traditional, it carries the image of the Sovereign enthroned on one side and on horseback on the other (this latter image was replaced in 2001 by a depiction of the Royal Arms). This is one of the later examples of such Letters Patent which are in the care of the Royal Archives; those creating Princes of Wales from the eighteenth century onwards can also be found here, as can royal warrants granting other royal titles, foreign orders and ranks within military, educational, institutional and other groups.

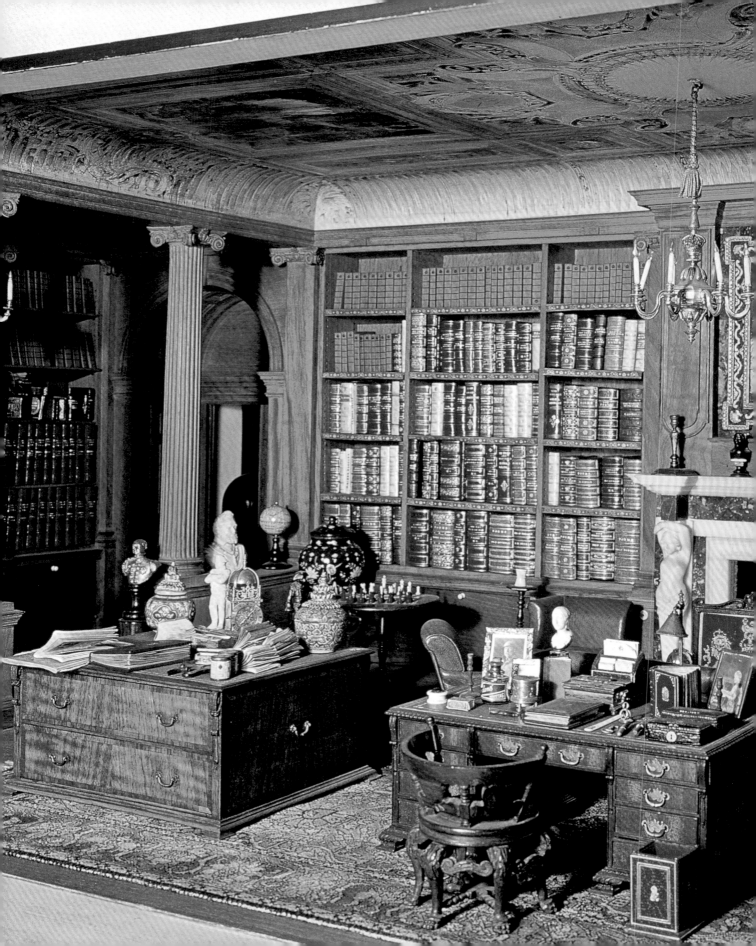

TWO ———————— PALACES &
POSSESSIONS

'I am gratified to learn that some of my poems are deemed
desirable for the Library of Little Manuscripts for the Dolls'
House that is intended as a gift to the Queen ...'

———————— LETTER FROM THOMAS HARDY TO PRINCESS MARIE
LOUISE, 9 JUNE 1922

RESIDENCES

In medieval and Tudor times, the Sovereign and their Court (including many government officers) were largely peripatetic, travelling between the numerous royal residences. From the late sixteenth century, however, royal travels were increasingly restricted to the palaces in and around London, and other residences further afield were abandoned.

Windsor Castle, the oldest royal residence still in use by the British Royal Family, was first built by William I shortly after the Norman Conquest of 1066. Although little can be seen today of this Norman castle, much of the fourteenth-century building remains, as well as many of the additions and alterations made by Charles II in the late seventeenth century – including three of the splendid ceilings painted by Antonio Verrio in the State Apartments (p. 50) – and by George IV in the 1820s.

In the eighteenth century, as government separated out from the Court, the royal family increasingly sought more privacy. In 1762, a notable addition was made to the royal family's London residences, with the purchase by George III of Buckingham House (p. 51), to provide just such a private family home. It did not become the official London residence of the Sovereign, as Buckingham Palace, until Queen Victoria's reign.

With the coming of the railways in the nineteenth century members of the royal family were encouraged to look further afield again for their private homes. By now their official and private lives had become quite distinct and newly acquired properties – Osborne House on the Isle of Wight, Balmoral Castle in the Scottish Highlands and Sandringham House (p. 48), in Norfolk – were bought and run as private estates. The acquisition of Balmoral also allowed Queen Victoria to begin the custom, continued by her successors, of staying regularly at Holyroodhouse, her Palace in the heart of Edinburgh, which was a convenient stopping-point on the way to or from the Highlands.

Whilst the palaces provided a fitting backdrop for the official events for which they were primarily used, in their private properties members of the royal family could create more modest and comfortable homes, indulging their own personal tastes to a greater degree. Queen Victoria's husband, Prince Albert, for instance, involved himself in all the details of the building of their new homes at Osborne (p. 54) and Balmoral.

These private country residences had their own wider estates. At Windsor George III indulged his interest in farming, but also continued the development of the fashionable landscape created by his uncle, William Augustus, Duke of Cumberland, in the 1740s and 1750s (p. 52). This farming tradition was carried on by Prince Albert at Windsor, Osborne and Balmoral, and later by his son, King Edward VII, who developed and improved both the farms and the forestry on his estate at Sandringham (p. 58). Farming and forestry are still major parts of these working country estates, and under the stewardship of the Duke of Edinburgh, who runs the private royal estates for The Queen, there is a new emphasis on wildlife and conservation.

The royal family has long valued the well-being not only of their estates, but also of the staff and tenants on those estates, and of the local communities. New cottages and schools were built on the private royal estates in the nineteenth century (p. 56), churches renovated, doctors appointed to look after the health of the estate residents and various social activities established. Although the State has assumed the provision of some of these facilities in the intervening years, The Queen and the Duke of Edinburgh continue the tradition of managing the royal estates not only for their own benefit, but also for that of their staff and tenants.

PAGE 44 *The Library of Queen Mary's Dolls' House, created in 1923 and filled with tiny works by the major artistic figures of the day.*

OPPOSITE *William Leighton Leitch (1804–83),* Osborne House, during building operations *(detail),* C.1847. *Watercolour* RCIN 919843

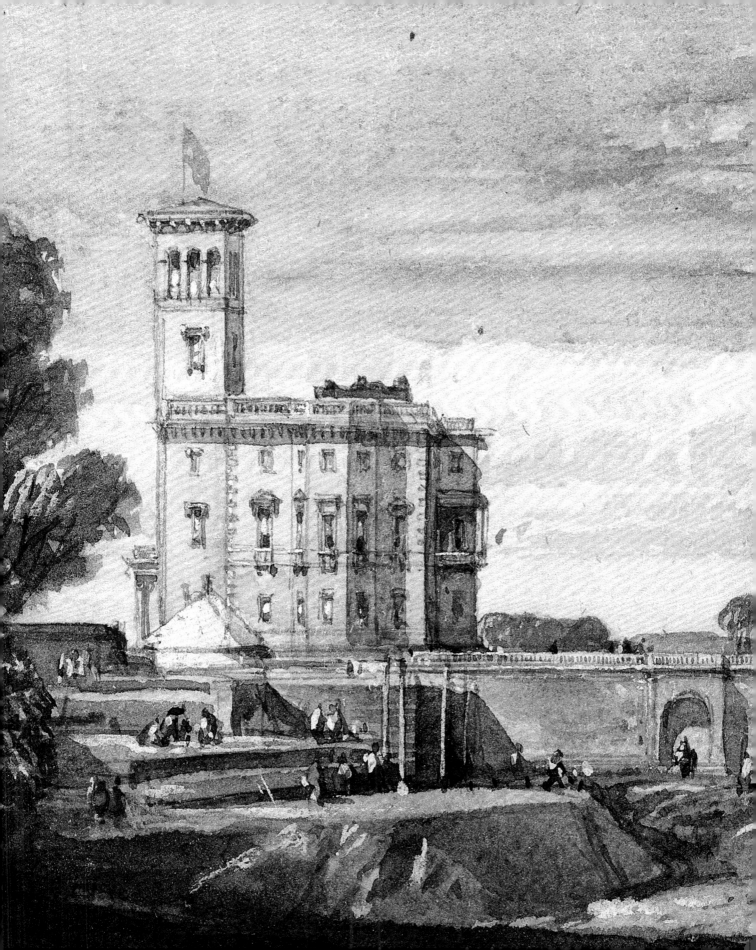

Licence for the sale of the manor of West Hall, Norfolk, from Sir Thomas Paston and his wife Agnes to Robert Rede, 2 November 1545

RA LAW/UK/SHM/15/7/3/1

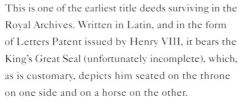

This is one of the earliest title deeds surviving in the Royal Archives. Written in Latin, and in the form of Letters Patent issued by Henry VIII, it bears the King's Great Seal (unfortunately incomplete), which, as is customary, depicts him seated on the throne on one side and on a horse on the other.

The document licenses Sir Thomas Paston (c.1517–50) and his wife Agnes, Richard Heydon (c.1508–53) and Nicholas Rokewode (c.1511–57) to sell to Robert Rede the manor of West Hall, in the parishes of Dersingham, Ingoldesthorpe, Shernborne, Sandringham, Babingley and Anmer, in the county of Norfolk. For this, the King received a fee of £4 6s 8d (about £1,000 in modern money). Manors sold without such a licence from the Sovereign could be seized by the Crown.

Paston, his cousin Heydon and Rokewode were all from Norfolk families. Heydon and Rokewode, both lawyers, acted as trustees for various properties

acquired by Paston, as in this case. Paston, a favoured member of the Court of Henry VIII, acquired a number of estates following the dissolution of the monasteries, including that of Binham Priory in north Norfolk, of which West Hall was a part. Heydon, too, benefited from the dissolution, buying the estate of the neighbouring Weybourne Priory in 1545. All three men served as members of parliament for Norfolk constituencies, and clearly were part of the upwardly mobile landed gentry that was emerging at this period.

In 1575 Robert Rede's son sold the manor of West Hall to the Cobbe family, who already owned the Sandringham estate, thus uniting it with that estate. Nearly three centuries later it came into royal ownership when the Prince of Wales bought the Sandringham estate in 1862, and with the purchase acquired this title deed, along with other old deeds for properties making up the estate, to prove his title to (i.e. ownership of) it. Similarly, old title deeds for some other properties bought privately by the Royal Family over the years – including Buckingham Palace, Osborne House and Balmoral Castle – came into royal possession and are now in the Royal Archives.

Account book for works at Windsor Castle, 1676–87

RA SP/ADD/1/158

Charles II spent much of his exile following the Civil War and the execution of his father, Charles I, in 1649 living in France, where his cousin Louis XIV was to begin work on his splendid country residence at Versailles in 1664. This may well have influenced Charles II's decision, after the restoration of the monarchy in Britain in 1660, to turn Windsor Castle from a cramped fortified castle, designed primarily for defence, into a beautifully decorated palace with attractive pleasure grounds.

In July 1674 it was announced that 'the King … has given orders to make several additions and alterations to the Castle and Park, to make it more fit for his summer's residence every year'. Some sections were completely rebuilt and all of them were given new, larger windows and colourful interior decoration in the fashionable Baroque style. Antonio Verrio (c.1636–1707), an Italian artist, was chosen to paint the ceilings for the larger rooms, which now form the State Apartments.

Verrio painted 20 ceilings, three staircases, the King's Private Chapel and St George's Hall, for which he received over £10,000 (the equivalent of about £850,000 today). Sadly, only three of Verrio's ceilings survive, including that in the King's Dining – or 'Eating' – Room, which depicts a banquet of the gods, and for which this entry shows he was paid £250.

This book is a rarity in the Royal Archives. Most records relating to work on the fabric of the various royal residences are to be found in government documents in The National Archives, as it was government departments which formerly arranged and paid for such work to be done.

Transcript (part) of Windsor Castle account book, Verrio entry

The Kings Eating Room
To Seigniour Verrio for painting of the Ceiling of the Kings Eating Roome, finding all workeman and Coulloers belonging to the Ceiling of the said Eating Roome (excepting the guilding worke) The full Sume of Two hundred and ffifty pounds According to a Contract and agreemt: made CCLli

Title deed for George III's purchase of Buckingham Palace, 20 April 1763

RA GEO/BOX/3/60

The official London residence of the Sovereign since the reign of Queen Victoria, Buckingham Palace has belonged to the Royal Family since 1762. In that year George III arranged to buy the then Buckingham House for a sum of £28,000 (over £2,000,000 in modern money) from Sir Charles Sheffield. Sheffield was the illegitimate son of the sixth Duke of Buckingham, who in the early eighteenth century had transformed and enlarged the house which came to be named after him.

This deed of 1763 completed George III's purchase. It includes, in a roundel in the top left-hand corner of the first page, a stylised portrait of the King.

The King bought Buckingham House primarily for his wife, Queen Charlotte, as a private family house separate from their official residence, St James's Palace, and 13 of their children were born in the house, renamed the Queen's House. But it was their eldest son, George IV, who, with his architect John Nash (1752–1835), transformed the family home into a lavish palace, though work on the building was not completed until after the King's death in 1830, and he never lived there as King. His successor, William IV, a man of simple tastes, had no desire to move into the new palace and attempted to dispose of it, first offering it as a barracks for the Foot Guards, and then as a replacement for the Houses of Parliament, which had been destroyed by fire in 1834. Eventually he agreed to take up residence there, but the building works were not completed until a few weeks before his death. It was his niece, Queen Victoria, who became the first royal resident of Buckingham Palace, moving in on 13 July 1837, less than a month after her accession.

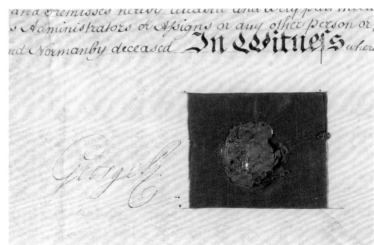

ABOVE *The deed is an indenture. It has an indented, or serrated, top edge, showing where it was formerly joined to its identical copy, which would have been given to the vendor; this was to prevent forgeries;* only these two documents cut from the same sheet of parchment would have matched when the indented edges were put together.*

Nathaniel Kent's recommendations for improvements for picturesque beauty in Windsor Great Park, n.d. [1791]

RA GEO/ADD15/372

The landscape of Windsor Great Park as it is seen today was largely created between 1746 and 1765, under the rangership of William Augustus, Duke of Cumberland. The Duke's nephew, George III, admitted that he did not admire 'the fine *wild* beauties of nature', and was more interested in the potential for agriculture of his estate at Windsor. In 1791 the King employed Nathaniel Kent (1737–1810) to improve the conditions and running of the Great Park.

Nathaniel Kent had studied Flemish husbandry during his early career as a diplomat in Brussels. On his return to England in 1766 he was persuaded to abandon his diplomatic career to become an agricultural adviser. His book *Hints to Gentlemen of Landed Property*, published in 1775, which recommended the enclosure and drainage of land and the rotation of crops, made Kent famous and contributed to the agricultural revolution of the period. The two farms that he was to run for the King in Windsor Great Park, Norfolk Farm and Flemish Farm, were named after the two different forms of crop rotation practised on them.

It is clear that Kent also gave the King advice regarding the improvement of the uncultivated land in the Great Park. The first entry in Kent's 'Journal of the progressive Improvements in Windsor Great Park', which is kept in the Royal Library, records that on 1 and 2 March 1791 he 'took a general view of the Park, to consider what would be the best way of managing it, in order to introduce Beauty, and Profit'.

In 1951 a group of about seventy documents, which seems to have been part of Nathaniel Kent's own papers, was discovered in a bookshop in London and purchased for the Royal Archives. These relate mostly to farming in the Great Park, including lists of the livestock there and proposals for crop rotation. However, they also include these recommendations for improving the 'picteresque Beauty' of the Park by the removal of certain trees in the valley between Cooks Hills and at Snow Hill, to improve the views, with sketches illustrating Kent's points. Although undated, this document must have been written in 1791, for in November that year he wrote in his journal that, having obtained the King's approval, he had issued orders for the removal of the trees he had identified near Cooks Hills, 'that the full effect of these Alterations may be at once seen, and afford a fair sample of an Hundred other similar improvements'.

BELOW *Thomas Sandby (1721–98)*, Windsor Great Park, from the vicinity of Sandpit Gate, looking north, *1750–60*. *Watercolour RCIN 914637*

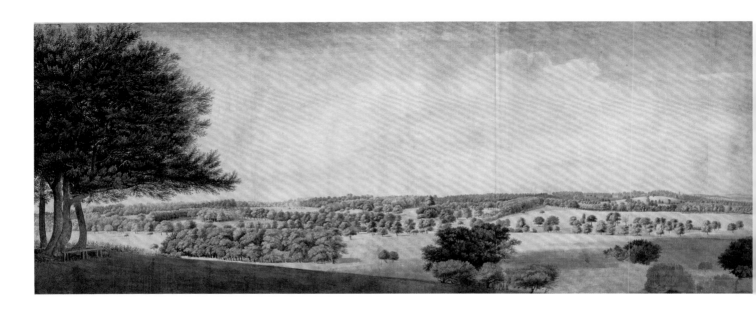

Transcript of Nathaniel Kent's recommendations

Primary Improvements recommended in Windsor Great Park, as far as relate to picteresque Beauty

After passing through Bishop Gate & Keeping the Reading Road on the right the Eye is thrown on a magnificent Body of Wood which covers two gentle Hills called Cooks Hills with a Valley between them, also covered with Trees. over the Tops of the Trees in the Valleys is perceived the upper part of Windsor Castle but not such a View as might be given of that noble Structure – with the surrounding Country – if the Trees in the Vale were cleared The Hills would appear bold – covered with such venerable Trees, and the distant View shutting the Horizon between those two Hills would in my Opinion make this View equal to any in the Park

Still Keeping the Reading Road
A little Way beyond the 21 Mile Stone – Snow Hill appears upon the right – beautifully – and nothing seems wanting but the carrying off a few straggling Trees and stunted Thorns which stand about half way up the Hill. The Plantations however at the Top would be much better with a little facing – so that the Bodies of the Trees were not seen …

Letter from Prince Albert to his step-grandmother, Caroline, Duchess of Saxe-Gotha-Altenburg, reporting the progress of the building work for Osborne House, 29 November 1845

RA VIC/MAIN/M/35/83

Queen Victoria and Prince Albert purchased Osborne House, on the Isle of Wight, in 1845, in order to replace the less secluded Royal Pavilion at Brighton as a seaside holiday retreat for their young family. They also wanted a private home that belonged personally to them, unlike Windsor Castle and Buckingham Palace.

It was apparent from the start that the eighteenth-century house would not be big enough for their needs. At first, Prince Albert felt that 'The house as it is requires no alteration, only the addition of a few rooms to make it a very suitable and comfortable residence for the Queen and the children and part of the suite', but plans to extend it were soon abandoned in favour of building an entirely new house. The builder Thomas Cubitt (1788–1855), who had made his name as a building developer in London, was employed to prepare specifications for the new house, with much input to the design from the enthusiastic Prince Albert.

The foundation stone of the new house, which was built in an Italianate style, was laid on 23 June 1845 by the Queen, the Prince and their two eldest children. Thereafter, work progressed rapidly, as the Prince reported in this letter to his grandmother, written in November in German, in which he told her that the new house was already roofed; he included a little sketch showing the main building with the tower behind.

The Royal Family moved in to their new property on 14 September 1846, Queen Victoria writing in her Journal: 'It appears to me like a dream to be here now in our own house.' Developing the building, grounds and estate continued to be a delight for Prince Albert.

ABOVE *Charles Brocky (1807–55)*, Prince Albert, *1841. Coloured chalks on fawn paper*
RCIN 450456

BELOW *William Leighton Leitch (1804–83)*, Osborne House, during building operations, c.*1847. Watercolour*
RCIN 919843

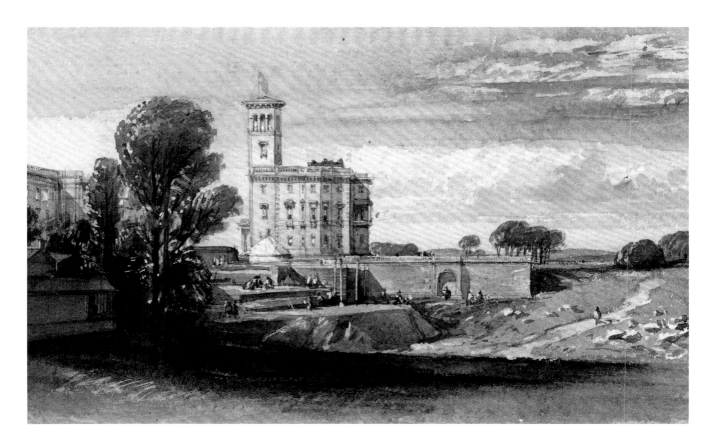

Translation of Prince Albert's letter to his step-grandmother

Dear Grandmama

I have just received your dear letter of the 21st and sit down at once to answer it, so as not to be guilty of delay again. We have been here since the 25th, but unfortunately in the most abominable weather, with such great storms and so much rain that one is positively swept away. The new house is roofed, and a tall tower has risen up next to it. It looks something like this.

I fear this abominable drawing will give you a sorry opinion of it, but I assure you that it is very pretty, and I will send you a proper drawing of it one day.

The poor Prince and Princess of Rudolstadt are much to be pitied. I had never seen the Hereditary Prince nor heard much of him, so that I was surprised that he was already 24 years old.

Hofrath Klenke is a loss for which Gotha has my deepest sympathy.

I will pass on your recommendations to the Duke of Cambridge. Thank you very much for your good wishes on the birthdays of the two eldest children. They are both very well, as is Alice, who is also here with us. Little Affie was left behind in Windsor, but he too is in the best of health.

I shall now end with affectionate wishes for your good health, and I am, as always,

Your
faithful grandson
Albert
Osborne.
Nov: 29th 1845

Victoria will answer your last letter very soon and meanwhile wishes me to thank you for it.

List of children on the Osborne estate, noting the level of their education, *c*.1855

RA PPTO/PP/OSB/MAIN/OS/115

Queen Victoria and Prince Albert were concerned not only for the welfare of their own family, but for that of their staff and the tenants on their estates and their families. New houses, considered as model accommodation by the standards of the day, were built on the estates at Windsor, Osborne and Balmoral. Other measures introduced included the provision of lending libraries for the staff, and schools for the local children. (It was not until the 1870 Education Act that government was required to provide schools; prior to that, such schools as there were, were set up by benevolent landowners, churches or charities.)

When the Queen bought the Osborne estate in 1845, plans were already in place to erect a school nearby at Whippingham; a local landowner had given a piece of land for the purpose, and the cost of the building was raised from donations. The one-room school, with accommodation for the schoolmaster attached, was erected in 1848.

This list of local children seems to date from 1855, judging by the ages of the children listed and a comparison of them to the children's ages on the 1851 national census returns. It shows that the majority of the children aged between 5 and 14 could read reasonably well, but that less than half of the older children, who had no school when they were young, were able to read.

In 1855 the schoolmistress at Whippingham, Mrs Baker, was dismissed by the school's management committee because of her lack of discipline and control over her class; her husband, the schoolmaster, was given six months' notice. This list may well have been drawn up following Mrs Baker's dismissal, as consideration was given then to how to improve education for the Osborne estate children.

It became clear that neither the school nor the schoolhouse was big enough, and in 1859 the decision was made to provide a new building. Prince Albert drew up a plan for it and Queen Victoria, who opened the new building on 4 February 1864, paid for it entirely herself.

This list of children, together with other correspondence and papers about Osborne, is preserved in the series of Privy Purse records relating to Queen Victoria's private estates and kept in the Royal Archives.

LEFT *The new Whippingham School in the mid-nineteenth century.*
RCIN 2117206

Name	Age			At School	Where Employed	State of Education			
	5-10	10-15	15-20			Read & Write	Read only	Neither	Imperfectly or otherwise
Mary Chambers		12							
Sarah Chambers	9			Yes					
Harriet Chambers	6			Yes		Yes			Fairly
Sophia Chandler				Yes	At home	Yes	Yes		Imp
Henry Chandler	8	18					Yes		Well imp
Thomas Fokes				Yes	Barton	Yes			imp
Eliz. H. Fokes			20	At home	Yes				imp
Anne Fokes	9	15		Yes		Yes			Well
Alice Scott		16		No	At home	Yes			Well
Anne Scott	9			Yes					Well
James Scott	6			No		Yes			
Thomas Scott		15							Fairly
Henry Hallock		11		Yes	At home	Yes			
James Jackson		18			Barton	Yes			Well
John Lones		14			Barton	Yes			Well imp
James Fleming	8	11		Yes	At home	Yes	Neither		
Caroline Fleming				Yes		Yes			Fairly
	12								imp
		18		By J. Morris	Read				imp
		14		Mr Blandfor	Read				imp
		11		Barton	Yes				well
				Yes	Yes				Well
				Yes	Yes				Well
				At home	Yes				imp
	6	17		Yes	At home	Yes			Fairly
		14		At home Mr	Yes				imp
		15		At home	Yes				imp
	12			No	No				Fairly
				Rev J Jolliffe	Yes				
	15			At home	Yes				Well
				Yes	Yes				Fairly
	14			At home	Yes				

57

Sandringham estate farms terrier, 1865

RA SHM/AGENT/TERRIER/FARM

In 1862 Albert Edward, Prince of Wales (later King Edward VII), purchased the Sandringham estate in Norfolk for the sum of £220,000 (the equivalent of about £950,000 today). This was in fulfilment of the wish of his late father, Prince Albert, that when he came of age (on 9 November 1862) he should acquire a country residence.

Despite the apparently favourable impression that the estate made on the Prince and his advisers on their visits before the purchase was made, it was not long before he was following his father's example by carrying out an extensive programme of improvements to the house and estate. The late eighteenth-century house was demolished (apart from the conservatory, which was converted into a billiard room), and replaced by a large, handsome, Jacobean-style building. A kitchen garden was created, the ornamental gardens were remodelled, a new Home Farm was constructed, a stud was set up for breeding racehorses, the commercial forestry was improved and extended, new houses were built for the staff and tenants, and schools were established for the local children.

To assist in the process of deciding what improvements were required, a great deal of information about the Sandringham estate was gathered in the first few years of the Prince of Wales's ownership including this terrier, or register, of all the farms on the estate, including those leased out to tenants. When the Prince bought the estate it comprised approximately 7,000 acres (3,000 hectares) of land – it now covers some 20,000 acres (8,000 hectares) – and, as is still the case today, the majority of the land on the estate was leased to tenant farmers. The terrier includes a plan of each farm and a list of all the fields and other sections within it.

This volume is a rare survival as, apart from these records assessing the estate at the time of the Prince of Wales's purchase and various account books, very little material has survived from the Sandringham estate for the early years of royal ownership. Fortunately, more records for the twentieth century have been preserved.

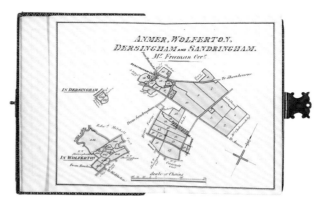

Balmoral Home Farm work diary, 1933

RA BAL/FARM/MIXED/WORK

As well as providing country homes for the Royal Family, their properties outside London have always been run as normal working country estates, with farms, commercial forestry and other enterprises. Farming in particular has long been an interest for the Royal Family. George III's involvement in the agricultural improvements taking place in the eighteenth century earned him the nickname 'Farmer George', while later Prince Albert won prizes for his pedigree pigs, sheep, cattle and hens.

After Queen Victoria purchased Balmoral in the Scottish Highlands in 1848, Prince Albert began energetically to restore the neglected estate. As well as building a new castle to house their growing family and providing model cottages for the estate staff, he created a new Home Farm, at Invergelder, a mile from the castle. The farm buildings were completed in March 1862, three months after the

Prince's death, but his plans for the farm were continued and Invergelder remains a working farm to this day.

Among the archives relating to the farm is this unusual and fascinating series of volumes recording the activities of the farm labourers each week from 1922 to 1952, a period that saw the gradual change from the use of horses for all the heavy work to full mechanisation.

Because of the mountainous nature of much of the estate, and the climate, only small areas are suitable for farming and forestry. The farm concentrates on providing grazing and winter fodder (cereal crops and root vegetables) for the livestock. These animals are currently Highland cattle and ponies, but at the time when these farm work diaries were kept the estate ran a dairy herd of Ayrshire cattle, and also had some poultry, as well as working horses – as can be seen in this example, which gives a flavour of the farm's activities in the busy period before winter closed in.

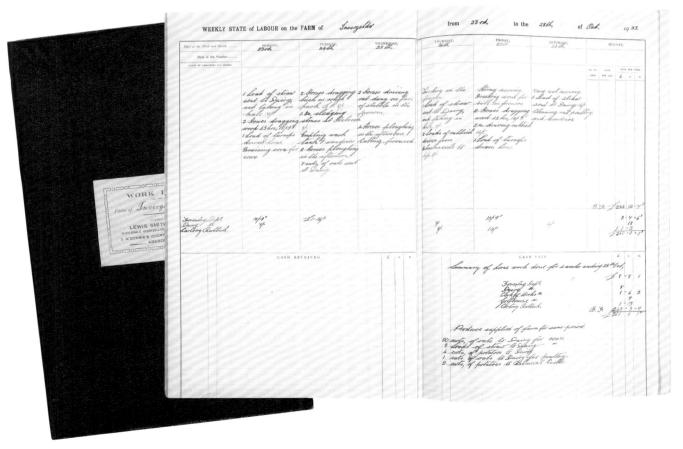

ROYAL COLLECTORS _____

OPPOSITE *Detail of the Neptune Centrepiece (p. 62)*

The treasures in the various royal residences that today make up the Royal Collection – paintings, decorative arts, books and much else besides – have been brought together over several centuries by members of the royal family. Many items have been purchased, while others have been gifts, private or official. Some of the more splendid objects were acquired in order to help provide a fitting setting for monarchy in the palaces, while other more restrained ones may reflect the tastes or personality of their original royal owner. Almost all members of the Royal Family have made some contribution to the Royal Collection, although some, for whom collecting works of art was more of a passion, stand out, including George IV, Queen Victoria and Queen Mary.

George IV's famed extravagance, which caused him to run up huge debts as he acquired many magnificent items, is reflected in the outstanding collection of bills for his purchases (p. 62). Queen Victoria, under the guidance of Prince Albert, also made substantial, though more measured, additions to the Royal Collection, as can also be seen in the surviving records; these include a number of inventories meticulously recording the provenance and location of her possessions (p. 64). Interestingly, these inventories include some that make early use of the new art of photography to record items in the Collection. Queen Mary was particularly devoted to documenting her collections in this way, and several inventories of her possessions survive. She specialised in collecting miniature works of art; in tribute to this interest she was presented with a most amazing gift: Queen Mary's Dolls' House, with all its contents. The work involved in putting together this wonderful creation is documented in the Royal Archives (p. 68).

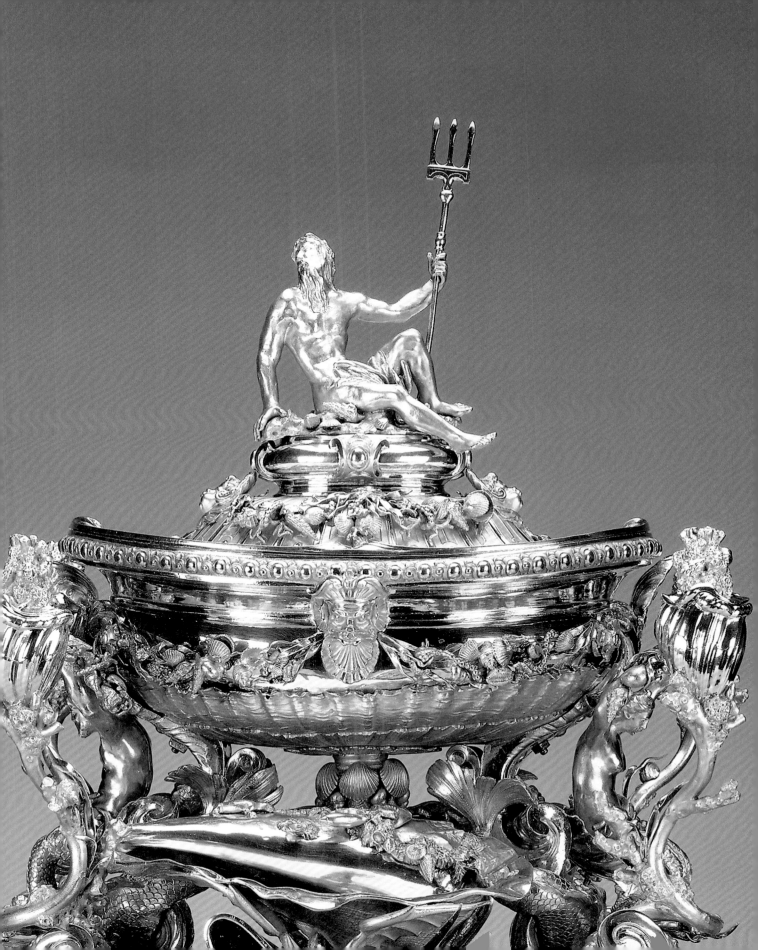

Selection of bills for purchases by George IV, 1780s to 1820s

RA GEO/MAIN/26324, 27083 and 26397

The large collection of bills in the Royal Archives for purchases made by George IV bears witness to his extravagant tastes as Prince of Wales, Prince Regent and, finally, King. They range in date from the 1780s, when as a young man he began to amass his vast collection of works of art, right through to after his death in 1830, when his executors were left to deal with many outstanding bills.

The bills cover a wide range of purchases, including not only major pieces of art – such as paintings, gold plate, furniture, porcelain, sculpture, jewellery and clocks – but also such items as arms and armour, books, telescopes and musical instruments; as well as more mundane objects, including fishing tackle and newspapers, and payments for gas lighting and rates.

George IV's acquisitions form a major part of the Royal Collection today. Not only did he commission new works but he also purchased older ones, including items from the old Royal Collection which had been dispersed after the execution of Charles I, and many from Continental collections which came on the market in the wake of the French Revolution. As the bills demonstrate, he bought direct from the artists or from dealers, auctioneers or shops; for Continental goods in particular he often made use of agents, including some of his French staff, such as François Benois, his confectioner.

On the left of the three bills illustrated is a list of paintings commissioned from Sir Thomas Lawrence (1769–1830), including the great series of portraits of those who helped defeat Napoleon, for the Waterloo Chamber in Windsor Castle, where they are still to be seen. On the right is a bill for several items of Sèvres and other porcelain purchased from the London dealer Robert Fogg in 1810, including £157 10s 0d for a group of 12 items – three dessert plates, three dishes and six cream cups – from the magnificent Sèvres service commissioned by Louis XVI of France for his palace at Versailles in 1783, most of which was bought by the then Prince of Wales after Louis's execution ten years later.

The bill in the centre is one of the large number in the Collection for the goldsmiths Rundell, Bridge & Rundell, this one dated 1827. It lists several very expensive items, including, at the top, £398 17s 1d for a 'very richly chased silver Stand' for the Neptune centrepiece made for the King's grandfather, Frederick, Prince of Wales, with further sums for the engraving and gilding of this piece; a later hand has noted the total sum for this stand as £484 1s 7d (approximately £36,000 in today's money). Several of the bills bear similar later annotations, including some by Queen Mary, confirming their continuing importance in telling the history of the Royal Collection.

LEFT *Studio of Sir Thomas Lawrence (1769–1830), George IV, 1822–30. Oil on canvas* RCIN 405309

OPPOSITE TOP LEFT *Paul Crespin (1694–1770), Neptune Centrepiece, hallmark 1741/2. Silver gilt* RCIN 50282

OPPOSITE TOP RIGHT *Sèvres porcelain factory, the Louis XVI dinner service, 1792. Soft-paste porcelain* RCIN 58027

INVENTORY OF JEWELS

THE PROPERTY OF

HER MAJESTY THE QUEEN.

1896

LEFT *Detail of frontispiece in the Inventory of Queen Victoria's jewels, 1896*

BELOW LEFT *Gunn & Stuart,* Queen Victoria *(detail), 1896. Gelatin silver photographic print* RCIN 2105779

Inventory of Queen Victoria's jewels, 1896

RA VIC/ADDT/316/526

This inventory was drawn up for Queen Victoria by Messrs Garrard & Co., the Queen's Jewellers. It is one of a number of inventories of possessions of members of the Royal Family that are kept by the Royal Archives or the Royal Collection. These volumes are particularly helpful in tracing the history of items that are, or once were, in the Royal Collection.

The page shown here records some of the jewellery given away by Queen Victoria during her lifetime, in this case to three of her daughters and one granddaughter, and the original provenance is given for some of the items listed. The brooch given to Queen Victoria's youngest daughter, Princess Beatrice, on her 24th birthday in 1879 is shown to have been a gift from the Queen's own mother, the Duchess of Kent, to her young daughter when she was still a child. The diamond given to the Queen's granddaughter Princess Alix of Hesse on her marriage in 1894 to Tsar Nicholas II of Russia (p. 244),had been one of a number sent to Queen Victoria by the Sultan of Turkey in 1838.

Sadly, no details are given concerning the diamond ferronnière (a jewel held to the forehead by a chain) given to the Queen's second daughter, Alice, Princess Louis of Hesse, on her 20th birthday in 1863. Perhaps by the time this inventory was compiled in 1896 it was so long since Queen Victoria had seen it that her memory of it was incomplete.

The most splendid item is one of those listed as having been given to Queen Victoria's fourth daughter, Princess Louise, in 1893: the 'rich diamond & emerald diadem with solid drop emeralds, containing 1248 brilliants, 166 rose diamonds, 102 emeralds & 23 solid emeralds', which Prince Albert had himself designed for the Queen in 1845. This was one of several items of jewellery designed by the talented Prince, the first one being a charming enamelled orange-sprig brooch to mark their engagement in 1839.

Jewels given away by Queen Victoria
— during Her Majesty's lifetime contd.

A Brooch in the shape of a Butterfly with diamond
emerald and ruby wings and opal body.
Given to the Queen by the Duchess of
Kent when the Queen was Princess Victoria.

A Diamond used for an ornament
From Turkish Diamonds sent to Queen
Victoria by the late Sultan Mahmoud 1838.

A ferroniere of Diamonds.

A rich diamond & emerald diadem with solid drop
emeralds containing 1248 brilliants 166 rose
diamonds 109 emeralds & 23 solid emeralds.
Designed by H.R.H. Prince Albert set by
Kitching 1845. £1000·0·0

A large Necklace composed of 10 square Emeralds & diamond
borders with 10 diamond ornaments between.
A large Brooch with Emerald & diamond border.
A pair of ditto Earrings to match.
A pair of ditto with long Emerald drops.
Garrard £309·10·0

Given to Princess Beatrice 14th April 1879

Given to the Empress of Russia on her
Marriage 1894.

Given to Princess Louis of Hesse 25th April
1863.

Given to Princess Louise Marchioness of Lorne
June 19th 1893.

Queen Alexandra's visitors' book, 1908–25, with electro-silver binding, 1896

RA VIC/ADDW/28

This beautiful Art Nouveau electro-silver binding, mounted on dark blue velvet, was designed by Miss M. Lilian Simpson (1871–97) as a commission for the Art Union of London. Her design won a gold medal in 1894 in a national competition run by the government for all the schools of art.

The overall theme of the design is love, symbolised by angelic figures, and the growth of life, represented by plants. The angels in the corners of the two main panels which form the front and back covers of the book express, by the positions of their arms, their watchful concern over new life. They draw the eye inwards towards the graceful central figures. That on the front cover holds an oil lamp, symbolising light, and stands in the middle of a large, stylised flower, whilst that on the back is pointing downwards at another flower, one of a number of flowers and seed pods swirling around these two figures. On the spine a crouching angel represents the plant before growth begins, while a cherub on the clasp carries a cornucopia of the harvest and holds together the pages of the Book of Life.

The original design was subsequently exhibited at the Royal Academy in 1896 and a number of copies were produced, including this one. It was bought by the then Prince of Wales (the future King Edward VII) and eventually given by him to his wife, Queen Alexandra, as a Christmas present in 1905. Other copies of the binding are in the collections of the British Library and the Victoria and Albert Museum.

The Queen used her volume as a visitors' book, and it contains the signatures of many relations and friends, including, as shown on this page from 1923, members of the British and Russian royal families, and three musicians, who each wrote out a piece of music under their signature. The Queen's fellow Dane, the composer Carl Nielsen (1865–1931), selected an extract from his opera *Maskarade*; Sir Landon Ronald (1873–1938), better known as a conductor and as Principal of the Guildhall School of Music, produced a bar from his best-known work, the song '*Down in the Forest*'. The Russian violinist Mischa Elman (1891–1967), meanwhile, who had come to Marlborough House to perform for Queen Alexandra, chose Tchaikovsky's Violin Concerto for his musical signature.

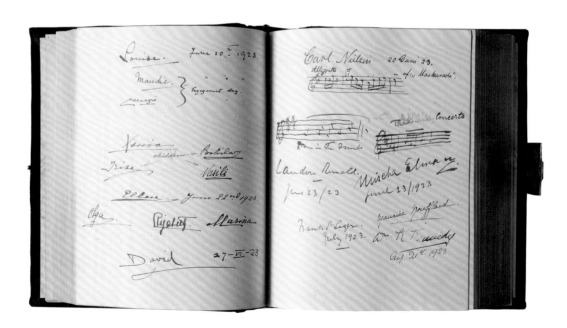

ART UNION OF LONDON 1ST JANUARY 1896.

Queen Mary's Dolls' House, 1921–2: illustrated letter from Sir Edwin Lutyens, letters from J.M. Barrie and Thomas Hardy, and letters from the Marmet Baby Carriage company and Stephens' Inks

RA VIC/ADDA18/ML/22 and 202, and Folders 6/24, 11/28 and 12/8/1

Queen Mary's great interest in collecting and arranging works of art can be seen to this day in the Royal Collection and Royal Archives. Her handwriting can be found on some of George IV's bills, identifying the location of objects he had purchased, while items in the Royal Collection which Queen Mary herself had acquired are often accompanied by little notes she wrote, giving their origin and date of acquisition.

The Queen's particular interests as a collector were twofold. She liked to collect items with a family association; more famously, though, she was an avid collector of miniature objets d'art, including pieces by Fabergé.

The most striking item in the Royal Collection with which she is associated, Queen Mary's Dolls' House, which so well reflects her interest in the miniature, was in fact presented to her as a tribute.

Princess Marie Louise, one of Queen Victoria's granddaughters, first came up with the idea and brought it to fruition. She commissioned Sir Edwin Lutyens (1869–1944) to design the dolls' house and Gertrude Jekyll (1843–1932) the garden, numerous writers and artists to produce works for inclusion in its library and on its walls, and many firms to make miniature versions of their products to ensure that the house was fully equipped in the style of a great country house.

Princess Marie Louise's papers in the Royal Archives tell much of the story of this magnificent project, as shown in the items pictured here. These include a brief note to her from Lutyens, with a charming little sketch; a handwritten letter by J.M. Barrie (1860–1937), the author of *Peter Pan*, sending his contribution (an autobiography); and letters from two companies, Marmet Baby Carriages and Stephens' Inks, concerning the products they were to supply for the dolls' house. The letter signed by Thomas Hardy (1840–1928), agreeing to the inclusion of some of his poems, suggests the use of just three items; in fact nine were included in the miniature book, written in another hand as Hardy's weak eyesight prevented his doing it himself (as he explains here).

MAX GATE, DORCHESTER.

June 9: 1922.

Dear Madam:

In reply to your kind inquiry I can assure you that I am gratified to learn that some of my poems are deemed desirable for the Library of Little Manuscripts for the Dolls' House that is intended as a gift to the Queen.

Three of my poems that would be suitable are I think, "The Oxen" "When I set out for Lyonesse", and "In Time of the Breaking of Nations". They are all in the volume of my "Collected Poems"(Macmillan).
pp.243,(298,511,)

I regret to say that a weakness of the eyes prevents my writing them out small and clearly. So that if you can get them copied in any way you wish I will sign them with the greatest pleasure.

I am,

Very faithfully yours,

Thomas Hardy.

The Princess Marie Louise.

RIGHT AND BELOW *The tiny book of Thomas Hardy's poems, in the Library of Queen Mary's Dolls' House, with verses written out in a professional hand.*

I LEANT UPON A COPPICE GATE When Frost was spectre-grey, And Winter's dregs made desolate The weakening eye of day. | The tangled bine-stems scored the sky like strings of broken lyres, And all mankind that haunted nigh Had sought their household fires.

ADELPHI TERRACE HOUSE, STRAND, W.C.2.

March 17, 1922

Her Royal Highness Princess Marie Louise.

Dear Madam.

I am very sorry that I have forgotten the little book for the Queen's Doll House belonging so long, and I now enclose it, filled up as far as my failing fancy allows, with many apologies, and thanks for your Royal Highness's forbearance.

Your Obedient

J. M. Barrie.

From Sir Edwin L. Lutyens, R.A.

Telephone No. 95 Gerrard.
Telegraphic Address:
"Auditheat, London."

17, QUEEN ANNE'S GATE,
WESTMINSTER, S.W.1.

Aug. 30. 21.

Dear Madam

What fun

I shall obey the command & shall turn up at a quarter to three.

Yr obedient servant

E. Lutyens

(1) I saw one of these gentlemen's costumes the day outside some Highness' Palace!

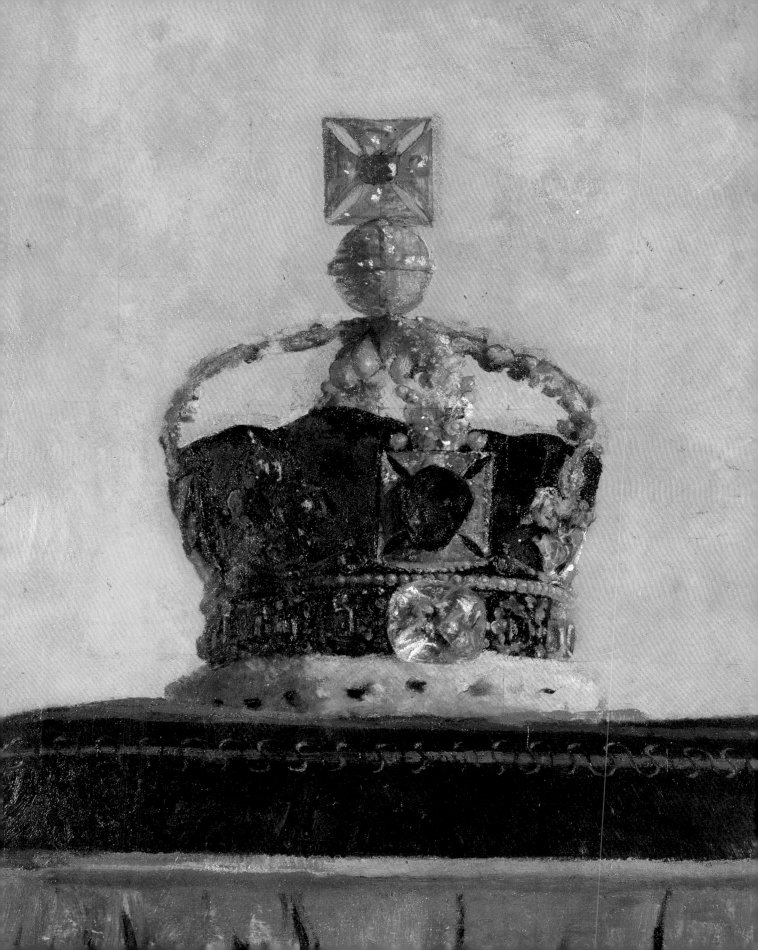

THREE ——————— THE BUSINESS OF GOVERNMENT

'Mr Gladstone not only appeared, but rushed into the debate. The House, very full, was breathless. The new members trembled & fluttered like small birds when a hawk is in the air.'

——————— LETTER FROM BENJAMIN DISRAELI TO QUEEN VICTORIA, 17 MARCH 1875

INTRODUCTION

Britain has had a constitutional monarchy since the changes in the late seventeenth century, notably the Bill of Rights of 1689. As a constitutional monarch, the Sovereign, though Head of State, must govern according to the binding conventions of the constitution, acting on the advice of ministers rather than according to their own free will, and must remain politically neutral.

The Bill of Rights established the supremacy of the elected Parliament, so that Parliament alone can make and pass legislation. Since 1689 Parliament has become more truly representative of the will of the people. This was reinforced by the Great Reform Act of 1832 (p. 78), which redistributed parliamentary seats to provide better representation for the growing industrial towns and broadened the electorate to include the middle classes. Further reform acts continued the process, though it was not until 1928 that all adults gained the vote.

The early eighteenth century saw the emergence of the position of prime minister as the leader of the elected government, and the development and formalisation of the role of the Cabinet, the 'board' of ministers which replaced the monarch at the head of the executive side of government. Nevertheless, the monarchy has remained a constant and essential thread throughout, so that, if a monarch were unable to fulfil their role, as happened with the illness of George III, it would be necessary to appoint a regent to act in their stead (p. 76).

The Sovereign's relationship with Parliament, the prime minister and the Cabinet plays an important part in the governance of the country. Although no longer directly involved in the day-to-day business of government, it is vital for the Head of State to be kept informed, and so a system emerged for regular reports of Cabinet meetings (p. 75) and sittings of Parliament (pp. 89) to be sent to the Sovereign.

As Head of State, the Sovereign carries out certain constitutional duties, such as opening new sessions of Parliament, and also represents the nation, for instance carrying out state visits to other countries in support of diplomatic and economic relations. The Sovereign is the Fount of Justice, so may grant pardons to prisoners on the advice of ministers, and is Head of the Armed Forces. They are also the Fountain of Honour, and, as such, have the sole right of conferring all titles of honour, including peerages, knighthoods and gallantry awards, on the advice of the Cabinet Office. Certain honours, however, are conferred at the discretion of the Sovereign alone, including the Order of Merit, which was instituted by King Edward VII (p. 84).

The concept and practice of constitutional monarchy has evolved over the last three hundred years and the role of the monarch within it has been much discussed. Today it is generally accepted that the analysis given in Walter Bagehot's book *The English Constitution*, published in 1867, is one of the best, and it is interesting to see that this was studied by the future King George V in his preparation for kingship (p. 83). His efforts as King to bring the opposing sides together in an attempt to solve the problems in Ireland (p. 86) demonstrate that, despite the constraints imposed on monarchs by the constitutional framework within which they operate, there are still occasions when a Sovereign can have a very active and useful, but non-partisan, role in politics.

PAGE 70 *Sir Gerald Festus Kelly (1879–1972),* The Imperial State Crown, *1939–45. Oil on millboard RCIN 404824*

OPPOSITE *Her Majesty The Queen, accompanied by The Duke of Edinburgh, The Prince of Wales and The Duchess of Cornwall, at the State Opening of Parliament, 8 May 2013.*

3833

at Ld Stormonts office June 6th
$\frac{45}{m}$ p. Eleven. P.M..

The Disorders are encreasing to such a Degree
and the outrages committed are of such a
Nature that it is the humble but unanimous
opinion of Your Majestys servants underwritten
that where the Civil Magistrate declines to
direct the Soldiers to act with Effect,
other Methods must be taken to preserve the
Peace and protect the Lives & Properties
of Your Majestys subjects.

and it is also humbly submitted to Your
Majesty that in this dangerous crisis it
appears to us absolutely necessary that
during the continuance of these Disorders
the whole Military Force should be
under one Command. The Manner of
doing this is submitted to Your Majestys
Wisdom, but our humble opinion is that the
appointment should be made immediately

Geo: Germain Bathurst P.
Northe. Stormont. Dartmouth C.P.S.
 Hillsborough
Amherst.

Report to George III on the conclusions of a Cabinet meeting to discuss the suppression of the Gordon Riots, 6 June 1780

RA GEO/MAIN/3833

The Cabinet, which is made up of the prime minister and other senior government ministers, is the principal executive body of government, implementing government policy and the legislation enacted in the Houses of Parliament. It has evolved over centuries from the practice of individual officers of state offering advice to the monarch in private, in a cabinet or small room. In the early seventeenth century many people disapproved of these secretive 'cabinet counsels', but after the Civil War Charles II began to chair regular meetings of his advisers when he was in London. George I, who spoke no English and who was relatively unfamiliar with British politics, rarely attended these meetings after 1717, and from 1721 they were chaired by the newly appointed First Lord of the Treasury and Chancellor of the Exchequer, Sir Robert Walpole (1676–1745), whom history has acknowledged as the first British Prime Minister. Thus the Cabinet, in the form that we would recognise it today, came into being.

Nevertheless, the monarch was still Head of State and, as such, it was important that they should be kept abreast of the deliberations of ministers in Cabinet. Reports on these meetings were therefore provided, usually by the prime minister, and sent to the monarch, normally on the same day. Until 1916, when the Cabinet Office and secretariat were set up and regular minutes kept of the meetings, these reports were the only written record of Cabinet meetings.

This example dates from June 1780, at the height of the anti-Roman-Catholic Gordon Riots in London, and shows the Cabinet recommending to the King that, in order to deal effectively with the disorder, 'the whole Military Force should be under one Command'. Unusually, it is signed by all the ministers present, including the Prime Minister, Lord North (1732–92).

Transcript of report

at Ld Stormonts office June 6th
45/m p. Eleven. P.M..

The Disorders are encreasing to such a Degree and the outrages committed are of such a Nature that it is the humble but unanimous opinion of Your Majestys Servants underwritten that where the Civil Magistrate declines to direct the Soldiery to act with Effect, other Methods must be taken to preserve the Peace and protect the Lives & Properties of Your Majestys Subjects.

and it is also humbly submitted to Your Majty that in this dangerous crisis it appears to us absolutely necessary that during the continuance of these Disorders the whole Military Force should be under one Command. The Manner of doing this is submitted to your Majestys wisdom, but our humble opinion is that the appointment should be made immediately.

Geo: Germain Bathurst P.
North. Stormont. Dartmouth. C.P.S.
Amherst. Hillsborough

Letter from the Prime Minister, William Pitt, to George, Prince of Wales, proposing that, because of the illness of George III, the Prince be created Regent, with limited powers, 30 December 1788

RA GEO/MAIN/38361–3

The first incapacitating bout of the illness that was finally to render George III unfit to rule for the last ten years of his life occurred in 1788–9. This illness was long regarded as a form of mental illness or madness, but in the 1960s was attributed instead to a physical disorder, porphyria. However, recent scholarship has discounted this theory and it is now believed that the King was indeed suffering from some mental disorder, possibly bipolarity.

This episode lasted from June 1788 until February 1789, with a respite between July and mid-October. It began with a severe bilious attack; later symptoms included weakness, a rapid pulse, muscular pains, insomnia, mental agitation and delirium, rendering the King incapable of carrying out his duties as Sovereign for four months.

The Prime Minister, William Pitt (1759–1806), and his Tory colleagues were faced with having to turn to the Prince of Wales to act as Regent for however long the King's illness might last (and,

as the doctors had little idea of the cause of his suffering, they could not say with any certainty whether he would recover). In the eighteenth century no government could hope to stay in power without the support of the Crown, so the Tory ministers could be fairly certain that they would soon be replaced by the Prince of Wales's Whig friends.

While Pitt played for time, hoping that the King would recover, a Regency Bill was prepared which, as he explained in this letter to the Prince, would not allow the Regent to exercise the full powers of the monarch. In particular he would not be able to grant peerages (and thus would be unable to add to his Whig supporters in the House of Lords). The Prince reluctantly agreed to these restrictions and in February the Bill was passed in the House of Commons. However, three days before it came into effect, it was announced that the King was convalescing and the plans for a Regency were abandoned. It was not until George III's illness overtook him permanently 22 years later that the Prince of Wales finally became Prince Regent, in 1811.

Transcript of letter from William Pitt

Sir,

The Proceedings in Parliament being now brought to a Point which will render it necessary to propose to the House of Commons the particular measures to be taken for supplying the Defect of the Personal Exercise of the Royal Authority during the present Interval … I take the Liberty of respectfully entreating Your Royal Highness's Permission to submit to your Consideration the Outlines of the Plan which His Majesty's Confidential Servants humbly conceive (according to the best Judgement which they are able to form) to be proper to be proposed in the present Circumstances.

It is their humble Opinion that Your Royal Highness should be empowered to exercise the Royal Authority in the Name and on the Behalf of His Majesty, during His Majesty's Illness, and to do all Acts which might legally be done by His Majesty; with Provisions nevertheless, that the Care of His Majesty's Royal Person, and the management

of His Majesty's Household, and the Direction and Appointment of the Officers and Servants therein should be in the Queen, under such Regulations as may be thought necessary; That the Power to be exercised by Your Royal Highness should not extend, to the Granting the Real or Personal Property of the King (except as far as relates to the Renewal of Leases) – to the Granting any Office in Reversion, or to the Granting, for any other Term than during His Majesty's Pleasure, any Pension, or any Office whatever, except such as must by Law be granted for Life or during Good Behaviour, – nor to the Granting any Rank or Dignity of the Peerage of this Realm, to any Person, except His Majesty's Royal Issue who shall have attained the Age of Twenty one years. These are the chief Points which have occurred to His Majesty's Servants. I beg Leave to add that their Ideas are formed on the Supposition that His Majestys Illness is only

temporary and may be of no long duration. It may be difficult to fix beforehand, the precise Period for which these Provisions ought to last, but if unfortunately His Majesty's Recovery should be protracted to a more distant Period than there is at present reason to imagine, It will be open hereafter to the Wisdom of Parliament to reconsider these Provisions whenever the Circumstances appear to call for It …

I have the honor to be
with the utmost Deference and Submission,

Sir, Your Royal Highness's most dutiful and devoted Servant

W Pitt.

Downing Street.
Tuesday night Decr 30th 1788

Letter from William IV to his Prime Minister, Earl Grey, confirming his willingness to create additional peers to aid the passage of the Reform Bill, 18 May 1832

RA GEO/ADD15/1870

William IV became King on 26 June 1830, aged 64. As the third son of George III he had not been trained as a future monarch, but he entered upon his new role with energy and a desire to act as a conciliator in political difficulties.

This was soon put to the test, as Parliament addressed the pressing need for parliamentary reform. The issue brought down the Tory government, and the King asked the Whig Lord Grey (1764–1845) to form a coalition ministry. Its main purpose was to pass a Bill to replace the confused electoral system with a uniform franchise for all male householders owning property of a certain value, and to redistribute parliamentary seats from the 'rotten' boroughs (those with a tiny electorate) to the new industrial towns.

The Reform Bill's tortuous passage is told in the Grey Papers, the letters from William IV and his Private Secretary to Lord Grey. It took 15 months and three versions for the Bill to pass. The King, content to see the Bill become law but concerned at the huge controversy it aroused and the measures which might be required to achieve its success, veered between supporting and thwarting his ministers.

Strengthened by the general election results in 1831, which meant that the Bill could safely pass in the House of Commons, Grey asked the King to create additional Whig peers in order to force the Bill through the Lords. The King refused, but finding the Tories unable to form a government, he realised that his only constitutional alternative was to agree to the request, and in this letter, written by his Private Secretary, but signed by the King himself, declared his readiness 'to afford [his Ministers] the Security They require for passing the Reform Bill unimpaired'.

This promise was sufficient: without the creation of any new peers; the Bill was passed and received the royal assent on 7 June 1832.

In the absence of the King's own papers (p. 14), the gift to the Royal Archives of the Grey Papers provides a window on the King's involvement in the political affairs taking place during his reign.

ABOVE *Sir David Wilkie (1785–1841)*, William IV, *1832. Oil on canvas* RCIN 404931

Transcript of letter from William IV

St James' Palace May 18
1832

The King's mind has been too deeply engaged
in the consideration of the circumstances in which
this Country is placed and of His own Position to
require that His Majesty should hesitate to say in
Reply to the Minute of Cabinet left with Him this
Afternoon by Earl Grey and the Lord Chancellor
that it continues to be, as stated in His recent
Communications to His Confidential Servants
His Majesty's Wish and Desire that They remain
in His Councils

His Majesty is therefore prepared to afford to
Them the Security They require for passing the
Reform Bill unimpaired in its' Principles, and in its'
essential Provisions, and as nearly as possible in its'
present form, – and, with this View His Majesty
authorizes Earl Grey, if any Obstacle should arise
during the further Progress of the Bill to submit
to Him a Creation of Peers to such Extent, as shall
be necessary to enable Him to carry the Bill, always
bearing in mind that it has been and still is His
Majesty's Object to avoid any permanent Encrease
to the Peerage and therefore that this Addition
to the House of Peers, if unfortunately it should
become necessary, shall comprehend as large
a proportion of the Eldest Sons of Peers and
Collateral Heirs of Childless Peers as can possibly
be brought forward …

Subject to these Conditions, which have been
already stated verbally, and admitted by Earl Grey
and The Lord Chancellor, His Majesty assents to
the Proposal …

William R.

Letters to Queen Victoria from two of her prime ministers, Benjamin Disraeli, 17 March 1875, and William Gladstone, 3 March 1894

RA VIC/MAIN/A/48/32 and RA VIC/MAIN/A/69/88

Although the powers of the monarch had been reduced by the constitutional reforms of the late seventeenth century, the monarch's role, as Head of State, remained a vital one in the constitution. From the eighteenth century onwards ministers carried out much of the business of government independent of the monarch, in effect, but it was expected that they would provide regular reports on affairs. If they failed to do so, they could expect to receive an admonishment from the Sovereign. The Royal Archives, therefore, holds a large number of letters from prime ministers and other ministers, providing detailed reports of government and parliamentary business.

Despite the serious nature of these letters, the different characters of the writers often come across, as in these letters from the Tory Benjamin Disraeli (1804–81, later Lord Beaconsfield), who served Queen Victoria as Prime Minister in 1868 and again from 1874 to 1880, and his Liberal rival, William Gladstone (1809–98), who was Prime Minister four times between 1868 and 1894. Disraeli's flamboyant report on a debate in the House of Commons, on the Regimental Exchanges Bill in 1875, likens Gladstone's intervention, after having threatened to quit politics, to Napoleon's 'return from Elba', so that 'the new members trembled & fluttered like small birds when a hawk is in the air'. Gladstone's letter, tendering his final resignation as Prime Minister in 1894, is very much drier, no doubt as befits the occasion, but also as characteristic of his serious, sometimes ponderous writing style.

It is well known that Queen Victoria greatly preferred Disraeli to Gladstone. Indeed, twice – in 1880 and 1886 – she even asked other leading Liberals to form a government in preference to Gladstone, though on each occasion she was finally obliged to appoint Gladstone as premier, as the only man who had the support of a majority in the House of Commons. Queen Victoria's Private Secretary,

Sir Henry Ponsonby, attributed this difference in her relationships with these two premiers not just to matters of policy but also to the style of their letters to the Queen, noting her preference for Disraeli's witty epigrams, which successfully conveyed his meaning, to Gladstone's deeply considered but involved sentences, which nevertheless failed to give the Queen the information she required.

Transcript of letter from Benjamin Disraeli

Mar 17 [18]75

Mr Disraeli with his humble duty to Yr Majesty …

Yesterday was a great day in the Ho[use] of Comm[ons].

In consequence of the tactics of delay on the part of the opposition, Mr Disraeli was obliged to have recourse to a morning sitting; unprecedented before Easter = so, yesterday the House was sitting all day.

But the greater event was – the return from Elba – Mr Gladstone not only appeared, but rushed into the debate. The House, very full, was breathless. The new members trembled & fluttered like small birds when a hawk is in the air. As the attack was made on Mr Secy [Secretary] Hardy & his department, Mr Disraeli was sorry not to be able to accept the challenge – but he had nothing to regret. Mr Hardy, who, suffering under a great sorrow, has been languid this Session, was inspired by the great occasion, & never spoke with more force & fire. The Bill was carried thro' committee by large majorities, & witht [without] alteration.

Mr Disraeli forgot to tell Yr Majesty, that he wrote also to H.R.H. the Prince of Wales about Mr Cole.

Yr Majesty will pardon this hasty letter, but Yr Majesty's messenger has arrived.

2, Whitehall Gardens,
S.W.

By the return from
Elba — Mr Gladstone
not only appeared, but
rushed into the
debate — The House
very full, was breathless.
The new members
trembled & fluttered
like small birds
when a hawk is

in the air. As the
attack was made
on Mr Secy. Hardy &
his department, Mr
Disraeli was sorry not
to be able to accept
the challenge — but
he had nothing to
regret. Mr Hardy, who,
suffering under a
great

March 3.1894

10, Downing Street,
Whitehall.

Mr. Gladstone presents his most humble duty to Your Majesty.

The close of the Session, and the approach of a new one, has offered Mr. Gladstone a suitable opportunity for considering the condition of his sight and hearing, both of them impaired, in relation to his official obligations. As they now place serious, and also growing, obstacles in the way of the efficient discharge of those obligations, the result has

Transcript of letter from William Gladstone

Mr. Gladstone presents his most humble duty to Your Majesty.

The close of the Session, and the approach of a new one, have offered Mr. Gladstone a suitable opportunity for considering the condition of his sight and hearing, both of them impaired, in relation to his official obligations. As they now place serious, and also growing, obstacles in the way of the efficient discharge of those obligations, the result has been that he has found it his duty humbly to tender to Your Majesty his resignation of the high offices, which Your Majesty has been pleased to intrust to him. He desires to make this surrender accompanied with a grateful sense of the condescending kindnesses, which Your Majesty has graciously shown him on so many occasions during the various periods for which he has had the honour to serve Your Majesty.

Mr. Gladstone will not needlessly burden Your Majesty with a recital of particulars He may, however, say that, although at eighty four years of age he is sensible of a diminished capacity for prolonged labour, this is not of itself such as would justify his praying to be released from the restraints and exigencies of official life. But his deafness has become, in Parliament, and even in the Cabinet, a serious inconvenience, of which he must reckon on more [?] progressive [?] increase. More grave than this, and more rapid in its growth, is the obstruction of vision, which arises from cataract in both his eyes…

Accordingly, he brings together these two facts, the condition of his sight and hearing, and the break in the course of public affairs brought about in the ordinary way by the close of the Session. He has therefore felt that this is the fitting opportunity for the resignation, which by this letter he humbly prays Your Majesty to accept.
March 3. 1894.

TOP LEFT *Sir John Everett Millais (1829–96)*, William Ewart Gladstone, *1879. Oil on canvas National Portrait Gallery, London*

Notes by George, Duke of York, on Walter Bagehot's *The English Constitution*, 1894

RA GV/PRIV/AA3

George, Duke of York (later King George V), was the second son of the then Prince of Wales (the future King Edward VII), and so not expected to succeed to the throne. Consequently, his education was directed towards his following a career in the Royal Navy, and from 1890 to 1891 he served as commander of the gunboat HMS *Thrush*. But while he was awaiting his next naval appointment, tragedy struck, with the death in January 1892 of the Duke's elder brother, the Duke of Clarence. Now that he would, barring accidents, become King one day, the Duke had to turn his attention to taking on royal duties and preparing himself for his future role. At 26 years old, he needed to resume his education. He began attending parliamentary debates and in March 1894 he started to receive instruction on the law and the constitution from J.R. Tanner, a fellow of St John's College, Cambridge. The Duke of York's notebook on Walter Bagehot's work on the constitution was written at this period.

Walter Bagehot (1826–77) was an economist and political analyst who edited *The Economist* for 17 years. His most famous book, *The English Constitution*, was first published in 1867 and is now often regarded as the best analysis of the role of the monarchy ever published, with its appreciation of the magic of monarchy and of its significance as a focus for national loyalty and its constitutional role in terms of influence rather than power.

Some historians have questioned whether Bagehot's interpretation of the constitution was valid, even at the time he wrote it. It might, indeed, be more accurate to say that his thoughts on constitutional monarchy, absorbed by the Duke of York, reached fruition when the Duke became King: Bagehot's statement that the Sovereign had 'the right to be consulted … the right to encourage … and the right [to] warn' the government of the day, so carefully copied out by the future King, became his guiding principle.

Monarchy..

(1.) The value of the Crown in its dignified capacity.

(a.) It makes Government intelligible to the masses.

(b.) It makes Government interesting to the masses.

(c.) It strengthens Government with the religious tradition connected with the crown.

After the accession of George III the Hanoverian line inherited the traditional reverence of Stuart times.

(d.) The social value of the Crown.

If the high social rank was to be scrambled for in the House of Commons, the number of social adventurers there would be incalculably more numerous & indefinitely more eager.

(e.) The moral value of the Crown.

Great for good or evil.

Compare the courts of Charles II & George III in their influence on the nation.

(f.) The existence of the crown serves to disguise change, & therefore to deprive it of the evil consequences of revolution. e.g. The Reform Bill of 1832.

Copy letter from King Edward VII to the Prime Minister, Lord Salisbury, setting out his wishes for the proposed Order of Merit, 20 April 1902

RA VIC/MAIN/R/22/83

The Order of Merit, one of the senior British honours, is given to 'such persons, subjects of Our Crown, as may have rendered exceptionally meritorious service in Our Crown Services, or towards the advancement of the Arts, Learning, Literature and Science, or such other exceptional service as We see fit to recognise'. Its award is in the personal gift of the Sovereign, and so free of political influence, and the Order is limited to 24 Ordinary Members at any one time; this makes it particularly highly prized. Current members include such luminaries as Sir Tom Stoppard, Sir David Attenborough, Sir Timothy Berners-Lee and David Hockney.

The Order owes its foundation to King Edward VII, who had long been interested in honours and decorations, and took seriously the Sovereign's role as the Fountain of Honour. In 1902 the King opened discussions with his ministers on the subject, explaining that 'for many years it has been my great wish' that an Order should be created in England similar to the Prussian Order 'Pour le Mérite'. In the letter displayed here, one of the pivotal documents in the story of the creation of the Order of Merit, the King also stressed to the Prime Minister his desire that military men should be eligible to receive the new Order, described the proposed design for the badge, and approved Lord Salisbury's suggestion that the Order's numbers be strictly limited. These ideas all came to be included in the final proposals for the Order.

After further discussion between the King and his ministers, the Order of Merit was instituted by Letters Patent under the Great Seal of the Realm on 23 June 1902; the first 12 appointments, which included Lord Kitchener and Lord Lister, were announced in the Coronation Honours list three days later.

Transcript of letter from King Edward VII

Copy

20 April 1902
My dear Lord Salisbury

The letter of 17th Inst which I have received from you, has caused me some surprise, and I fail to see any arguments brought forward by the Secy [Secretary] of State for War & the First Lord of the Admiralty why the "Order for Merit" should not be conferred on Officers of the Army & Navy who have greatly distinguished themselves on active Service.

The Order which will be instituted, will have only one Class, & no rank given for it. It will consist of a Red Cross worn round the neck, the only difference being that the Order conferred on Officers of the Army & Navy will have two swords crossed, as was the case in the Hanoverian Order of the Guelph.

For many years it has been my great wish that this "Order of Merit" should be instituted so as to reward in a special manner Officers of the Navy & Army, & Civilians distinguished in Arts, Sciences & Literature.

I have always been so much impressed by the Prussian Order "Pour le Mérite", which was I believe instituted originally by Frederick the Great conferring such distinctions, that I have always wished that a similar one might be created for England.

Your view that there should be a limited number is well worthy of consideration, & possibly 12 for the Army & Navy & 12 for Civilians would be the right number.

I shall be glad to see Mr. Broderick on the subject on my return to London.

I should wish it to be a decoration entirely vested in the Sovereign's hands, who would naturally consult the Prime Minister, & the Ministers at the head of certain Departments.

Believe me &c
(Signed) Edward R.

ABOVE *Sir Samuel Luke Fildes (1843–1927),* King Edward VII, *1902. Oil on canvas* RCIN 404553

OPPOSITE TOP *The insignia of the Order of Merit as it appears today.*

20 April 1902 Sandringham,
 Norfolk.

My dear Lord Salisbury

The letter of 17th Inst which I
have received from you, has caused
me some surprise, and I fail to
see any arguments brought forward
by the Secr. of State for War & the
First Lord of the Admiralty Why the
"Order for Merit" should not be conferred
on officers of the Army & Navy who
have greatly distinguished themselves
on active Service —
The Order which will be instituted,
will have only one Class, & no rank

given for it — It will consist of a
Red Cross worn round the neck,
the only difference being that the
Order conferred on Officers of the
Army & Navy will have two swords
crossed, as was the case in the
Hanoverian Order of the Guelph —
For many years it has been my
great wish that this "Order of Merit"
should be instituted so as to reward
in a special manner officers of the
Navy & Army, & civilians distinguished
in Arts, Sciences & Literature.
I have always been so much
impressed by the Prussian order
"Pour le mérite", which who I believe

instituted originally by Frederick the
great conferring such distinctions, that
I have always wished that a
similar one might be created for
England —
Your view that there should be a
limited number is well worthy of
consideration, & possibly 12 for the
Army & Navy & 12 for civilians
could be the right number —
I shall be glad to see Mr Brodrick
on the subject on my return to London.
I should wish it to be a decoration
entirely vested in the Sovereign's hands,
who would naturally consult the Prime
Minister, & the Minister at the head of
certain Departments.
 Believe me &c
(Signed) Edward R.

Draft letter from King George V to the Prime Minister, Herbert Asquith, authorising the announcement of a conference to be held at Buckingham Palace to discuss the Irish crisis, 18 July 1914, with the King's copy of the speech he made at the opening of the conference on 21 July

RA PS/PSO/GV/C/K/2553/6/16A and RA PS/PSO/GV/SPE/5/55

Throughout the nineteenth century, tensions had grown in Ireland (then one country within the United Kingdom) between the ruling Protestant aristocracy and the majority Roman Catholic population. Attempts in the 1880s and 1890s to introduce Home Rule for Ireland failed, leaving 'the Irish question' unresolved.

In 1912, in return for the support of the Irish Nationalist members of parliament in pushing through the Parliament Act of 1911, the government introduced a new Home Rule Bill, which was passed by the House of Commons but, like its predecessors, rejected by the Lords. However, under the terms of the new Parliament Act it could still become law before the end of 1914 if it were passed by the Commons twice more. Before this could happen, the situation deteriorated rapidly and there was a very real fear of civil war in Ireland.

The Parliament Act had removed the House of Lords' absolute veto, so only King George V stood in the way of the Home Rule Bill becoming law. He could refuse to sign the Bill, or even dismiss his government, but this would alienate Ireland's Catholic population. By signing the Bill, though, he would cause the forcible exclusion from the United Kingdom of the predominantly Protestant Ulster.

Placed in this invidious position, the King was determined to act constitutionally and to leave it to the elected politicians to decide whether Ireland should have Home Rule; yet he was equally concerned to achieve a consensual settlement. For over a year he worked patiently to bring the two sides together to reach an agreement acceptable to everyone. Finally, in July 1914, his proposal that all the interested parties attend a conference to negotiate a settlement was agreed to by the Prime Minister.

Sadly, the King's hopes for the conference were not fulfilled. While all parties agreed that Ulster should be excluded from the terms of the Home Rule Bill, they could not agree on the area to be included as 'Ulster'. Nevertheless, in the flurry of events surrounding the outbreak of the First World War, the Bill was passed by both Houses of Parliament, with a promise that it would not be implemented until after the War and that, before then, the position of Ulster would be regularised. This received the Royal Assent on 17 September. Even then the matter was not settled, and it was not until 1921 that agreement was finally reached that the 26 counties with a Catholic majority could break away from the United Kingdom to form the Irish Free State. On 22 June of that year King George V opened the first Parliament for Northern Ireland in Belfast.

Speech made at opening of Conference on July 21st 1914.
held at B. P. to try & settle the Irish question
 The Speaker chairman
 Prime Minister Ld Lansdowne
 Lloyd George Bonar Law
 Mr Redmond Sir E. Carson
 Mr Dillon Capt Craig

BUCKINGHAM PALACE

Gentlemen,

It is with feelings of satisfaction and
hopefulness that I receive you here today, and I thank
you for the manner in which you have responded to
my summons. It is also a matter of congratulation
that the Speaker has consented to preside over your
meetings.

My intervention at this moment may be
regarded as a new departure. But the exceptional
circumstances under which you are brought together
justify my action.

For months we have watched with deep misgivings
the course of events in Ireland. The trend has
been surely and steadily towards an appeal to
force, and today the cry of Civil War is on the lips
of the most responsible and sober minded of my
people.

We have in the past endeavoured to act as a
civilising example to the world, and to me it is
unthinkable, as it must be to you, that we should
be brought to the brink of fratricidal strife upon

House of Commons.

13th February, 1924.

 The Prime Minister with his humble duty
to Your Majesty.

 Beyond the fact that the Galleries and
the House itself were unusually crowded there was
little in yesterday's proceedings to indicate that
the occasion was unique and historical in the
annals of the British Parliament. Every Gallery
was filled to its utmost capacity and on the Floor
of the House many of the gangways were blocked by
Members who were unable, owing to the limited
accommodation, to find seats. Sir Charles Barry,
whatever his merits as an architect may have been,
was not a political prophet. To any parliamentary
observer the proceedings would have been full of
 interest

Report by the Prime Minister, James Ramsay MacDonald, to King George V on the first sitting of the House of Commons under a Labour government, 13 February 1924

RA PS/PSO/GV/PARL/UK

Since the reign of George III a daily report on the proceedings in the House of Commons has been prepared for the monarch. Formerly this report was written by the prime minister, or by the leader of the house, but for nearly a century now the task has fallen to the Vice-Chamberlain of the Household. The Vice-Chamberlain, whose principal duties are as a government whip, is one of three political appointees to the Royal Household from the House of Commons.

Throughout the seventeenth and eighteenth centuries members of parliament had vigorously opposed publication of reports of their proceedings, seeing this as a breach of parliamentary privilege. Finally, however, in 1771 they had to give way, following the successful campaign by the radical Member of Parliament and journalist John Wilkes. In 1800 publication began of the edited transcripts of daily proceedings, initially weekly but later daily, which are know today as *Hansard*.

Nevertheless, the private parliamentary reports to the Sovereign, which tend to be pithier and at the same time more personal in character than the official *Hansard* House of Commons' reports, carried on. Their continuing value to the monarch is confirmed by the facts that King George VI requested that the reports be resumed in 1945, after a temporary abeyance during the Second World War, and that, since the Scottish Parliament was re-established in 1999, reports on the proceedings of that body have also been provided, by the Minister for Parliamentary Business.

Amongst the large number of these reports surviving in the Royal Archives is this by

James Ramsay MacDonald (1866–1937) from 1924, the first one ever written by a Labour prime minister. He describes an occasion that 'was unique and historical in the annals of the British Parliament' as he took his seat on the government benches for the first time, in front of a packed House, facing 'four ex-Chancellors of the Exchequer sitting in a row on the Front Opposition Bench, and two ex-Prime Ministers sitting beside each other on the Benches below the gangway'. All were eager to see how the inexperienced ministers coped with the 'difficult and trying ordeal' of Question Time, but 'it was generally agreed that they acquitted themselves with great credit' and Ramsay MacDonald concluded that 'on the whole it was a very encouraging start'.

ABOVE *Bassano Ltd,
Ramsay Macdonald, 1923.
Vintage print
National Portrait Gallery,
London*

FOUR ——————— CHANGING SOCIETY

'I just now see an extraordinary building flaming with fire.
The country continues black, engines flaming, coals, in
abundance, every where, smoking and burning coal heaps ...'

——————— PRINCESS VICTORIA'S JOURNAL, 2 AUGUST 1832

POLITICAL CHANGES

The eighteenth and nineteenth centuries were a time of huge change for Britain in terms of its economy and role in the world, and this in turn led to rising demands for political change, particularly with the call for increased suffrage. The authorities in nineteenth-century Britain eyed revolutionary unrest in Europe with horror and alarm, and as monarchies were overthrown they began to wonder whether the same would happen at home. The rise of radical political movements such as the Chartists (p. 96), who called for, amongst other things, universal suffrage, horrified the ruling classes. The government responded with electoral amendments, such as the Great Reform Act of 1832 (p. 78), which enfranchised the middle classes, and subsequent Acts that further enlarged the voting populace. These, coupled with rising economic prosperity, helped to avoid revolution in Britain.

One group that found its voice during the nineteenth century was the working class. As wages were pushed down and unemployment increased as a result of the mechanisation brought about by the Industrial Revolution, workers began to take measures to protect their jobs. The Luddites who destroyed some of the labour-saving machinery were an extreme example, but workers generally began to form groups to fight for better pay and working conditions.

At first such groups were outlawed by the Combination Acts of 1799 and 1800, which prohibited the 'combining' (coming together) of workers to demand better wages and conditions. These very unpopular laws were repealed in 1824 and, although the Combination Act of 1825 that replaced them restricted the actions of trades unions and prohibited strikes, it at least recognised that membership of a trade union was no longer illegal. Following this, workers began to form local trades unions, such as the ill-fated Tolpuddle Martyrs (p. 94), and the more prosperous 1840s and 1850s saw a considerable development in the union movement. However, it was not until the Trades Union Act of 1871 that unions gained full legal status.

Throughout this period of great change, although it was increasingly the politicians who decided policy, monarchs retained the right to be informed and to give advice. This, together with a monarch's natural interest in and concern for all matters that affected the well-being of the nation, explains why the Royal Archives today contains literally thousands of papers relating to political topics. They include extensive correspondence from politicians and other leading figures, providing a very valuable and often unique source of information for historians.

PAGE 90 *Joseph Mallord William Turner (1775–1851), Dudley, Worcestershire (detail), 1830–33. Watercolour Lady Lever Art Gallery, National Museums Liverpool*

OPPOSITE *W.E. Kilburn, photograph of the Chartist meeting on Kennington Common in London on 10 April 1848 (detail) RA VIC/MAIN/C/56/19*

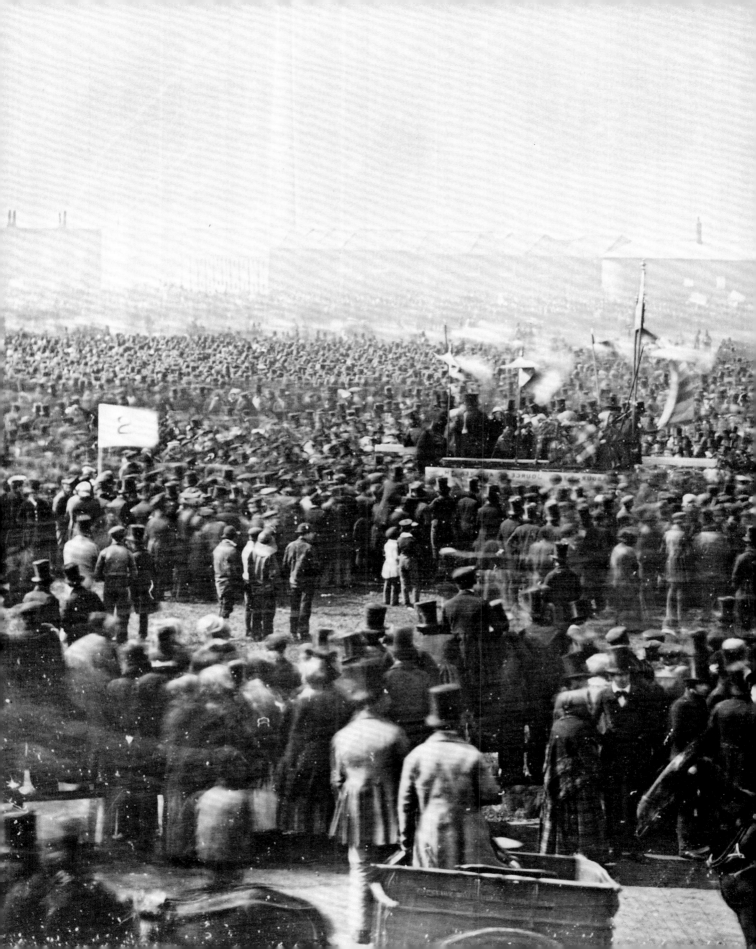

**General Laws and Byelaws of the Friendly Society of Labourers, 1833 and Poster issued by the Magistrates of Dorchester in February 1834 condemning membership of 'Illegal Societies or Unions … which bind themselves by unlawful oaths',
22 February 1834**

RA MP/89/101 and RA MP/89/106

The case of the Tolpuddle Martyrs was the most celebrated incident in the early history of the Trades Union Movement in Britain, which was in its infancy in the 1830s.

In 1833 six men from Tolpuddle near Dorchester in Dorset founded the Friendly Society of Labourers to protest against the lowering of agricultural wages in the 1830s (caused by the surplus supply of labour following increasing mechanisation) and to campaign for a living wage. The society, led by George Loveless (1797–1877), a local Methodist preacher, met in the house of his brother-in-law Thomas Standfield (1794–1864). Although the society wished to press its claims peacefully, the authorities were alarmed by a general resurgence of working-class agitation in the early 1830s. The repeal of the Combination Acts in 1824 meant that it was no longer illegal to belong to a trade union, but on 21 February 1834 the Dorchester magistrates, having first consulted the Home Secretary, Lord Melbourne (1779–1848), declared that membership of the tiny society was a crime because members took unlawful oaths. The ringleaders – Loveless, his brother James (1808–73), Thomas Standfield and his son John, James Brine (1813–1902) and James Hammett (1811–91) – were all arrested. The men were tried under an old statute and, when found guilty of administering illegal oaths, were transported to Australia for seven years. However, after much public and political agitation in support of the 'Martyrs', the new Home Secretary, Lord John Russell, was finally persuaded in March 1836 to pardon most of the men. They returned to Britain for a time before emigrating to Canada.

This copy of the General Laws of the Friendly Society of Labourers comes from the Melbourne Papers; it was found in the house of George

CAUTION.

WHEREAS it has been represented to us from several quarters, that mischievous and designing Persons have been for some time past, endeavouring to induce, and have induced, many Labourers in various Parishes in this County, to attend Meetings, and to enter into Illegal Societies or Unions, to which they bind themselves by unlawful oaths, administered secretly by Persons concealed, who artfully deceive the ignorant and unwary,—WE, the undersigned Justices think it our duty to give this PUBLIC NOTICE and CAUTION, that all Persons may know the danger they incur by entering into such Societies.

ANY PERSON who shall become a Member of such a Society, or take any Oath, or assent to any Test or Declaration not authorized by Law—

Any Person who shall administer, or be present at, or consenting to the administering or taking any Unlawful Oath, or who shall cause such Oath to be administered, although not actually present at the time—

~~Any Person who shall not reveal or discover any Illegal Oath which may have been administered—~~

Any Person who shall not reveal or discover any Illegal Oath which may have been administered, or any Illegal Act done or to be done—

Any Person who shall induce, or endeavour to persuade any other Person to become a Member of such Societies,

WILL BECOME

Guilty of Felony,

AND BE LIABLE TO BE

Transported for Seven Years.

ANY PERSON who shall be compelled to take such an Oath, unless he shall declare the same within four days, together with the whole of what he shall know touching the same, will be liable to the same Penalty.

Any Person who shall directly or indirectly maintain correspondence or intercourse with such Society, will be deemed Guilty of an Unlawful Combination and Confederacy, and on Conviction before one Justice, on the Oath of one Witness, be liable to a Penalty of TWENTY POUNDS, or to be committed to the Common Gaol or House of Correction, for THREE CALENDAR MONTHS ; or if proceeded against by Indictment, may be CONVICTED OF FELONY, and be TRANSPORTED FOR SEVEN YEARS.

Any Person who shall knowingly permit any Meeting of any such Society to be held in any House, Building, or other Place, shall for the first offence be liable to the Penalty of FIVE POUNDS ; and for every other offence committed after Conviction, be deemed Guilty of such Unlawful Combination and Confederacy, and on Conviction before one Justice, on the Oath of one Witness, be liable to a Penalty of TWENTY POUNDS, or to Commitment to the Common Gaol or House of Correction, FOR THREE CALENDAR MONTHS ; or if proceeded against by Indictment may be

CONVICTED OF FELONY,

And Transported for SEVEN YEARS.

COUNTY OF DORSET,
Dorchester Division.

February 22d. 1834.

C. B. WOLLASTON,
JAMES FRAMPTON,
WILLIAM ENGLAND,
THOS. DADE,
JNO. MORTON COLSON,

HENRY FRAMPTON,
RICHD. TUCKER STEWARD,
WILLIAM R. CHURCHILL,
AUGUSTUS FOSTER.

G. CLARK, PRINTER, CORNHILL, DORCHESTER.

Loveless and was presumably sent to Lord Melbourne, together with other papers relevant to the case. Unusually, the political papers of Lord Melbourne (who later became Prime Minister) are held in the Royal Archives. They include much royal correspondence, and help to throw some light on to the politics of the reign of William IV, whose own papers have not survived. This was a period of major political changes, such as the Great Reform Act of 1832, which enfranchised the middle classes of Britain, and the early years of the Trades Union Movement.

Transcript (part) of General Laws

General Laws

20th That if any Master attempts to reduce the wages of his workmen if they are Members of this Order they shall instantly communicate the same to the corresponding Secretary in order that they may receive the support of the Grand Lodge and in the mean time they shall use their utmost exertions to finish the work they may have in hand, if any and shall assist each other so that they may all leave the place together and with as much promptitude as possible

21st That if any Member of this Society renders himself obnoxious to his employers solely on account of taking an active part in the affairs of the Order (and if guilty of no violence or insult to his Master) and shall be discharged from his employment solely in consequence thereof either before or after the turn out, then the whole body of men at that place shall instantly strike and no Member of this Society shall be allowed to take work at that place until such Member be reinstated in his situation …

The Chartists, 1848: printed plan of the Organisation of the National Charter Association, letter from the Prime Minister, Lord John Russell, to Queen Victoria, reporting on the Chartist meeting on Kennington Common in London on 10 April, and two copy photographs of the meeting

RA VIC/MAIN/C/56/87, 19 and 36

The Chartist Movement, a radical democratic movement of the mid-nineteenth century, derived its name from the 'People's Charter', a programme calling for, amongst other things, universal male suffrage, payment of members of parliament and the removal of property qualifications for membership of parliament.

In the 1840s, as the Chartist Movement was active in Britain, Europe was swept by a tide of revolutionary fervour. In February 1848 the French monarchy was overthrown and King Louis Philippe was forced to flee to Britain for safety. Against this background, the upper and middle classes in Britain regarded Chartist agitation as a threat to the established order and feared a revolution in their own country.

In spring 1848 the Chartists announced a meeting to be held on Kennington Common in south London on 10 April. It was to be a national gathering and then the assembled company of largely working men was to march upon Parliament to deliver a 'Monster Petition', with over five million signatures in support of the People's Charter. Alarmed, the government drafted in special constables and troops to defend London, and the royal family was persuaded to leave for Osborne on the Isle of Wight. On the day itself government buildings were barricaded and all bridges over the Thames closed in an attempt to confine any disturbances to the south of the river.

In the event, as this letter from Lord John Russell (1792–1878) to Queen Victoria explains, the meeting passed much more quietly than the authorities feared. Only a fraction of the anticipated 200,000 assembled on Kennington Common. The government refused to allow the mass march, but the petition was taken to Parliament. After the Chartist leader, Fergus O'Connor (1794–1855), had appealed for peace, the crowd on the common dispersed quietly.

ABOVE *This organisational plan was adopted by the Chartists' National Assembly in May 1848 to obtain the speedy enactment of the People's Charter.*

The government declared the meeting a failure. The Chartist Movement never recovered from the setback, especially when it was discovered that the petition contained fewer than two million signatures and included many forged and fictitious names. However, the Chartists helped raise awareness of the appalling working and social conditions that were widespread among workers, especially in the industrial areas, which led to calls from many, including Prince Albert, for a commitment from the rich and powerful to improve these conditions through philanthropy and legislation.

In 1848 the art of photography was still in its infancy, and these photographs of the Chartist

meeting may well be the first ever taken of a historic event. The original daguerreotypes were taken by W.E. Kilburn (1818–91) and the prints he made (now much faded) were filed by Prince Albert with his papers on the Chartist Movement – from which Russell's letter also comes. This is one of many files of political papers in the Royal Archives that were kept by the Prince on behalf of Queen Victoria. It is not known whether he commissioned the daguerreotypes, but he was aware of Kilburn's work and encouraged the use of the new art form as a documentary medium.

Transcript of letter from Lord John Russell

Lord John Russell presents his humble duty to Your Majesty and has the honour to state that the Kennington Common Meeting has proved a complete failure.

About 12 or 15.000 persons met in good order. Fergus O'Connor upon arriving on the ground in a car was ordered by Mr. Mayne [the Commissioner of Police] to come and speak to him. He immediately left the car and came looking pale & frighten'd to Mr. Mayne. Upon being told that the meeting would not be prevented, but that no procession would be allowed to pass the Bridges he expressed the utmost thanks & begg'd to shake Mr. Mayne by the hand. He then address'd the crowd advising them to disperse and after rebuking them for their folly he went off in a cab to the Home Office, where he repeated to Sir George Grey [the Home Secretary], his thanks, his fears, & his assurances that the crowd should disperse quietly …

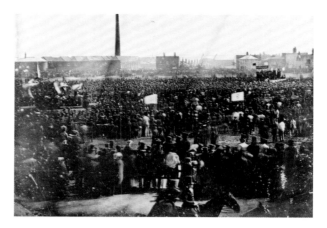

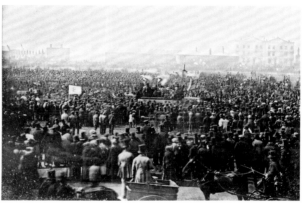

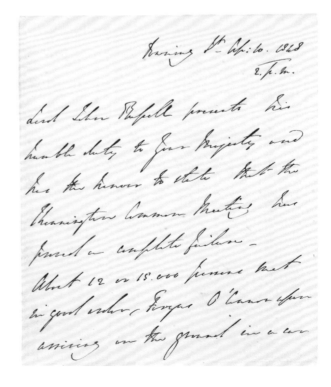

SOCIAL CHANGES _____

The Agricultural and Industrial Revolutions of the eighteenth and early nineteenth centuries changed the landscape and working practices of Britain forever. For some a booming economy brought great prosperity, but by the nineteenth century there was also a growing awareness that, particularly in the industrial towns and cities to which people had flocked from the countryside, the changes had created terms of employment which were sometimes incredibly harsh, and living conditions that were often appallingly overcrowded, lacking sanitation and disease-ridden.

The young Princess Victoria was shocked by the conditions she saw in the Black Country in 1832 (see p. 100) and nothing seemed to have improved when she visited the 'Iron District' in 1852, describing it as 'one of the most dreadful parts of the country one can imagine … one sees nothing but chimneys, flaming furnaces, & … wretched cottages … you have but a faint impression of the life … which a 3rd of a million of my poor subjects are forced to lead. It makes me sad!' The papers in the Royal Archives reveal how Queen Victoria and Prince Albert, and later their successors, all had a 'sincere interest' in the 'welfare and comfort of the working classes' and tried to improve their working and living conditions.

Through a series of Acts of Parliament designed to regulate employment, especially that of women and children, and to improve sanitation and overcrowding, the Victorian reformists, such as Lord Shaftesbury (1801–85), sought to help the working classes. In this they found a staunch supporter in Queen Victoria, who urged the government to prioritise legislation to improve the 'wretched tenements and still more wretched occupants'.

Prince Albert also was very active in trying to improve social conditions for those 'who have most of the toil and fewest of the enjoyments of this world', from supporting the abolition of slavery throughout the world (p. 104) to his presidency of the Society for Improving the Condition of the Labouring Classes, which advocated the creation of model housing with sanitation for families throughout the country. He also called for increased philanthropy by the rich to help the poorer classes. With no welfare state, national health service or national education system, pensions, allowances and charitable donations to individuals (pp. 102) and to institutions such as hospitals and schools (p. 107) were vital to many people's survival.

In the twentieth century the Royal Family continued to be identified with major charities and organisations, especially those concerned with young people, such as the Prince's Trust and the Scouts (p. 109) and these concerns and others extend into the twenty-first century. Royal patronage of a good cause has always played an important part in attracting support and funds, and the records in the Royal Archives reflect this aspect of the Royal Family's role. In addition, money raised for significant royal events such as jubilees has also been used in charitable ways, for example with the creation of Queen Victoria's Jubilee Nurses (the forerunners of today's District Nurses), the King George V Playing Fields Association and the more recent Jubilee Trusts of Queen Elizabeth II.

OPPOSITE *Benjamin Robert Haydon (1786–1846),* The Anti-Slavery Society Convention, 1840 *(detail), 1841. Oil on canvas National Portrait Gallery, London*

This painting shows the 1840 meeting in Exeter Hall of anti-slavery societies, over which Prince Albert, as president of the Society for the Extinction of the Slave Trade and the Civilisation of Africa, presided. Thomas Clarkson, the renowned abolitionist, is pictured speaking; amongst his listeners are the liberated slave Henry Beckford and the prison reformer Elizabeth Fry.

Extract from Princess Victoria's Journal describing a visit to the industrial Midlands, 2 August 1832

RA VIC/MAIN/QVJ/1832

In August 1832 Princess Victoria set off with her mother, the Duchess of Kent, on a visit to Powis Castle in Wales. Princess Victoria was the heir to her uncle, William IV, and, although the King disapproved, the Duchess of Kent took her daughter on a series of educational tours around the country, which allowed the public to see their future Queen.

As they left on this journey, the Duchess gave the young Princess a plain-leaved book so that she could record en route her impressions of the places they would be visiting. Their journey took them through the new industrial areas and they made several excursions for the Princess to see factories, a cotton mill and slate quarries. They also passed through the coal mining district in the Midlands. The young Victoria recorded, in a typically vivid description, her impressions of this world which seemed so alien to her, one where the people were 'black', the country 'desolate' and the buildings 'flaming with fire'. This first view of the industrial world obviously made a great impression

on her as a young girl, and throughout her life the Queen was sympathetic towards those who lived and worked in these crowded areas, often encouraging legislation and philanthropic projects that would help alleviate their conditions.

'This book, Mamma gave me, that I might write the journal of my journey to Wales in it.' With these words the 13-year-old Princess Victoria began the first volume of her Journal in 1832, thus starting a habit that would last until her death in 1901. In total 141 volumes of her Journal survive, numbering 43,765 pages. There are four different versions of the Journal, all of which are now available online (www.queenvictoriasjournals.org). The original Journals, of which only 13 small volumes survive, cover the period from 1832 to 1836. The abridged copies were made by the Queen's daughter Princess Beatrice on her mother's instructions, after the latter's death, and cover the period 1837 to 1901; there are also two other versions of the Journals which cover limited periods. None of these versions covers the whole period from 1832 to 1901. All are kept in the Royal Archives today.

As well as detailing household and family matters, the Journals reflect affairs of state; describe meetings with statesmen and other eminent figures,

both British and foreign; and comment on major events of the time. The wide range of subjects covered, together with the Queen's vivid and detailed writing style, make the Journals a valuable and unique primary source – truly one of the treasures of the Royal Archives.

Transcript of Princess Victoria's Journal entry for 2 August 1832

Thursday 2nd August. I got up after a very good night at 5 o'clock this morning. Mamma is much better I am happy to say and I am now dressing to go to breakfast … It is a very bad day. 10 minutes to 9. We have just changed horses at Birmingham where I was two years ago and we visited the manufactories which are very curious. It rains very hard. We just passed through a town where all [the] coal mines are and you see the fire glimmer at a distance in the engines in many places. The men woemen, children, country and houses are all black. But I can not by any description give an idea of its strange and extraordinary appearance. The country is very desolate every where; there are coals about, and the grass is quite blasted and black. I just now

see an extraordinary building flaming with fire. The country continues black, engines flaming, coals, in abundance, every where, smoking and burning coal heaps, intermingled with wretched huts and carts and little ragged children.

8 minutes past 10. We have just changed horses at Wolverhampton a large and dirty town but we were received with great friendliness and pleasure.

The scenery is quite changed for the country though not very pretty no more so black and the coal mines have disappeared. 10 minutes to ½ past 10. We just drove through a road hewn through the rock …

The country about here is very pretty. The bleak scenery is reappeared and coal mines with engines are seen in the distance but there is corn and some neat huts but underneath this hill all is desolate and wretched and dark and even up here now it has returned for a moment and the coals appear on the other side. Mountains are seen, the coals return now quite close. A canal runs along here and the thick smoke curling from the engines which are on the h[e]ights intermingled with patches of green grass here and there gives a strange appearance …

Copy memorandum from Joseph Hanby, Yeoman and Secretary in the Royal Almonry, to the Lord High Almoner (the Archbishop of York), suggesting in 1837 that the Maundy provisions allowance be replaced by a monetary one

RA PPTO/ALM/LB

The Royal Almonry, one of the oldest offices in the Royal Household, traces its origins back to at least 1103. The provision of alms, or gifts, to the poor has been associated with the Sovereign since medieval times, and gifts of food and money have been made regularly on behalf of the Sovereign by the Lord High Almoner and his assistants. Today the Royal Almonry still oversees the distribution of funds and other small grants, called 'Gate Alms' – the best-known example being the presentation of Maundy money by the monarch at the annual service on the Thursday before Easter.

Based on Christ's ministrations to his disciples at the Last Supper, the Maundy ceremony, which has taken place in England since the twelfth century, originally involved the monarch washing the feet of the poor and giving them food and clothing. The custom of the number of Maundy recipients being linked to the monarch's age dates back to at least 1363; since the reign of George I there has been an equal number of men and women receiving the Maundy, the number of each representing the Sovereign's age.

Gradually over the years, the washing of feet became symbolic and the giving of clothing was replaced by the grant of money. Food, however, continued to be distributed until, in 1837, it was suggested in the memorandum shown here (which has been copied into a Letter Book) that it would be better to replace the gifts of salt fish, which the Maundy recipients regularly sold for less than their value, with a money payment of 30 shillings, to which the King agreed.

Although in medieval times the distribution was carried out by the Sovereign in person, from the mid-eighteenth century no reigning Sovereign attended the ceremony for nearly two hundred years, until 1932 when King George V distributed

the Royal Maundy. King Edward VIII carried out the distribution in 1936 and King George VI also distributed Maundy money on several occasions, Queen Elizabeth II has done so nearly every year of her reign. Originally the Maundy service always took place in or near London, but in Queen Elizabeth II's reign it has moved around the country, to many different cathedrals. Another change is that recipients are no longer necessarily 'poor' – although they are still pensioners, they are now chosen on an interdenominational basis from various Christian churches in recognition of the service that they have given to their churches and communities.

The records of the Royal Almonry that survive in the Royal Archives unfortunately do not reflect its longevity, but there are lists of recipients of alms, pensions, Maundy money and common bounty from 1724 to 1886 (although they are not complete), together with other administrative and financial papers, which give an insight into this important aspect of the monarch's role.

ABOVE *Queen Elizabeth II hands out Royal Maundy money at York Minster, where the Royal Maundy service was held, 5 April 2012.*

Transcript (part) of copy memorandum from Joseph Hanby

4th The Maundy Men and Women are all very Aged, from 60 to 90 Years old and infirm. The Salt Provisions are generally speaking ill adapted to persons of such great age, and altho every effort has been used to prevent the Sale of the Fish, it is well known that they dispose of it, for a Sum very much below its cost or Value. It costs about £1.10.0 for each person and it is sold for Sums varying from 5/- to 10/- each …

6th A greater benefit would accrue to the Maundy Men and Women by each receiving a Sum of Money say £1.10.0 than by receiving Provisions which they sell for a very small consideration …

If the Lord High Almoner should under these circumstances approve of a Money payment in lieu of Provisions it will be necessary to obtain His Majestys Sanction to the change. The Sum to be granted to each Person might be presented to them during Divine Service, in addition to the other Maundy Gifts. To effect this change the Board of Green Cloth would pay over to the Lord High Almoner the Sums which otherwise would be paid to the Tradesmen who supply the Provisions …

Speech, written in his own hand, made by Prince Albert to the Society for the Extinction of the Slave Trade and the Civilisation of Africa, 1 June 1840

RA VIC/MAIN/Z/271/1

From the mid-seventeenth century onwards Britain was engaged in the triangular slave trade, selling British goods to Africa in return for slaves, who were sold on to the Caribbean plantation owners, who in turn sold sugar to British traders. This was a very lucrative trade, and by the mid-eighteenth century many British ports – particularly London, Liverpool and Bristol – thrived on it, and many fortunes were made.

However, by the late eighteenth century there was a growing movement against slavery, led by the Quakers. The Society for the Abolition of the Slave Trade was formed in 1787 and, after a campaign led by William Wilberforce (1759–1833), the Abolition Act of 1807 was passed, which made it illegal in Britain to trade in slaves. It was not until the Abolition of Slavery Act of 1833, however, that it became illegal to own slaves in Britain and the Empire. Even so, the Act did not fully abolish slavery in the British Empire, as it set up an 'apprenticeship scheme', whereby ex-slaves still had to work for six years on the plantations with few rights, so anti-slavery protests continued until the scheme was abolished in 1838, thus finally putting an end to slavery in Britain and throughout the British Empire.

Nevertheless, the slave trade was still being pursued by other countries, so the Abolitionists turned their attention to ending it throughout the world. In 1839 Thomas Buxton (1786–1845), a prominent member of the Abolitionist Movement, founded the Society for the Extinction of the Slave Trade and the Civilisation of Africa. This called for the universal abolition of the slave trade through the signature of treaties with the native rulers of Africa to replace the trade in people with trade in goods, and also sought the 'civilisation' of Africa by the spread of the Christian faith. Prince Albert, the newly married

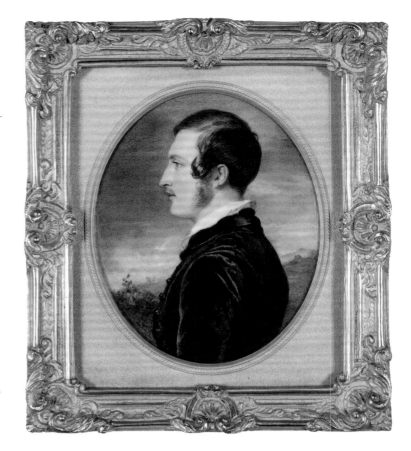

ABOVE *Sir William Ross (1794–1860), Prince Albert, 1840. Watercolour on ivory laid on card RCIN 421462*

consort of Queen Victoria, was asked to preside over a meeting of the society on 1 June 1840 at Exeter Hall in London; his speech is shown here.

This was the first speech made by the Prince after his marriage and on this occasion he wrote it initially in his native German, translated it, and then learnt it by heart, being, as the Queen recorded in her Journal, 'rather nervous, poor dear'. The Prince obviously felt strongly about the cause, denouncing the 'atrocious traffic in human beings … the blackest stain upon civilized Europe'. Nevertheless, in spite of the Prince's backing, the first time this cause had been given a formal, public seal of royal approval, it took until the 1860s for a system of treaties to be created to abolish the slave trade in at least some African countries.

June 1. 1840 – Slavery Abolition S. Meeting.

I have been induced to preside at the meeting of this Society, from a conviction of its paramount importance to the great interests of humanity and justice.

I deeply regret, that the benevolent and persevering exertions of England, to abolish that atrocious traffic in human beings (at once the desolation of Africa and the blackest stain upon civilized Europe). — But I sincerely trust that this great country will not relax in its efforts, until it has finally and for ever put an end to a state of things; so repugnant to the Spirit of Christianity and the best feelings of our nature.

Let us therefore trust; that Providence will prosper our exertions in so holy a cause, and that (under the auspices of our Queen and her government) we may at no distant period be rewarded by the accomplishment of the great and humane object, for the promotion of which, we have this day met.

Case papers for the grant in 1870 of the Queen's Bounty to Sarah Barnes, widow of Thomas Barnes, a gamekeeper in Windsor Great Park

RA PPTO/PP/PEN/QB/1/43

At a time when there was little provision for workers once they could no longer work, pensions, allowances and sometimes living accommodation provided by employers were of great value. The Royal Family has always upheld the idea that it is an employer's duty to look after employees and their families, as the many records in the Royal Archives of pensions and allowances paid to former royal servants demonstrate.

The Queen's (or King's) Bounty was a pension paid to the widows, and sometimes orphaned children, of royal servants who had no other income following the death of their husband or father. Candidates for a pension were recommended to the Board of Green Cloth, which then investigated the claimant's circumstances. If a pension was approved, a certificate to that effect was signed by the Sovereign. In the Royal Archives there are many such certificates granting pensions in Queen Victoria's reign, with the supporting papers describing the case. These latter are particularly interesting for the snapshot they give of people's lives.

In this case, it can be seen that Sarah Barnes was the widow of Thomas Barnes, a gamekeeper in Windsor Great Park, who was employed from 1842 until his death in service on 16 July 1863, at which point his salary was £72 per annum. Sarah and Thomas were married on 16 May 1843 and they had six children, two of whom were employed by the Deputy Ranger of the Park (as a nursery maid and a gardener). The other four were dependent on their mother. It seems that Thomas had been unable to leave any provision for his family, as his savings had been swallowed up by doctors' bills. At first, Sarah and her children had lived with her eldest son, but now he was to be married and they had to find another home and means of support. The papers explain that Sarah could not go out to work because of the children at home and her own weak health. Consequently it was agreed that Sarah would receive a pension of £12 10s, payable quarterly. The papers even include a note by Sarah in clear copperplate writing giving her age (50) and marriage date.

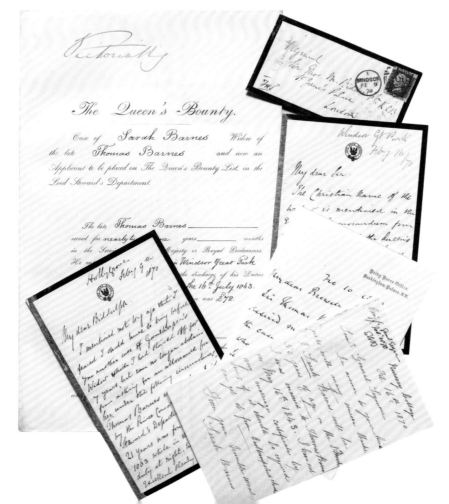

Pages from a ledger of Queen Victoria's account books showing the donations that she made to charitable institutions from 1877 to 1879

RA PPTO/PP/QV/QVACC/LED

These pages record donations made by Queen Victoria to worthy causes ranging from prominent charities, such as the Red Cross and the Bishop of London's Poor of London Fund, to disaster funds, such as the Haydock Colliery Explosion Fund. Inevitably, causes close to Queen Victoria's homes feature, like the Windsor Boys' Industrial School, but some further afield were also helped, including the Indian Famine Relief Fund and the Italian Society for the Protection of Animals (the Queen spent several holidays in Italy). Many of the charities reflect the Queen's particular interests, for instance the provision of medical services for the poor, as in the gift to the Queen's Hospital in Birmingham,

and improving the lot of women, as in the Society for Promoting the Employment of Women.

Other pages in this ledger record the donations that the Queen made to individuals (of which there were literally hundreds each year) and also the special donations given to multiple birth cases, usually triplets, whose parents were given a one-off payment of £3 to help meet extra expenses incurred.

Overall the charitable donations made by Queen Victoria took up a large part of her income. It has been estimated that in 1882 the Queen spent a total of £12,535 on 230 charities, about 20 per cent of her annual Privy Purse income (which excluded her private fortune), and that over the course of her long reign she donated about £650,000 (over £30,000,000 in today's money) to charitable causes, excluding cash handouts and pensions to retired servants. At a time when many institutions, such as schools and hospitals for the poor, as well as societies supporting the arts and sciences – such as the Royal Academy of Arts and the Royal Geographical Society – relied on donations from the wealthy, such philanthropy by members of the royal family was absolutely vital to the survival of many of these organisations.

This vellum-bound ledger is one of a series of financial records for the reign of Queen Victoria. Although not all royal accounts have survived, the Royal Archives holds many similar records for Sovereigns from George III onwards and for some other members of the royal family. If at first they appear dry and uninteresting, such material can give, sometimes in meticulous detail, a fascinating and informative account of how the Sovereign's money was spent: on salaries, building projects, the expenses of running the Royal Household and the Court, and even minor purchases such as stamps and newspapers. This makes them an immensely valuable resource.

The Castle,
Richmond,
Yorks.

15. Jan. 1910

My dear Davidson.

I am most grateful for His Majesty's
Kind interest in my career.

The principal reason for my contemplated
retirement from the Army is the development
of the Boy Scout movement.

This is gradually being organized on a
systematic basis and seems to promise such
possibilities for the Empire that, in weighing
my share in its further growth against such
services as I could render as a General Officer,

Letter from Lieutenant-General Baden-Powell to Sir Arthur Davidson, Assistant Private Secretary to King Edward VII, explaining why he felt that he should retire from the Army in order to devote his time to the Boy Scout Movement he had founded, 15 January 1910

RA PPTO/PP/EVII/MAIN/D/35196

Today, with an international membership of approximately 25 million, the Scout Movement is the world's largest voluntary organisation for boys and girls, but it had very humble beginnings. Its founder was Robert Baden-Powell (1857–1941), a man who spent his early career as a soldier and his later life as a worker for peace through the Scout Movement.

Baden-Powell was born into a large family in London and as a boy he spent much of his time developing his interest in woodcraft and outdoor pursuits, such as camping. In 1877 he went to India as a young Army officer and specialised in reconnaissance work and map-making, often training young soldiers in small units of patrols under one leader. He later went to Africa, where he employed local boys for the vital role of messengers during the successful defence of Mafeking during its 217-day siege at the start of the Boer (South African) War in 1899.

As a result, on his return to England, Baden-Powell found that he was a national hero, and that the small handbook he had written for soldiers was being used to teach observation and woodcraft to members of boys' clubs, including the Boys' Brigade. In August 1907 he held an experimental camp with 22 boys from public schools and working-class homes at Brownsea Island in Dorset to try to inspire young people to adopt a healthier lifestyle and to help others. It was a great success and he realised that his training and methods really appealed to young people. He rewrote his original handbook for use by boys, and in January 1908 the first edition of *Scouting for Boys* was published in fortnightly parts at 4d each. It was an immediate success and the new Boy Scout Movement grew quickly; when a Scout Rally was held at Crystal Palace in London in September 1909, it was attended by over 11,000 Scouts.

This success, however, meant that Baden-Powell felt that he must decide whether to continue with his Army career (he was by then a Lieutenant-General) or whether he should devote his time and energy to developing the new Scout Movement. King Edward VII was much interested in the movement and its leader, so when the General decided to resign from the Army in 1910, he wrote to the King to explain his reasons, saying that he felt that he 'might be of greater use to the country outside the Army than in it' because the new Scout Movement seemed 'to promise such possibilities for the Empire'. Two years later, in 1912, the Scout Movement was granted a Royal Charter and King George V became its patron, thus beginning the long association of the Royal Family with the Scouts.

This letter is an example of the many documents in the Royal Archives reflecting both the particular interests of the Sovereign and members of the Royal Family, and their role in civil society through their support for voluntary organisations.

FIVE —————— EMPIRE & BEYOND

'I therefore bless this strenuous time which has given South Africa such a real insight into the heart of our Commonwealth system. In the last resort it is a human situation, a living human link which holds this vast system together ...'

————— LETTER FROM THE PRIME MINISTER OF SOUTH AFRICA, FIELD MARSHAL SMUTS, TO KING GEORGE VI, 1 JUNE 1947

EMPIRE TO COMMONWEALTH

In the eighteenth and nineteenth centuries Britain's Empire grew rapidly, and by the end of Queen Victoria's reign, she was the ruler of a quarter of the world's population.

The Empire was initially made up of a series of colonies, run by British officials under the control of the British government. However, in 1867 Canada became the first colony to gain self-governing Dominion status, with its own national Parliament, although the British Sovereign remained Head of State, represented by a governor general. Later Australia, New Zealand, South Africa, the Irish Free State and Ceylon (now Sri Lanka) also became Dominions. The Imperial Conference of 1926 and the Statute of Westminster in 1931 declared that all Dominion Parliaments were equal. During the twentieth century many former British colonies gained full independence, and there was a move from the idea of a British Empire to a Commonwealth of Nations, where all nations were equal but independent and all accepted the British Sovereign as Head of State.

One major part of the British Empire was India, much of which was directly administered by the Crown until, in 1947, Britain transferred power to the national governments of India and Pakistan and both became Dominions. In 1949, however, India decided that it wished to become a Republic, with its own President as Head of State, but still remain within the Commonwealth. After much discussion, the London Declaration provided that India could still be a member because it accepted that King George VI was Head of the Commonwealth. This paved the way for many more former British colonies to become Republics but to remain as part of the Commonwealth.

An essential part of the role of the Crown has been to bind together all the disparate countries in the Empire and latterly the Commonwealth. The Sovereign is, even today, the Head of State of many of these countries and visits them not as the British Sovereign but as their own monarch. Queen Victoria recognised the importance of the royal family's visiting the Empire, and actively encouraged their visits overseas. In the twentieth century such visits became an increasingly important part of the Royal Family's duties, with King George V and Queen Mary touring the British Empire in 1901–2 (p. 118) and India in 1911, and King George VI visiting Canada in 1939 and South Africa in 1947 (p. 125). In addition, members of the Royal Family have served as governors general, such as the Duke of Connaught (Governor General of Canada 1911–16) and the Duke of Gloucester (Governor General of Australia 1945–7).

Communications have been vital for keeping the Sovereign aware of events across the Empire, whether letters from the wife of the Viceroy of India to Queen Victoria (p. 114) or the regular reports from the governors general to the Sovereign (p. 122). The Queen retains a strong interest in the business of the Commonwealth today and the Crown still is the 'living human link which holds … together' this Commonwealth of Nations.

PAGE 110 *W. Watson*, Queen Victoria with Mohammed Abdul Karim *(detail)*, c.1890. *Albumen photographic print* RCIN 2105802

OPPOSITE *Tom Roberts (1856–1931)*, The Opening of the First Parliament of the Commonwealth of Australia, 9th May 1901 *(detail), 1901–03. Oil on canvas* RCIN 407587

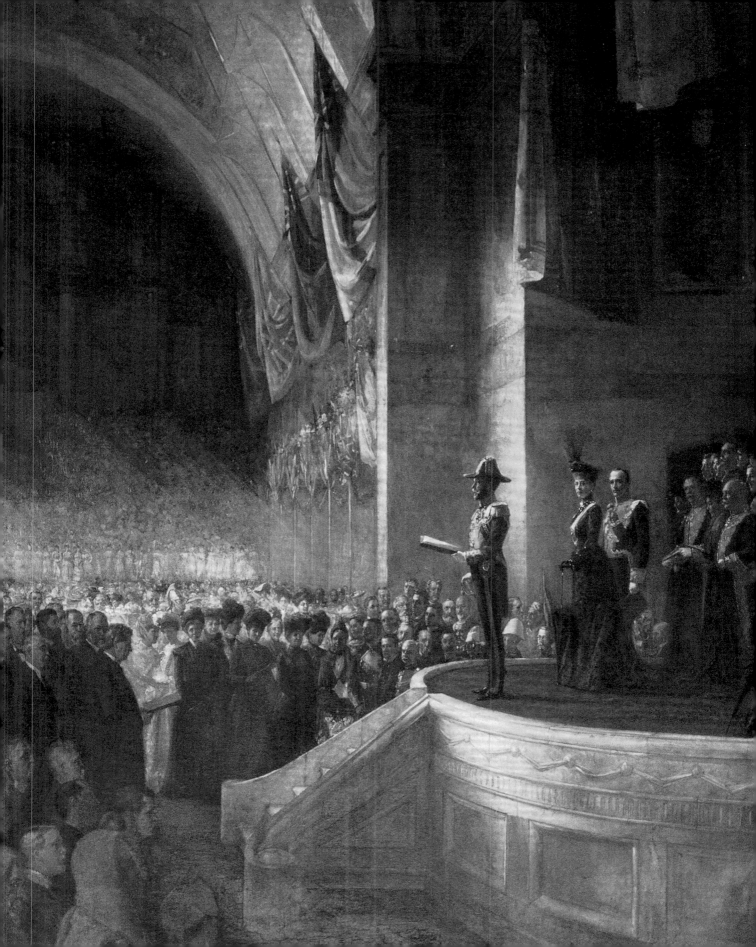

Letter from Lady Canning, wife of the Governor General of India, to Queen Victoria, describing the events of the Indian Mutiny, 19 May 1857

RA VIC/MAIN/Z/502/10

By the mid-nineteenth century the British Empire covered large parts of the globe and Queen Victoria's letters reflected this, with her correspondents writing from all corners of the world. They included the wives of high-ranking British officials, and this informal channel of communication gave her a female perspective on events in the Empire. The letters she received from Lady Canning were typical of this type of correspondence.

Charlotte Canning (1817–61) served as one of the Queen's Ladies of the Bedchamber from 1842 until 1855, when she left to accompany her husband, Lord Canning (1812–62), to India where he was to be the new Governor General. During her time in India she sent the Queen regular letters updating her on events in the country, including this one written during the Indian Mutiny.

The origins of the Mutiny are well known. At the time, about two-thirds of India was still controlled by the East India Company, and the trouble broke out amongst native soldiers in this British company's Bengal army. Antagonism to the religious and economic westernisation of India was widespread amongst the native population but the trigger was a rumour that the cartridges for the new Enfield rifles, which the native soldiers had to bite open, had been greased with cow and pig fat, thus offending both Hindus and Muslims. The cartridges were withdrawn, but in May 1857 the entire native garrison at Meerut rebelled, and Delhi fell into rebel hands. The revolt spread to nearby towns and had reached the Ganges valley by mid-June. Some Europeans were massacred and rumours of terrible atrocities were rife. Ultimately the Mutiny proved to be a relatively short-lived rebellion that was put down by loyal native and European troops, with

Delhi being retaken in September 1857 and Lucknow in March 1858. Lord Canning acted with clemency towards the rebels and tried to prevent indiscriminate revenge attacks, but, as Lady Canning predicted in her letter, there still were outbreaks of racial hatred.

When Lady Canning wrote this letter, Queen Victoria was already receiving long reports on the events in India from official sources. She was deeply moved by the plight of the Europeans in India but her lack of prejudice, her tolerance and humanity were always apparent. It was, she told Lady Canning, the native soldiers fearing that their religion was to be tampered with that had caused the trouble. 'I cannot say how sad I am to think of all this <u>blood</u> <u>shed</u> in a country … for which, as well as for its inhabitants, I felt so great an interest.'

One of the consequences of the Mutiny was that the Crown assumed direct control of the administration of India from the East India Company and Charles Canning became the first Viceroy of India. Sadly, his wife died in India from a fever in 1861 and he returned to England, only to die himself shortly after his arrival the following year.

ABOVE TOP *Orlando Norie (1832–1901),* Indian Mutiny: The Relief of Lucknow, 21st March 1858, *c.1858. Watercolour RCIN 990620*

ABOVE *After John Jabez Edwin Mayall (1813–1901),* Charlotte, Viscountess Canning, *1887 copy after an original of 1855. Carbon print RCIN 2906650*

Calcutta May 19 . 1857

Madam,

[handwritten letter text, transcribed below]

Transcript of letter from Lady Canning

This mail will take to Your Majesty some very bad accounts of the strange and terrible outbreaks in the last 9 days at Meerut, & Delhi, & Lord Canning would have wished much to write to Your Majesty himself: but the Telegraphic messages which reach him incessantly, often several in an hour on which he has to act and write his orders at once, will I fear, not leave him a moment before the departure of the mail to-day to send more than his official papers …

Your Majesty will by telegraph receive news at least a week later than this, but it is hardly possible that it can tell that Delhi is retaken, as the troops have some distance to collect and they move slowly at this, the hottest season. No doubt the Miserable insurgents at Delhi are proud enough of having possessed themselves of the ancient Capital and set up a King, but they are in truth actually in a trap & it is fearful to think of the retribution they will meet when the European soldiers encounter these cruel murderers.

We do not yet know the extent of the loss of the English residents & officers in the town and Cantonments every day news arrives of a few who have escaped. The details will surely be full of horrors and the suspense and anxiety of friends is very great …

Copy letter from Queen Victoria to the Colonial Secretary, Sir Edward Bulwer Lytton, in which the Queen suggests that the new territory to the west of the Rockies in Canada might be called British Columbia, 24 July 1858

RA VIC/MAIN/B/17/55

The territories which now constitute modern Canada came under British rule at various times and by various means. In 1849 the British colony of Vancouver Island was established, but the vast area on the mainland between the Rocky Mountains and the Pacific Ocean had not been formally colonised. The Columbia District, as it was known, was largely a fur-trading area, but when in 1857 there was a great influx of British and Americans looking for gold, the British government determined to create a new colony there at once. As Sir Edward Bulwer Lytton (1803–73), the Secretary of State for the Colonies, told Queen Victoria, this would require legislation in the British Parliament, and he invited the Queen to choose a name for the new colony for inclusion in the Bill creating it. He explained that the region had been called New Caledonia by early explorers, but said that this name was to be used by the French for the chief island of the New Hebrides in the South Pacific.

Queen Victoria took a great interest in her Empire and she was herself responsible for the naming of several of its towns and settlements. The letter giving Sir Edward her views well illustrates her personal involvement. She had clearly consulted several maps of the area and given the whole matter some thought. Her conclusion was that it would be better to avoid New Caledonia, but that although New Hanover, New Cornwall and New Georgia all appeared on some of the maps, 'the only name which is given to the whole territory in every map the Queen has consulted is "Columbia"'. However, as there was already a Columbia in South America and one in the United States, '"British Columbia" might be in the Queen's opinion the best name.'

The new colony was about half the size of the present Province, and in 1866 it joined with Vancouver Island. Following the establishment of Canada as the first Dominion (self-governing territory) within the British Empire in 1867, British Columbia was admitted as the sixth Province of the new country in 1871.

Queen Victoria's Hindustani diaries

RA VIC/MAIN/QVJ/HIND

Queen Victoria was fascinated by different cultures, and especially by the Indian sub-continent and its exotic people. On 1 January 1877 she became Empress of India, and henceforth signed herself 'VRI' (Victoria Regina Imperatrix). Sadly she herself was never able to visit the country but she delighted in having Indian people and Indian things about her.

In 1887 the first of who were to be several Indian servants in the Royal Household, Mohammed Bukhsh (d. 1899) and Abdul Karim (1863–1909), arrived at the British Court. At first they merely waited at table, but gradually Abdul Karim's role was expanded to that of the Queen's Indian Secretary and Munshi (teacher). The Queen loved to hear him talk about India and his own city of Agra, and within a few weeks of his arrival he had started to teach her some words of Hindustani. She noted in her Journal that '[I] am learning a few words of Hindustani to speak to my servants. It is a great interest to me, for both the language and the people, I have naturally never come into real contact with, before.'

Soon the few spoken words progressed to writing lessons and the Queen began to keep brief diaries in Hindustani. The Queen wrote at least 18 such diaries, but today in the Royal Archives only the last 13 volumes survive, dating from 1893 to 1899, and written in the Indian style from right-hand page to left. It is thought that Queen Victoria wrote the English text at the bottom. Abdul Karim then wrote the middle section, with the English text put into the correct word order for the Hindustani translation, and the Hindustani words below, in English script. Finally, the Queen wrote the text in Urdu characters at the top. Gradually the Queen's knowledge of the language improved, and by the time she was writing her final Hindustani diaries in 1899, she was writing longer pieces.

ABOVE *W. Watson,*
Queen Victoria with
Mohammed Abdul Karim
*(detail), c.1890. Albumen
photographic print
RCIN 2105802*

LEFT *The entry shown on
the right-hand page is from the
seventh volume of the diaries
and records that, whilst
enjoying a holiday in Florence,
the Queen attended church in
the morning (it was Good
Friday) and then visited
Lady Paget in the afternoon.
Although much shorter than
the equivalent entry in the
Queen's Journal, it clearly
relates to the same events,
which shows that, just as with
her main Journal, she kept this
one each day, even taking it
with her on holiday.*

Empire Tour by the Duke and Duchess of Cornwall and York, 1901: invitations to the Opening of the first Parliament of the Commonwealth of Australia on 9 May and to witness the presentation of an Address of Welcome on their arrival in Christchurch, New Zealand, on 21 June

RA QM/PRIV/CC113

In 1901 the Duke and Duchess of Cornwall and York (the future King George V and Queen Mary) undertook a tour of the British Empire, visiting Australia, New Zealand, South Africa and Canada, as well as a number of smaller colonies. They left Portsmouth on 16 March on board HMS *Ophir* and returned to England on 1 November.

This was the first time such a major tour had ever been undertaken by a member of the royal family. The Duke noted that, during the eight months he and his wife spent on tour, they covered over 45,000 miles (72,400 km) at sea and by train, laid 21 foundation stones, received 544 loyal addresses, presented 4,500 honours and medals, reviewed 62,000 troops and shook hands with 24,855 people at official receptions alone. This gruelling programme set the pattern for all future royal tours of the Empire and Commonwealth.

One reason for the tour was for the Duke to go to Melbourne to open the first Parliament of the newly formed Commonwealth of Australia, which had been created from the six former British colonies in the country. In his diary for 1 May the Duke recorded: 'I then read my speech (with my hat on) or rather message from the King & declared the first Parliament of the Commonwealth of Australia open in his name. I also read out a telegram which I received from Papa wishing Australia happiness & prosperity, which was greatly applauded by all present.'

From Australia the royal party went on to New Zealand, where the Duke and Duchess toured both islands. Of their arrival in Christchurch, the Duke wrote in his diary: 'There were large crowds in the streets, who gave us a very hearty welcome.' From New Zealand they sailed to South Africa and then on to Canada; everywhere they went they were greeted by huge, cheering crowds.

The effect of the tour on the Empire was enormous, strengthening the ties linking it to Britain and the Royal Family. The effect on the young couple was also great, as the Empire made a huge impression on them.

Eight days after his return from this momentous tour the Duke of York was created Prince of Wales, and nine years later he became Sovereign and thus reigned over all those places in the Empire that he had visited.

BELOW *These invitations come from one of the scrapbooks of the tour, which the Duchess kept and which are full of invitations, programmes, menus, and other souvenir mementoes of the places they visited.*

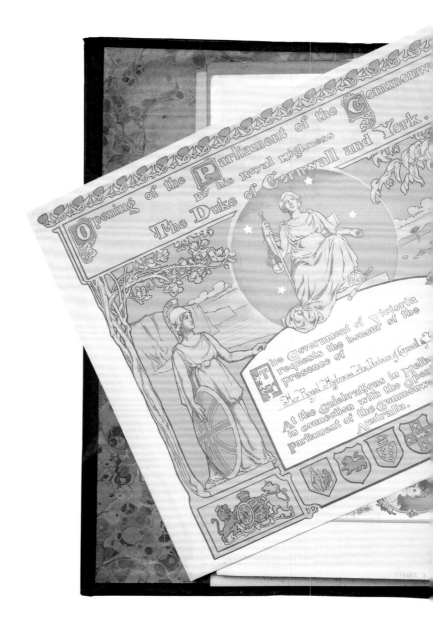

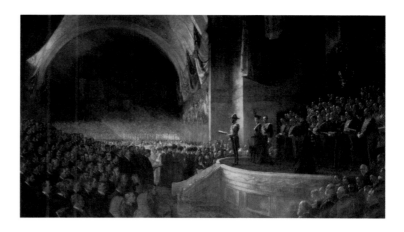

RIGHT *Tom Roberts (1856–1931),* The Opening of the First Parliament of the Commonwealth of Australia, 9th May 1901, *1901–03. Oil on canvas RCIN 407587*

Architectural drawings by Sir Edwin Lutyens depicting a rough outline and elevations for the design of New Delhi, and a letter, dated 15 August 1912, from Lutyens to the King's Private Secretary, Lord Stamfordham, discussing his views on the architectural style for the new city

RA PS/PSO/GV/C/N/389/10 and 13

In 1911 the new King-Emperor George V became the first reigning monarch to visit their Indian Empire. During the Coronation Durbar held at Delhi on 12 December the King announced that the capital of British India would be transferred from Calcutta (now Kolkata) to the ancient city of Delhi. Delhi had been the capital city of the Mughal Empire but lost its capital status following the Indian Mutiny in 1857–8. Now a new city was to be built – an imperial, planned city – close to, but distinct from, Old Delhi. The foundation stones of the new city were laid on 15 December 1912 and work was completed within twenty years, despite the First World War and economic and political crises in both India and Britain.

This remarkable building project was overseen by Sir Edwin Lutyens (1869–1944), who designed the principal buildings, including the Viceroy's House, which is now the residence of the President of India and is considered one of the great buildings of the world.

Once a site had been chosen to the south of the old city of Delhi, the area was laid out with a long east–west avenue culminating in the Viceroy's House. In contrast to Old Delhi, the new city was to be open, spacious and full of trees, with a low density of buildings and, above all, 'Imperial'.

The new city was officially opened in January 1931 but was to serve as the headquarters of British India for only 16 years, until Indian Independence in 1947. The transfer of power took place in the great Durbar Hall in the Viceroy's House at midnight on 15 August, and New Delhi became the capital of the Dominion (later Republic) of India. However, even today many of the buildings designed by Lutyens are still in use as government buildings.

ABOVE *In the sketches shown here one can see the influence of various architectural styles on Lutyen's initial designs, particularly that for the Viceroy's House, which is almost Roman in style. In the event Lutyens did create a hybrid style for the Viceroy's house – it is a blend of western classical style with Mughal, Hindu and Buddhist elements.*

LEFT *Main steps to the Viceroy's House, New Delhi, 1928*
RCIN 2702798

Personal. Aug. 15.12

Dear Lord Stamfordham –

... Lord Hardinge has asked me to design Government House & its precincts ... these sketches I should very much like to show you.

There seems to be a good deal of talk about style – & everyone seems anxious to give it a name! & one is tempted to tell those who advocate Mogul that it will be Rennaissance & those that favor the Rennaissance that it will be Mogul!!

It certainly cannot be Whitehall-Palladian! Nor can it be Mogul – a style devoted to fortifications tombs & the Love of women – & before which you cannot place, with effect, a portrait statue – & the same criticism applies to the earlier Hindu styles.

It cannot be Western – for as such it would be quite unsuitable to the Eastern Climate – nor Eastern as it would not be conducive to our ideas of modern comfort or efficiency – nor ought we to discard our 2000 year old traditions nor merely to insert Hindu or Mogul tit-bits to give them an eastern flavor – like a cook does truffles!!

It ought to be a new style – the outcome of the demands of needs & climate – & the style so created has yet to be named. The traditional & happiest name would, of course, be the King's.

Indian work is beautiful – but the beauty of it lies in 2 dimensions – & buildings must be of 3 dimensions – & herein may lie the essence of the new style – & consciousness of the sun pervading it all.

I dare not start another sheet so remain with a hope that I may see you.

As Yours V. Sincerely,
Edwin L. Lutyens

LEFT *Sir William Rothenstein (1872–1945)*, Sir Edwin Lutyens, c.*1923. Red chalk. This miniature portrait was produced for the Library of Queen Mary's Dolls' House, which Lutyens designed (p. 68). RCIN 927333*

Letter from the Governor General of Canada, Lord Tweedsmuir, to King George VI, reporting on events in the Dominion, 8 February 1938

RA PS/PSO/GVI/C/048/061

ABOVE *Wide World Photos*, King George VI and Queen Elizabeth with Lord and Lady Tweedsmuir, *20 May 1939* *RCIN 2941059*

Today the governor general is the Sovereign's representative in each of the member states of the Commonwealth (apart from Britain) that acknowledges the British Sovereign as Head of State, but formerly it was only the self-governing Dominions (Australia, Canada, New Zealand, Ceylon – now Sri Lanka, South Africa, India, Pakistan and the Irish Free State) that had governors general. Since the Imperial Conference of 1926 and the Statute of Westminster of 1931, which gave sanction to the legislative independence of the Parliaments of the former Dominions, the governor general has performed the same constitutional role in these countries as the monarch in Britain, and has the same relationship with the ministers of the country. However, unlike that of the Sovereign, the governor general's is not a life appointment. Prior to the 1930 Imperial Conference the British government proposed the candidates, so most governors general were British; since then, governors general have been appointed on the recommendation of the ministers of the country concerned.

As governors general represent the Sovereign and not the British government, one of their main duties is to send regular full and frank reports to the Sovereign on events and personalities in their country so that the monarch can keep abreast of developments there. Consequently there are in the Royal Archives large numbers of letters from governors general, particularly from the reigns of King George V and King George VI, which often give a unique insight into the politics and personalities of the Commonwealth.

Lord Tweedsmuir (1875–1940) – perhaps better known as John Buchan, author of *The Thirty-Nine Steps* – had a distinguished career in politics and the diplomatic service before being appointed Governor General of Canada in 1935, a post that he held until his death in 1940. During his tenure of office he travelled to all parts of the country, becoming the first governor general to visit the arctic regions of Canada, steered Canada through the Abdication crisis in 1936, oversaw the extremely successful tour of Canada made by King George VI and Queen Elizabeth in 1939, and witnessed the outbreak of war in Europe.

In this letter to King George VI in 1938, Lord Tweedsmuir describes his recent duties – such as the Opening of Parliament ceremony in Ottawa, where he read the King's speech, which was 'not too long, and non-committal as a King's speech should be.' It was followed by a Drawing Room, at which 'only 900' people were presented. He comments on the political situation in the country, saying that the opposition is 'disorganised and out of heart', and finally talks about Canada's economic recovery from the Depression, which had been much better than that of the USA. The King would have read this letter, but the governor general usually received a reply from the King's Private Secretary, conveying any comments from the King.

...ry both to Canada and to B...

The Drawing-room wh...

smaller

...ch over th...

...there havi...

...ery pretty s...

...ians present,

Canada is figh...

to be showing

element, and c...

sentative. ...

University

Dufferin.

which,

Sco...

recen...

as the...

in spite...

she suffered...

papers make t...

wh...

eighty-s...

one hundred th...

numbers, but the

States by means...

to be made...

the for...

export

to avoid

for

8th February, 1938.

Sir,

I present my humble duty to Your Majesty.

The wonderful winter weather which we have been enjoying, came to an end a week ago, and Ottawa has since then been enduring the discomforts of a thaw. It rained without intermission for several days, and much of the snow-cap has gone. The frost has now set in, the roads are sheets of ice, and walking on them is as dangerous as mountaineering. We can only pray for another snowfall. Going to Toronto on Saturday I found all the country along the shores of Lake Ontario completely clear of snow, so that it looked more like April than February.

The functions which began the parliamentary year went off very well. Canada has a real instinct for ceremony, and the opening of Parliament was admirably managed. They keep exactly to the traditional ritual of the British Parliament. When the faithful Commons are summoned to the Senate Chamber they take their time about it and arrive chattering - which has been the custom in England since the seventeenth century. The King's Speech was not too long, and non-committal as a King's Speech should be. The most interesting part of it was the proposal that Parliament should expressly sanction any arrangement to export power to the United

...ould be easy to find anywhere else on the...

...igorous and well-trained boys.

...er I went to see Sir James McBrien in

...king much better than I had expected.

...uty again in the full sense,

...ny years before him.

...some good

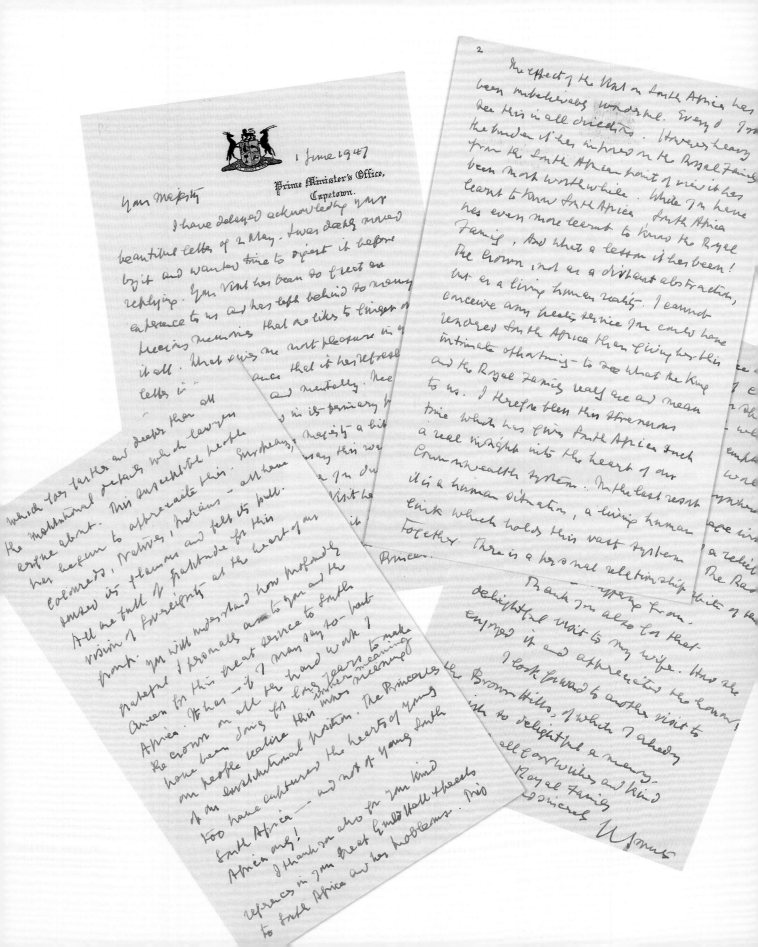

1 June 1947

Prime Minister's Office,
Capetown.

Your Majesty

I have delayed acknowledging your beautiful letter of 2 May. I was deeply moved by it and wanted time to digest it before replying. Your visit has been so great an experience to us and has left behind so many precious memories that one likes to linger over it all. What gives me most pleasure in your letter is ...

... and deeper than all the institutional details which lawyers which lay lighter and deeper than all ... about. This unspeakable people have begun to appreciate this. Suddenly her beauty ... aroused its flavour and felt its full. Colours, Natives, Indians – all have vision of sovereignty at the heart of our All are full of gratitude for this front, you will understand how profoundly grateful I personally am to you and the Queen for this great service to South Africa. It has – if I may say so – but the Crown on all the hard work I have been doing for long years to make our people realise the inner meaning of our constitutional position. The Princess too have captured the hearts of young South Africa — and not of young South Africa only! I thank you also for your kind references in your great Guild Hall speech to South Africa and her problems. This ...

2

The effect of the visit on South Africa has been unbelievably wonderful. Every day I see this in all directions. However heavy the burden it has imposed on the Royal Family, from the South African point of view it has been most worthwhile. While I'm here learnt to know South Africa. South Africa has even more learnt to know the Royal Family, And what a lesson it has been! The Crown, not as a distant abstraction, but as a living human reality. I cannot conceive any greater service you could have rendered South Africa than living here this intimate other-being – to see what the King and the Royal Family really are and mean to us. I therefore bless this strenuous time which has given South Africa such a real insight into the heart of our Commonwealth system. In the last resort it is a human situation, a living human link which holds this vast system together. There is a personal relationship African.

Thank you also for that delightful visit to my wife. How she enjoyed it and appreciates the honour!

I look forward to another visit to the Brown hills, of which I already ... to delight a many –

all best wishes and kind Royal Family
sincerely
J C Smuts

Letter, dated 1 June 1947, from the Prime Minister of South Africa, Field Marshal Smuts, to King George VI following the royal family's very successful tour of the Dominion

RA PS/PSO/GVI/PS/VISCOM/08100/69/65A

On 17 February 1947 King George VI and Queen Elizabeth, together with their daughters, Princess Elizabeth and Princess Margaret, arrived in Cape Town to undertake a tour of South Africa. It was the first time a reigning Sovereign had visited the country and over the next two months the royal family toured the length and breadth of the Dominion, travelling on the specially constructed Royal Train. Although it was a very exhausting trip, it had a great impact on strengthening the ties between South Africa and the royal family, especially as it was during this visit that Princess Elizabeth celebrated her 21st birthday and made her famous broadcast dedicating herself to the service of her peoples.

Following the tour, the King and Field Marshal Smuts (1870–1950), the South African Prime Minister, exchanged letters; these sum up very well the importance of the relationship to both parties. The King thanked the Prime Minister for the 'never-to-be-forgotten visit' and commented on the 'wonderfully friendly welcome given to us by all', which had made a 'deep impression'. He believed that the visit had altered the way that some South Africans thought of the monarchy, and the royal family's personal contacts with them had given them a new viewpoint: 'I for one will have gained immeasurably by my contacts with them.'

This letter from Field Marshal Smuts is one of many in the Royal Archives from the prime ministers of the Dominions and colonies, particularly in the twentieth century. Although the official route of communications between imperial politicians and the monarch was via the British government, in some cases correspondence did take place directly between the prime minister and the King. Many Dominion prime ministers built up a relationship with the Sovereign, which is reflected in the papers. Obviously tours like this one also helped to build a

personal relationship between the Sovereign and his overseas prime ministers – another very important part of ensuring that the links between Britain and other nations in the Commonwealth persisted.

ABOVE King George VI, Queen Elizabeth and Princesses Elizabeth and Margaret with Field Marshal Smuts, Drakensberg National Park, *March 1947* *RCIN 2704839*

Transcript (part) of letter from Field Marshal Smuts

… The effect of the Visit on South Africa has been unbelievably wonderful. Every day I still see this in all directions. However heavy the burden it has imposed on the Royal Family, from the South African point of view it has been most worthwhile. While you have learnt to know South Africa, South Africa has even more learnt to know the Royal Family. And what a lesson it has been! The Crown, not as a distant abstraction, but as a living human reality. I cannot conceive any greater service you could have rendered South Africa than giving her this intimate opportunity to see what the King and the Royal Family really are and mean to us. I therefore bless this strenuous time which has given South Africa such a real insight into the heart of our Commonwealth system. In the last resort it is a human situation, a living human link which holds this vast system together. There is a personal relationship which goes farther and deeper than all the constitutional details which lawyers argue about.

King George VI's speech, with alterations in his own hand, given at a dinner party for the Commonwealth prime ministers on 13 October 1948, when they met in London

RA PS/PSO/GVI/PS/MAIN/09196

The events of the Second World War led to a subtle change in relations between the nations of the Empire: there was a much greater feeling of the countries being 'equal but independent Nations' than previously. During the war, meetings had been held in London of the prime ministers of the Dominions (Canada, Australia, New Zealand, South Africa – and Southern Rhodesia, which had traditionally held a sort of hybrid status between colony and Dominion) and the British prime minister to discuss the best way to co-ordinate the war effort. Then in 1948 a conference was held, again in London, this time attended by the prime ministers, or their representatives, not only of the old Dominions but also of the new ones of India, Pakistan and Ceylon (Sri Lanka). This conference was arranged to allow the 'Brotherhood of Nations' to meet to discuss common problems and issues in the post-war world, and also to introduce the prime ministers of the new nations.

example
brotherly
the
il
in
work

7.

in a state of
es of the

6.
ers
aced
lief;

thought,
ense

5.
o
ur
s

is outward
thering

4.

a very great
mes gone

3.
ou,
of

ially welcome such
es me
ed.

2.
the absence
ie
in-
unrivalled

of

very

e

rs
e

The prime ministers arrived in London in October and were received by King George VI individually. On 13 October a large dinner was held for them at Buckingham Palace, at which the King made this speech. In it he talked about the 'high value' he set on 'personal contacts between those responsible for guiding our affairs in the different parts of the Commonwealth'. He also said that he would like these meetings to be held from time to time in different Commonwealth capitals. The Commonwealth Heads of Government Meeting is now held every two years, hosted by a different country of the Commonwealth. Addressing the prime ministers, the King pointed out that between them they were charged with the good government of more than five hundred million people, but that indirectly their responsibilities extended to many millions more. The world was looking for peace and it expected the Commonwealth of Nations to play a leading part in that process:

Our Commonwealth has always stood for certain principles, fundamental to the good of Humanity; it has never countenanced injustice, tyranny, or oppression. The self-governing members of the Commonwealth have always embraced peoples of different upbringing, social background and religious belief; they have all had this in common that they were peace-loving democracies in which the ideals of political liberty and personal freedom were jealously and constantly preserved.

King George VI, like many other public speakers, often had his speeches typed out on cards such as these, which he would then read and alter if necessary. There are many such examples in the Royal Archives, and they show that by this date the King, who, as is well known, had suffered from a speech impediment earlier in his life, was able to deliver long speeches with confidence.

THE WIDER WORLD

Britain's involvement with other nations was not based solely on a colonial relationship – often trade was the impetus for contact to be made with far-flung empires and different cultures. For instance, it was hoped that the Macartney Mission to China in 1793 would lead to more favourable trading terms for British merchants, but sadly it was a failure on that count (p. 132). However, by the end of the reign of George III in 1820 Britain had ambassadors and consuls throughout Europe and in places as far away as Persia, Brazil, America and North Africa.

Technological developments in communications also opened up the world, especially in the late nineteenth century, when inventions such as the telegraph system and then the telephone enabled news to be spread around the world much more easily. Developments in transport, such as the building of faster ships, of trains and ultimately aeroplanes, all served to make the world a much smaller place.

One country with which Britain could be said to have had a 'special' relationship was the United States of America. Parts of the country were for many years a British colony, until the War of Independence of 1775–83 resulted in the defeat of the British forces and the establishment of the American nation (p. 130). After this Britain and the United States continued to have a very close relationship, but now based on trade and common heritage.

When the American Civil War broke out in 1861 Britain remained neutral, although without Prince Albert's intervention it might have been drawn into the war (p. 135). Even today, the kindred feeling of which President Lincoln wrote in his letter to Queen Victoria on the death of Prince Albert in 1861 (p. 136) persists between Britain and the United States.

In spite of political changes and increasing democracy throughout the world, personal relationships between heads of state remained extremely important, sometimes having a profound influence on events in the world (p. 138). Today family relationships between monarchs are probably less important than they were, but even so the Sovereign still has a very active role to play in international affairs, as shown by the importance attached to the many State Visits undertaken or hosted by Her Majesty The Queen.

OPPOSITE *Detail of letter from the Chinese Emperor, Qianlong, to George III, 1793 (p. 132).*

方物用將忱悃朕披閱表文詞意肫懇具

見爾國王恭順之誠深為嘉許

爾國使臣到京照例筵宴賞賚疊加

恩視用示懷柔其瞻覲錫賚

爾國之人在京居住堂內俱用天朝服色安置堂內

天朝自有體制從無聽其往來常通信息

西洋人在京居住堂內俱用天朝服色不得改易服飾

該國欲常川貿易一節原無不可但止一日原無不加以恩視

其人即到京亦不能效法中國不過徒費供給而已

爾國若留人在京言語不通服飾殊制無地可以安置

天朝不肯強人以所難設天朝欲差人常駐爾國亦豈爾國所能遵行

西洋諸國甚多非止爾一國若俱似爾國王懇請派人留京豈能一一聽許

是此事斷斷難行豈能因爾國王一人之請以致更張天朝法度

若云爾國王為照料買賣起見則爾國人在澳門貿易非止一日

原無不加以恩視即有拖欠貨價之事中國地方官亦能代為料理清結

該國若能仰體天朝加恩遠人撫育四夷之道則

勅諭到時永矢恭順以保乂爾有邦共享太平之福

並錫賚國王文綺珍物

Reflections, in the hand of George III, on the loss of the American colonies, 1783

RA GEO/ADD32/2010

George III is remembered by many as the King who lost the American colonies, and his reputation on both sides of the Atlantic has suffered accordingly. The causes of the American War of Independence, however, are complex. They include the British government's decision in 1763 that the territories in North America recently acquired from the French should be settled and organised for defence and economic benefit and, since this would be expensive, America should be taxed heavily. The Americans, not surprisingly, felt that there should

'no taxation without representation'. Anti-British feeling grew and war finally broke out between the American settlers and the government in 1775.

On 4 July 1776 the Continental Congress issued the Declaration of Independence. The conflict was protracted, but in 1781, with the assistance of France, Spain and the Netherlands, the Americans won the land war, compelling the British Army to surrender at Yorktown. In 1783 the Treaty of Paris ended the war and recognised the sovereignty of the United States.

At the time many people felt that this defeat was a disaster for Britain. The Prime Minister, Lord North, was forced to resign and there was much criticism of both him and the King for the hard line that North

America is lost! Must we fall beneath the blow? Or have we resources that may repair the mischiefs? What are those resources? Should they be sought in distant Regions held by precarious Tenure, or shall we seek them at home in the exertions of a new policy?

The situation of the Kingdom is novel, the policy that is to govern it must be novel likewise, or neither adapted to the real evils of the present moment or the dreaded ones of the future.

For a Century past the Colonial Scheme has been the system that has guided the Administration of the British Government. It was thoroughly known that from every Country there always exists an active emigration of unsettled, discontented, or unfortunate People, who failing in their endeavours to live at home, hope to succeed better where there is more employment suitable to their poverty. The establishment of Colonies in America might probably increase the number of this class, but did not create it; in times anterior to that great speculation, Poland contained near 10,000 Scotch Pedlars, within the last thirty years not above 100. occasioned by America offering a more advantageous asylum for them.

A people spread over an immense tract of fertile land, industrious because free, and rich because industrious, presently became a market for the Manufactures and Commerce of the Mother Country. An importance was soon generated which from its origin to the late conflict was mischievous to Britain, because it created an expense of blood and

had taken against the colonists. However, the King himself took a much more sanguine approach to the defeat, as can be seen in this essay.

This is one of a series of essays written either by the King himself or by his mentor, Lord Bute (1713–92). They formed an important part of George's education, first as Prince, and later as young King, and cover a wide range of subjects reflecting his many and varied interests. All show an interested and intelligent mind.

Transcript (part) of essay by George III

America is lost! Must we fall beneath the blow? Or have we resources that may repair the mischief? What are those resources? Should they be sought in distant Regions held by precarious Tenure, or shall we seek them at home in the exertions of a new policy?
… It is to be hoped that by degrees it will be admitted that the Northern Colonies, that is those north of Tobacco were in reality our very successful rivals in two Articles the carrying freight trade, and the Newfoundland fishery. While the Sugar Colonies added above three millions a year to the wealth of Britain, the Rice Colonies near a million, and the Tobacco ones almost as much; those more to the north, so far from adding anything to our wealth as Colonies, were trading, fishing, farming Countries, that rivalled us in many branches of our industry, and had actually deprived us of no inconsiderable share of the wealth we reaped by means of the others. This compartative view of our former territories in America is not stated with any idea of lessening the consequence of a future friendship and connection with them; on the contrary it is to be hoped we shall reap more advantages from their trade as friends than ever we could derive from them as Colonies; for there is reason to suppose we actually gained more by them while in actual rebellion, and the common open connection cut off, than when they were in obedience to the Crown; the Newfoundland fishery taken into the Account, there is little doubt of it.

The East and West Indies are conceived to be the great commercial supports of the Empire; as to the Newfoundland fishery time must tell us what share we shall reserve of it. But there is one observation which is applicable to all three; they depend on very distant territorial possessions, which we have little or no hopes of retaining from their internal strength, we can keep them only by means of a superior Navy … It evidently appears from this slight review of our most important dependencies, that on them we are not to exert that new policy which alone can be the preservation of the British power and consequence. The more important they are already, the less are they fit instruments in that work. No man can be hardy enough to deny that they are insecure, to add therefore to their value by exertions of policy which shall have the effect of directing any stream of capital, industry, or population into those channels, would be to add to a disproportion already an evil. The more we are convinced of the vast importance of those territories, the more we must feel the insecurity of our power, our view therefore ought not to be to increase but preserve them.

Letter from the Chinese Emperor, Qianlong, to George III regarding Lord Macartney's diplomatic mission to China, 1793

RA GEO/ADD31/21A

By the end of the eighteenth century European trade with the vast Chinese Empire was very lucrative but it was carefully controlled by the Chinese, who permitted it to take place only in Canton province for five months of the year. Eager to gain trading concessions, several European countries sent embassies to China, but all failed. In 1792 a mission was sent for the first time from George III to the Emperor of China, Qianlong (1711–99). Led by Lord Macartney (1737–1806), its principal aims were to establish direct diplomatic relations between Britain and China by having a British ambassador at the Chinese court, and to negotiate trading concessions and open up new markets. The mission travelled to China in ships laden with the very best of British goods to present to the Emperor and with letters from the King explaining his requests.

Sadly from the trade point of view, the mission was a complete failure, although Macartney received two edicts, or letters, from the Emperor to the King, together with many gifts. The first letter contained the Emperor's refusal to allow a British ambassador at his Court under the usual diplomatic terms, because it would not be possible for a British envoy to be treated differently from other Europeans in China, who had no freedom of movement and were never permitted to leave the country. The second contained the Emperor's detailed refusal to agree to any of the requested trade concessions.

The Emperor's edicts, together with two lists of the presents that he sent, are some of the most extraordinary documents in the Royal Archives. They are written in three languages, having been drafted in Mandarin Chinese, then translated into Manchurian Chinese and finally into Latin by Jesuit missionaries in Peking. Hitherto the Chinese had zealously guarded their written language, with severe penalties for any Chinese found translating the written language for westerners. When Macartney returned to England with these documents, for almost the first time people in the West could begin to translate and study the written Chinese language.

One interesting point about the Emperor's first edict is that it was drafted on 3 August 1793, three days before Macartney's arrival in China, so it seems that the Emperor had decided to dismiss the mission even before it appeared. Another is that when the missionaries translated it into Latin they toned down the language, to avoid giving too much offence to the Europeans.

Although a failure in trade terms, in addition to its value for the translation of written Chinese, Macartney's mission had other important, if unforeseen, consequences. The informed notes that Macartney and his party had been able to make on Chinese society, trade, agriculture and medicine during their visit became the basis of European knowledge of China for many years.

Translation (part) of Emperor Qianlong's first edit

You, O King, live beyond the confines of many seas, nevertheless, impelled by your humble desire to partake of the benefits of our civilisation, you have dispatched a mission respectfully bearing your memorial. Your Envoy has crossed the seas and paid his respects at my Court on the anniversary of my birthday. To show your devotion, you have also sent offerings of your country's produce …

Swaying the wide world, I have but one aim in view, namely, to maintain a perfect governance and to fulfil the duties of the State: strange and costly objects do not interest me. If I have commanded that the tribute offerings sent by you, O King, are to be accepted, this was solely in consideration for the spirit which prompted you to dispatch them from afar. Our dynasty's majestic virtue has penetrated unto every country under Heaven, and Kings of all nations have offered their costly tribute by land and sea. I set no value on objects strange or ingenious, and have no use for your country's manufactures.

This then is my answer to your request to appoint a representative at my Court, a request contrary to our dynastic usage, which would only result in inconvenience to yourself. I have expounded my wishes in detail and have commanded your tribute Envoys to leave in peace on their homeward journey. It behoves you, O King, to respect my sentiments and to display even greater devotion and loyalty in future, so that, by perpetual submission to our Throne, you may secure peace and prosperity for your country hereafter. Besides making gifts (of which I enclose an inventory) to each member of your Mission, I confer upon you, O King, valuable presents in excess of the number usually bestowed on such occasions, including silks and curios – a list of which is likewise enclosed. Do you reverently receive them and take note of my tender goodwill towards you! A special mandate!

Draft from the Queen to Lord Russell &c

This Draft was the last the
beloved Prince ever wrote; he was
very unwell at the time, & when
he brought it in to the Queen, he
said—"I could hardly hold my pen." &c.

W. Castle
Dec: 1. 1861.

The Queen returns these
important Drafts which
upon the whole she approves
but she cannot help feeling
that the main Draft, that
for communication to the
American Govt, is somewhat
meager. She should have
liked to have seen the ex-
pression of a hope, that
the American Offrs: did not
act under instructions
or, if he did say, that he
misapprehended
of them, that the U. S. Govt
must be fully aware that
the British Govt could not
allow its flag to be in-
sulted & the security of her

Draft memorandum in the Prince Consort's hand about the '*Trent* incident' in 1861, which may have prevented the United Kingdom from becoming involved in the American Civil War

RA VIC/MAIN/Q/9/23

This draft memorandum is very significant in a number of ways. In 1861 civil war broke out in America between the United Federal States of the North and the Confederate States of the South. At first, countries in Europe remained neutral. In an effort to persuade them to support the Confederate States, the Confederate President, Jefferson Davis (1808–99), sent two envoys to Europe on board the British mail steamer, the *Trent*. At sea, the *Trent* was intercepted by a warship of the northern Federal government and the two envoys were taken off – a clear violation of international law. On 30 November the British Foreign Minister, Lord John Russell, sent Queen Victoria a draft memorandum that he proposed to send to the Federal President, Abraham Lincoln (1809–65), complaining strongly about the actions of the Federal government. Prince Albert read the draft at 7 am on 1 December and, fearing that its tone and demands might lead Britain into the war, he suggested that the rebuke be toned down by saying that Britain did not believe that the Federal government had intended an insult and suggesting that they be given an opportunity to make amends with honour, by freeing the envoys and making a suitable apology. The Queen copied out the Prince's amended version of the draft and sent it off, the note to the Federal government was modified, and the risk of war between Britain and America averted.

The human significance of this memorandum is obvious from Queen Victoria's words on the mount. In November 1861 the Prince Consort was suffering from a bad cold and neuralgia. By 1 December, the date of this memorandum, he was failing rapidly. His health continued to deteriorate and on 7 December he was diagnosed with typhoid fever. At times he seemed to rally, but he died at 10.45 pm on 14 December, surrounded by his wife, family and servants.

The Prince Consort had acted as Queen Victoria's confidant and adviser. Their desks were set up next to each other and he often helped her conduct government business. He wrote summaries of her meetings in his own hand, attended meetings and met ministers for her (especially when she was pregnant), penned memoranda and even began to draft many of the Queen's official letters, as shown here. He was given full access to Cabinet and State papers and from 1841 onwards attended audiences. The Prince carefully filed all the Queen's political papers; those files are still in the Royal Archives today.

Transcript of draft memorandum by Prince Albert

Draft from the Queen to Lord Russell
This Draft was the last the beloved Prince ever wrote; he was very unwell at the time & when he brought it in to the Queen, he said "I could hardly hold my pen.["] VR

W. Castle
Dec: 1.1861.
The Queen returns these important Drafts which upon the whole she approves but she cannot help feeling that the main Draft, that for communication to the American Govt., is somewhat meager. She should have liked to have seen the expression of a hope, that the American Cptn: [Captain] did not act under instructions or, if he did, that he misapprehended them, that the U.S. Govt. must be fully aware that the British Govt. could not allow its flag to be insulted & the security of her Mail communications to be placed in jeopardy & H.M.'s Govt. are unwilling to believe, that the U.S. Gt. intended wantonly to put an insult upon this country & to add to their many distressing complications by forcing a question of dispute upon us, & that we are therefore glad to believe that upon a full consideration of the circumstances & of the undoubted breach of international Law committed, they would spontaneously offer such redress as alone could satisfy this country viz: the restoration of the unfortunate passengers & a suitable apology.

Letter from President Lincoln to Queen Victoria sending condolences on the death, in December 1861, of her husband, Prince Albert, the Prince Consort, 1 February 1862

RA VIC/MAIN/M/65/63

Following the death of the Prince Consort from typhoid fever on 14 December 1861, Queen Victoria received hundreds of messages and letters of condolence. It is interesting to note that, in the days before the establishment of a regular telegraph service across the Atlantic, the news of such events had to be carried by ship, and so there was a delay before the President of the United States, Abraham Lincoln, learnt of Prince Albert's death. There was then, of course, a similar delay before President Lincoln's letter of condolence reached the Queen.

The President talked about the close relationship between Britain and America: 'The People of the United States are kindred of the People of Great Britain … The American People, therefore, deplore [the Prince's] death and sympathize in Your Majesty's irreparable bereavement with an unaffected sorrow.' He also referred to the recent visit made to the United States by the Prince of Wales (later King Edward VII), the first by a British heir to the throne, which further served to cement the friendly relations between the two countries.

Formal letters from heads of state on behalf of their nation are often sent as marks of respect at times of important events within a country, such as births, marriages or deaths of members of the royal family, or at a change in the head of state. They are also sent in the form of Letters of Credence, which a new ambassador to a country presents to the head of state, and sometimes they are sent at the end of conflicts or at times of natural catastrophe. The Royal Archives holds many such letters from heads of state from all parts of the world, dating from the eighteenth century to the present reign as the Queen still sends and receives messages on behalf of the nation. The letters, often written in French, formerly the common language of diplomacy, are couched in formal terms. They are written on many different materials, from hand-made paper to parchment or silk, and may also come in varied formats, such as scrolls or sheets. Some are highly decorated and many bear seals for authentication.

Interestingly, when President Lincoln was assassinated in 1865, Queen Victoria wrote a far less formal letter to his widow:

No one can better appreciate than I can, who am myself utterly broken-hearted by the loss of my own beloved Husband, who was the light of my life – my stay – my all – what your sufferings must be; and I earnestly pray that you may be supported by Him to whom alone the sorely stricken can look for Comfort, in this hour of heavy affliction!

Transcript (part) of letter from Abraham Lincoln

Great and Good Friend:

By a letter from your son, His Royal Highness the Prince of Wales, which has just been received, I am informed of the overwhelming affliction which has fallen upon Your Majesty, by the untimely death of His Royal Highness the late Prince Consort, Prince Albert of Saxe Coburg …

I would fain have Your Majesty apprehend, on this occasion, that real sympathy can exist, as real truthfulness can be practised, in the intercourse of nations. The People of the United States are kindred of the People of Great Britain. With all our distinct national interests, objects, and aspirations, we are conscious that our moral strength is largely derived from that relationship, and we think we do not deceive ourselves when we suppose that, by constantly cherishing cordial friendship and sympathy with the other branches of the family to which we belong, we impart to them not less strength than we derive from the same connection …

Your Good Friend,
Abraham Lincoln

Washington, 1st Feby, 1862 …

ABOVE *[Photographer unknown], frontispiece photograph from* Abraham Lincoln: The Prairie Years, VI, *by Carl Sandburg, 1940* RCIN 1024207

Abraham Lincoln,
President of the United States of America,

To Her Majesty Victoria,
 Queen of the United Kingdom
 of Great Britain and Ireland,
 &c., &c., &c. Sendeth Greeting!
Great and Good Friend:

By a letter from your son, His Royal Highness the Prince of Wales, which has just been received I am informed of the overwhelming affliction which has fallen upon Your Majesty, by the untimely death of His Royal Highness the late Prince Consort, Prince Albert of Saxe Coburg.

The offer of condolence in such cases is a customary ceremony, which has its good uses, though it is conventional and may sometimes be even insincere. But I would fain have Your Majesty apprehend, on this occasion, that real sympathy can exist as real truthfulness can be practiced, in the intercourse of Nations. The People of the United States are kindred of the People

American People, therefore, deplore his death and sympathize in Your Majesty's irreparable bereavement with an unaffected sorrow. This condolence may not be altogether ineffectual, since we are sure it emanates from only virtuous motives and natural affection. I do not dwell upon it, however, because I know that the Divine hand that has wounded, is the only one that can heal. And so, commending Your Majesty and the Prince Royal, the Heir Apparent, and all your afflicted family to the tender mercies of God, I remain
 Your Good Friend,

 Abraham Lincoln

Washington, 1st Feby, 1862.

By the President:

 William H. Seward. Secretary of State.

ABOVE *Although not in his hand, this letter is signed by President Lincoln. It is bound into a volume of letters of sympathy sent to Queen Victoria by other heads of state from around the world, including those from as far away as Brazil and Turkey, Russia and Spain.*

Letter from Tsar Nicholas II to his cousin, King George V, asking him to continue to strive for good relations between Britain and Russia, just as his father, King Edward VII, had done, 25 April / 8 May 1910

RA GV/PRIV/AA43/129

The very formal head-of-state letter from the President of the United States (p. 137) contrasts with this much more heartfelt and informal letter from the Russian Emperor, Tsar Nicholas II (1868–1918), to the British King, George V, following the death of King Edward VII. Using Russian and British dates (the Russian calendar was 13 days behind that used in Britain) and their affectionate names of 'Georgie' and 'Nicky', the Emperor sympathised with the King on the death of his father, reminding him that he also knew the pain of losing his father and acceding to the throne.

Since the Crimean War in the mid-nineteenth century, relations between Britain and Russia had been poor, but King Edward VII, often known as 'the Uncle of Europe' because of his ties of kinship with nearly every Continental Sovereign, had worked hard to try and restore more friendly terms. Now Tsar Nicholas asked the new King to continue to show the same friendship with, and interest in, Russia that his father had. Between them these two cousins, together with Emperor William II of Germany (1859–1941), another of King George V's cousins, ruled over a large part of the world.

Sadly the relationship between the three men failed to prevent the outbreak of the First World War in 1914, in which Britain and Russia opposed Germany. Four years later, circumstances had changed dramatically: the Russian Emperor saw the old Tsarist order swept away by Bolshevism and he, together with his wife and children, was killed during the Russian Revolution.

The royal families of Europe had always intermarried and so were often closely related to each other (indeed, King George V and Tsar Nicholas II bore a striking resemblance to each other), and when eight of Queen Victoria's children married into other European royal families, it made the ties across Europe and the interrelationships even stronger.

The Royal Archives holds literally hundreds of letters from (and a few to) heads of state and members of foreign royal families, as one might imagine when the web of family relationships was spread so extensively. Sometimes, of course, intermarriage could cause problems, as when relatives found themselves on opposite sides in conflicts, but in a world where democracy was in its infancy, the personal links and friendships between Sovereigns played an important part in European, and increasingly world, politics.

BELOW *William & Daniel Downey*, George, Duke of York, and Tsarevitch Nicholas of Russia, *July 1893. Albumen print* RCIN 2905168

Transcript of letter from Tsar Nicholas II

Tzarskoé Sélo

<u>April 25</u> 1910
8 May

Dearest Georgie,

Just a few lines to tell you how <u>deeply</u> I feel for you the terrible loss you and England have sustained. I know alas! by experience what it costs one. There you are with your heart bleeding and aching, but at the same time duty imposes itself and people & affairs come up & tear you away from your sorrow.

It is difficult to realize that your beloved Father has been taken away. The awful rapidity with which it all happened! How I would have liked to have come now & be near you!

I beg you dearest Georgie to continue our old friendship and to show my country the same interest as your dear Father did from the day he came to the throne.

No one did so much in trying to bring our two countries closer together than Him. The first steps have brought good results let us strive and work in the same direction. From our talks in days past & from your letters I remember your opinion was the same.

I assure you that the sad death of your Father has provoked throughout the whole of Russia a feeling of sincere grief & of warmest sympathy towards your people. God bless you my dear old Georgie! My thoughts are always near you.

With much love to you & dearest May
[Queen Mary]
ever your devoted friend,
Nicky

SIX _____ WAR & CONFLICT

'At this moment we heard the unmistakable whirr-whirr of a
German plane ... before anything else could be said, there was
the noise of aircraft diving at great speed, and then the scream
of a bomb – It all happened so quickly, that we had only time
to look foolishly at each other ...'

_____ LETTER FROM QUEEN ELIZABETH TO QUEEN MARY,
13 SEPTEMBER 1940

THE JACOBITE REBELLION, 1745

In 1685, upon the death of his brother, Charles II, the Duke of York acceded to the throne as James II (James VII in Scotland). During the later years of the royal family's exile the Duke of York had shown a growing interest in the Roman Catholic faith. The precise date of his conversion is unknown, but it seems that he was officially received into the Roman Catholic Church in 1672, although he continued to attend Anglican services until 1676. As King he attempted to promote Roman Catholicism through the dismissal of high-level officials who refused to repeal anti-dissident laws. He also appointed Catholics to senior military and political posts, a policy which alienated many of his subjects. On 10 June 1688 his second wife, Mary of Modena, gave birth to a son, Prince James Francis Edward, reigniting the fear that a new Roman Catholic dynasty was being established in what was by then a Protestant country. In December James II's nephew and son-in-law William, Prince of Orange, arrived with an army on English soil, having been formally invited to claim the throne by a small group of the disaffected Protestant politicians. The King fled the country to France, thereby allowing Parliament to state that he had abdicated his throne; the Scottish Estates followed suit a few months later. William and his wife Mary (James II's daughter) were then offered the throne to reign as joint monarchs, becoming William III and Mary II.

There was a minority of people who, believing that James II and his descendants were the rightful claimants, tried to restore the exiled Stuarts to the throne; these became known as the Jacobites (derived from the Latin Jacobus for James). The two most notable uprisings were the rebellions of 1715 and 1745. The 1715 rebellion was led by the Earl of Mar who, having been dismissed from his post as Secretary of State for Scotland by George I, sought revenge by wholeheartedly throwing his support behind the Jacobite cause. However, despite numerical advantage, he failed to defeat completely the British government forces led by the Duke of

Argyll, allowing the latter to regroup his forces. Prince James Francis Edward Stuart ('The Old Pretender') belatedly landed in Scotland, but by this time the impetus had been lost; further military action proved ineffectual, and with the rebellion faltering, both the Prince and Lord Mar fled to France.

In 1745 Prince Charles Edward Stuart ('The Young Pretender') attempted to claim the throne for his father ('The Old Pretender'), having been promised assistance by Louis XV of France. He landed in Scotland on 23 July and set about obtaining the support of the Scottish clans, who were initially uncertain, although within a few weeks he had amassed an army of nearly 2,500 men. The campaign's initial battle occurred at Prestonpans (near Edinburgh) on 21 September 1745, and resulted in a resounding victory for the Jacobite army, which marched across the border unopposed, arriving in Derby in early December. However, at a Council of Chiefs held on 5 December the Prince was advised by his generals that to push further south would be a gamble, because of limited support for their cause and inadequate intelligence. This situation was exacerbated by a deception that a large army awaited them north of London. Despite the Prince's own belief that opposition would be toppled by one last push, he agreed, and the army moved back north, pursued by the government's forces. In January 1746, the two equally matched armies, both approximately eight thousand strong, met at Falkirk Muir. The Jacobite army again emerged victorious but did not press home their advantage, and instead continued to retreat north.

In March 1745 William Augustus, Duke of Cumberland, had been appointed Captain-General of His Majesty's Land Forces by his father, George II. In January 1746 he arrived in Edinburgh to take command of the forces opposing the Jacobites. He began making preparations to quell the rebellion. His Army undertook an intense programme of training at their temporary barracks in Aberdeen, although it was not until the spring that the

PAGE 140 *Lady Elizabeth Butler (1846–1933),* The Roll Call: Calling the Roll after an Engagement, Crimea *(detail), 1874* *Oil on canvas* *RCIN 405897*

OPPOSITE *John Pettie (1834–93),* Bonnie Prince Charlie Entering the Ballroom at Holyroodhouse, *1891–2. Oil on canvas* *RCIN 401247*

campaign began in earnest. On 16 April 1746 the Jacobite army of approximately six thousand faced an estimated eight thousand men of the British government forces at Culloden (near Inverness) (p. 145). The battle was a decisive victory for the British, who captured over two thousand Jacobite soldiers (p. 146). 'The Young Pretender', or 'Bonnie Prince Charlie' as he is more sentimentally known, fled overnight by boat to the Scottish island of Skye, finally escaping to the Continent, where he remained in exile until his death in Rome in 1788.

Interestingly, the papers of the leaders of both armies taking part in the Battle of Culloden are now held in the Royal Archives. The items shown here come from these collections.

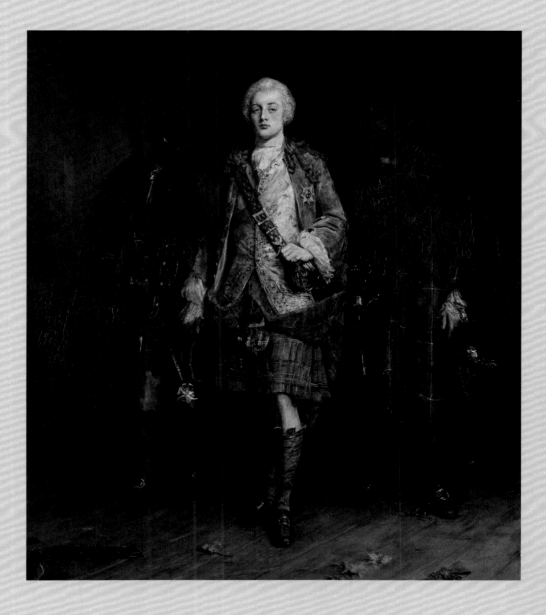

Memorandum by General Lord George Murray (1694–1760) issuing the combat orders to be observed by the Jacobite army during the forthcoming battle at Culloden, April 1746

RA CP/MAIN/13/404

Transcript of General Murray's memorandum

Orders from the 14th to the 15th Apl. 1746
Rie James (in English King James)

It is His Royall Highness posetive Orders that Evry person attach themselves to some Corps of the Armie & to remain with that Corps night & day till the Batle & persute be finally over; This regards the Foot as well as the Horse

 The Order of Batle is to be given to evry Ginerall officer and evry Commander of Regiments or Squadrons.

 It is required & expected that each indeviduall in the Armie as well officer as Souldier keeps their posts that shall be alotted to them, & if any man turn his back to Runaway the nixt behind such man is to shoot him.

 No body on Pain of Death to Strip the slain or Plunder till the Batle be over.

 The Highlanders all to be in Kilts, & no body to throw away their Guns; by H:RH Command George Murray

Account by Lord Cathcart (1721–76), aide-de-camp to the Duke of Cumberland, describing 'ye Order of March from Nairne to Inverness, and of the Battle of Culloden April ye 16th. 1746', including sketches showing the order of battle

RA CP/MAIN/14/4

Transcript of Lord Cathcart's account

Description

of ye Order of March from Nairne to Inverness and of the Battle of Culloden April ye 16th. 1746. Humbly presented to his Royal Highness the Duke By his R.H's most Dutiful and most Devoted Servant and Aid de Camp Cathcart.

The Army under his R.H.'s Command marched from Nairne Camp towards Inverness on Wednesday the 16th at 5 in ye morning …

Having marched between 5 and 6 miles his R.H received intelligence from ye advanced Partys that the Ennemy was very near, and the ground being extreamly broken before us thought proper to order the army to form: this was instantly executed without ye smallest Confusion ye different Corps wheeling up at once into their respective Lines as appears by ye Sketch … The Country being further reconnoitred we found the Ennemy was not so near as we had had reason to believe: The Army was again reduced into Columns and the March continued.

Having advanced about 2 miles the whole Rebel Army was plainly descryed forming betwixt Culloden Park wall and the Nairne

At first the Athole men and Highlanders composed their first line, the Lowlanders being drawn up in 2 Bodies in the rear of their right and left; behind the Lowlanders on the right was FitzJames's Horse, on ye left 2 Squads. of Rebel Cavalry; betwixt ye 2 bodies of Cavalry were the French Piquets and Drummond's Regt. in one line, with the Hussars in their Rear.

Before the Action the Lowlanders were brought up into the 1st line and extended on ye right and left of ye Highlanders: the Corps from behind closed forwards, and formed ye Order expressed

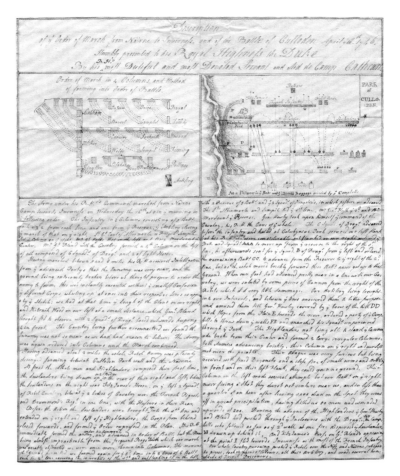

ABOVE *Thomas Sandby (1721–98)*, A sketch at the field of the Battle of Culloden, *1746. Watercolour RCIN 914722*

ABOVE *Detail of sketches showing the order of battle at Culloden*

in the Plan. His R.H. immediatly formed the army under his Command, and advanced in Order of Battle but the Moor being almost impracticable from the frequent Bogs by which our march was greatly obstructed we were once more thrown into Columns: The moment the ground permitted we formed again for ye 3d. time in to 2 lines of 6 Batts. each the 2d line covering the intervalls of the 1st. and outflanking it on the left, with a Reserve of 3 Batts. and ye 2 Squads. of Kingston's, in which posture we advanced …

The 6 Squads. of Drags. advanced before the infantry and halted at Colwhyniac Park secured our left flank but his R.H. finding we were considerably out flanked on our right ordered ye Batt. and Squads.: AAA to move up from ye reserve to the right of the 1st. line … When our foot had advanced pretty near in a line with our Cavalry, we were saluted by some pieces of Cannon from the right of the Rebels which did very little dammage.

Our Artiliry being brought in to our Intervals, and between ye lines answered them to better purpose and amused them till Genl. Hawley covered by ye brow of the hill DD which slopes from the Plain E towards the river, ordered a party of ye Campbells to throw down ye walls FF and marched his Squads. unperceived through ye Park.

The Highlanders not being able to stand ye Cannonade broke from their Center and formed 2 large irregular Columns: both Armies advancing briskly, their Column on ye right and our Left met near the point G

Their Attaque was very furious but being received with fixed Bayonets and a close fire of small arms and Artiliry in front and on their left Flank, they could gain no ground. Their Column on the left made several attempts but our Batts. on ye right never firing a shot they durst not venture near us, and in less than a quarter of an hour after leaving 1,000 dead on the Spot they went off in great precipitation, having killed us 50 men and wounded upwards of 200 …

Our whole Cavalry pursuing pushed ye Rebels over the Ness and Nairne, cut 1,000 to pieces, took 12 pairs of Colours, all their Artiliry, and made several hundreds of French Prisoners.

List of the officers and soldiers of the Jacobite army who were captured after the Battle of Culloden, 19 April 1746

RA CP/MAIN/14/52–4

ABOVE *The names include the fourth Earl of Kilmarnock, who was executed on Tower Hill on 18 August 1746, and Colonel Francis Farquharson, who received a reprieve on the day of his execution but was not permitted to return to Scotland for over twenty years.*

MILITARY MAP-MAKING AND
THE ORDNANCE SURVEY_____

In 1747, whilst serving as Deputy Quartermaster General in North Britain (Scotland), Lieutenant-Colonel David Watson (1713?–61) realised that the current military maps were inadequate, and therefore suggested to the Duke of Cumberland that a survey of Scotland should be undertaken in order to assist the government forces in their continuing attempts to pacify the Scottish clans. The Duke sought the agreement of his father, George II, who saw the benefit of having the country mapped and agreed to the proposal. The King commissioned a military survey of the Scottish Highlands and placed Watson in charge. Among his assistants were William Roy (1726–90) and the artist Paul Sandby (1731–1809). By 1752 Watson's original proposal to survey the Highlands was nearing completion and his remit was extended to the whole of Scotland. However, in 1755 the engineers were reassigned as preparations were under way for the Seven Years War; as a result the work ceased and the project was curtailed.

William Roy was appointed Practitioner Engineer in 1755 and a few weeks later received a commission in the Army. He saw service overseas, where his skills for map-making were heavily utilised. During this time Roy realised that Britain was vulnerable to invasion, and in 1763 he proposed that a national survey should be undertaken to facilitate national defence. This proposal was dropped on account of the estimated cost. Despite this setback, in 1766 Roy suggested a more modest version of his original proposal, with a detailed analysis of the probable cost; a copy of this is held in the Royal Archives (p. 149). However, it was not until the 1780s that he was finally able to undertake work on this national survey.

Roy had an illustrious career as a cartographer, eventually reaching the rank of Major-General in the Army, and is widely regarded as the founder of the Ordnance Survey. The Ordnance Survey was established in 1791 to continue the production of military maps for the Army, coming under the jurisdiction of the Board of Ordnance, which was predominantly responsible for the manufacture and supply of armaments and munitions to the British Navy and Army. The Ordnance Survey's remit would soon expand into the civilian sector; it finally ceased to come under military jurisdiction in 1870.

General William Roy's memorandum on 'Considerations on the Propriety of making a General Military Map of England, with the Method proposed for carrying it into Execution, & an Estimate of the Expence', 24 May 1766

RA GEO/MAIN/415

Transcript of General Roy's memorandum

… It therefore would seem, not only prudent, but necessary, for the good & safety of the State, that during times of peace & tranquillity, this knowledge should be acquired, in as far, at least, as regards the Nature of the Coast, and the principal Positions & Posts which an Army should occupy, when called upon to defend the Country against the Invasions of its Enemies.

The only Method of attaining this Knowledge, seems to be, by making a good Military Plan or Map of the whole Country, upon which the principal Positions and Posts should be particularly marked, and such observations made on the nature of the Ground as should appear most useful and necessary with respect to Military purposes.

But as the raising of this Plan very accurately, by a particular Survey of the whole Kingdom, as was proposed in a Scheme presented in the year 1763, would be a Work of much time and labour, and attended with great Expence to the Government – The following method of carrying it into Execution, so as to answer fully the End proposed, and at the sametime, at a moderate Expence, is humbly submitted …

THE CRIMEAN WAR

Control of access to a number of religious sites in the Holy Land had long been a cause of tension between Roman Catholic France and Orthodox Russia. In 1853, riots broke out between Russian and French monks in Bethlehem (a part of the Ottoman Empire ruled by Turkey). This precipitated a wider conflict between the great powers for influence over the declining Turkish Empire, bringing an end to three decades of peace in Europe.

Tsar Nicholas I (1796–1855) blamed Turkey for the monks' deaths, and made demands on the Turkish court for the dispute to be resolved in favour of the Orthodox Church. These demands were not answered and the Russian army crossed the river Pruth into Moldavia on 2 July 1853; in response, Turkey declared war on Russia on 5 October. Following the Russian navy's destruction of the Turkish fleet at Sinope, Britain and France were concerned about Russian expansion in the region and the potential threat to their trade routes, and they demanded that the Russian army retreat from the Dardenelles. This ultimatum was not met so they declared war on Russia in March 1854. Despite their initial belief that British and French naval supremacy would ensure a quick victory, the war carried on for nearly two years.

The Crimean campaign included actions well known in British military history, such as the siege of Sevastopol, the battle of Inkerman, and the famous Charge of the Light Brigade at Balaklava. The war came to an end with the signing of the Treaty of Paris on 30 March 1856.

The Crimean War was the first conflict to have its own war correspondent, journalist William Howard Russell (1820–1907) of *The Times*, who sent first-hand dispatches from the front line. The British photographer Roger Fenton (1819–69) travelled to the Crimea and his photographs brought the battlefields into a wider public consciousness. The newly invented electric telegraph enabled news to travel across the Continent in hours rather than weeks, and therefore reports in British newspapers of the poor conditions faced by the sick and wounded soldiers caused public outrage, resulting in organisations sending nurses to the field hospitals to administer to the wounded. The Crimean War led to major innovations in healthcare provisions for wounded soldiers.

Queen Victoria admired the work that Florence Nightingale (1820–1910), the most famous of the Crimean nurses, was undertaking in improving conditions in the military hospitals, and sent her a gold enamelled brooch in recognition of her endeavours (p. 153). Upon Florence Nightingale's return from the Crimea, Queen Victoria summoned her to Balmoral to hear of her experiences first hand. Nightingale persuaded the Queen and Prince Albert of the need to reform the military hospital system, and in May 1857 a Royal Warrant was duly issued.

Queen Victoria took a keen interest in the preparations for and progress of the war. On 28 February 1854, at her request, the 1st Battalion of the Scots Guards arrived at Buckingham Palace on their way to the Crimea. She recorded in her Journal that they presented arms and 'gave 3 hearty cheers, which went to my heart … May God protect these fine men, may they be preserved & be victorious!' The Queen was kept informed of events and the condition of the troops, and showed her concern for the welfare of the wounded by arranging for items such as Windsor soap, beef tea, newspapers, magazines and books to be sent to the military hospital in Scutari for distribution among the patients. On several occasions she and Prince Albert went to see wounded veterans in the military hospitals in Britain. During one such visit to Chatham on 3 March 1855, which the Queen described in her Journal as 'an intensely interesting, touching, & gratifying one to me', she drew sketches of some of these soldiers (p. 152).

OPPOSITE *Goupil & Co.: Paris*, The Crimean Campaign *(detail), 1854–5. Print RCIN 750993.b*

Sketches by Queen Victoria, from
her Journal, showing some of the patients
wounded in the Crimea whom she met
during her visit to the military hospital
at Chatham on 3 March 1855, including
Sergeant Breese and Sergeant Scarfe

RA VIC/MAIN/QVJ/1855

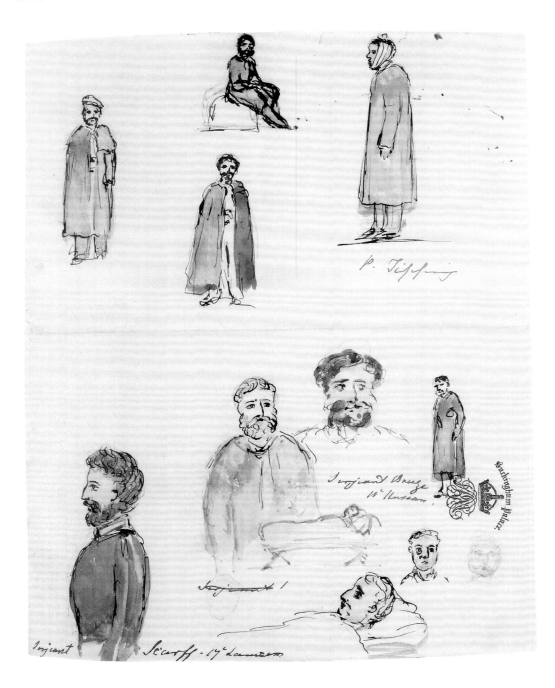

Letter from Queen Victoria to Florence Nightingale sending a gold enamelled brooch, November 1855, and sketch of the brooch, designed by Prince Albert and made by the Royal Jewellers, Garrards

RA VIC/MAIN/F/4/1 and RA VIC/MAIN/F/4/16

Transcript of letter from Queen Victoria

Dear Miss Nightingale,
You are I know well aware of the high sense, I entertain, of the Christian devotion which you have displayed during this great & bloody War, & I need hardly repeat to you – how warm my admiration is for <u>Your</u> services wh are fully equal to those of my dear & brave Soldiers whose sufferings you have

had – the <u>privilege</u> of alleviating in so merciful a manner. I am however anxious of marking my feelings in a manner wh I trust will be agreeable to you, – & therefore send you with this letter a brooch the form & emblems of wh com[me]morate your great & blessed work – & wh I hope you will wear as a mark of the high approbation of your Sovereign! –

It will be a very great satisfaction to me to have you return at last to these Shores to make the acquaintance of one who has set so bright an example to our Sex, & with every prayer for the preservation of your valuable health,

believe me always,
your's sincerely

VR

THE VICTORIA CROSS _____

The Crimean War highlighted the need for an appropriate means of rewarding individual gallant conduct. It was decided that a new award should be created which would be open to all ranks of the British armed forces, and that 'neither rank nor long service, nor wounds nor any other quality whatsoever save the merit of conspicuous bravery shall be held as sufficient qualification for the Order'. Queen Victoria and Prince Albert were very much involved in the creation of this award, which became known as the Victoria Cross, the Prince Consort writing a memorandum detailing his views on the criteria for its inception (p. 155). The draft warrant, including proposed medal designs, was sent to Queen Victoria and Prince Albert for their comments (p. 156). In her response the Queen proposed that the inscription on the medal should read 'for valour', rather than the Government's suggestion of 'for the Brave', as she believed that this implied non-recipients were not brave, and it is indeed the Queen's wording which appears on the Victoria Cross (p. 157).

Queen Victoria signed the Royal Warrant creating the new Order on 29 January 1856, although it was backdated to recognise acts of valour during the Crimean War. It was stipulated that the ribbon should be dark blue for Navy and red for Army recipients; however, with the creation of the Royal Air Force in 1918, this distinction was abolished through a new warrant, and all subsequent VCs have had red ribbons. It is generally believed that the bronze used for the insignia of the Victoria Cross was taken from Russian guns captured during the siege of Sevastopol; however recent research has cast doubt on whether this is true for all medals.

ABOVE *The Victoria Cross, front and back views.*

Prompted by the many posthumous VCs awarded during the First World War (nearly a quarter of those issued), a new warrant was published in 1920 which officially stated that the Order could be awarded posthumously. The Victoria Cross is the highest military decoration available, taking precedence over all other Orders, decorations and medals. Since its inception it has been awarded only 1,357 times to 1,354 individual recipients, with three individuals receiving a Bar – a second VC – to their original award.

Memorandum written by Prince Albert expressing his views on the need for a new military award to be established which recognises instances of 'personal deeds of valour', 22 January 1855

RA VIC/MAIN/E/5/18

Transcript (part) of Prince Albert's memorandum

Copy

Memordm

Windsor Castle

January 22. 1855

The question of rewards for military service by decoration is one of the most difficult …

The difficulty which meets us, is: to establish, first, a competents tribunal for ascertaining in what the services of "A" differ from, or are superior to the services of "B", & secondly, (if such a difference exist) a sure mode of bringing them to the notice of Govt with a certainty that a similar superiority on the part of "C" is not overlooked …

It is now proposed to establish a third mode of reward, neither reserved for the few, nor bestowed upon all, which is to distinguish on a liberal scale individual merit in the Officers of the lower ranks, in Sergeants & in Privates …

The only mode, I see, in which the difficulty could be overcome seems to me to be something like the following:

1. That a small cross of Merit for personal deeds of valour be established.

2. That it be open to all ranks.

3. That it be unlimited in number.

4. That an annuity (say of £5) be attached to each cross.

5. That it be claimable by an Individual on establishing before a Jury of his Peers subject to confirmation at home, his right to the distinction.

6. That in cases of general action it be given in certain quantities to particular regiments, so many to the Officers, so many to the Sergeants, so many to the men (of the last say 1 per company) & that their distribution be left to a jury of the same rank as the persons to be rewarded. By this means alone could you ensure the perfect fairness of distribution & save the Officers in command from the invidious task of making a selection from those under their orders, which they now shrink from in the case of the Bath. The limitation of the number to be given to a Regiment at one time, inforces the necessity of a selection & diminishes the pain to those who cannot be included …

(sign.) A

Copy draft warrant for the creation of a new award for individual gallant conduct, which was to become known as the Victoria Cross, the final warrant for which Queen Victoria signed on 29 January 1856

RA VIC/MAIN/E/6/69

In December 1855 a draft of the warrant was submitted to the Queen for her preliminary approval. Prince Albert returned the draft to Lord Panmure, the Secretary of State for War, noting: 'Having gone through it carefully together with the Queen, I have marked in pencil upon it all that occurred to us.' A copy of this document was kept by the Prince.

superior to any an individual could perform & influencing the fate of a field or even campaign: In such a case it would not do to refuse the Cross on account of there being too many brave men, & yet to give it to all of them would not answer the purpose of the institution. In such a case the deed might be rewarded by a certain number of Crosses being given to the whole body participating in it, leaving to a "jury" of those engaged to select the proper representatives, I even hope that this will be the most common case; For instance, the maintenance of the Sandbay Battery at Inkermann, the charge of Balaclava, the storming party of the Quarries, 7th June &c Those are deeds more valuable than the throwing of a shell out of a Battery, or carrying a mounted officer off the Field.

Transcript (part) of draft warrant

…1. The order would be styled
~~"The Military order of Victoria"~~
Motto. "God defend the Right"
or "For Queen & Country"
("The Victoria Cross"?)
("The Reward of Valour"?)
("The Reward of Bravery"?)
("For Bravery")
N.B. The Motto should explain the decoration & exclude the possibility of it's object being misunderstood.
2. * The Queen constitutes Herself Sovereign of the Order.
…
3. The order to consist of one degree.
N.B. I would throughout drop the designation "Member" of the order &c and treat it, as it is, as a cross granted for distinguished service, which will make it simple & intelligible.
4. The number of the members shall be unlimited.
5. The Insignia to be a cross of ~~Steel or~~ Bronze suspended from the breast by a blue Ribbon for the Navy & a red Ribbon for the Army …

A most important case has been left unnoticed, viz: where a body of men say a Brigade, a Regiment, a Company &c may have performed a deed of valour

Draft memorandum from Queen Victoria to Lord Panmure, the Secretary of State for War, recording her reaction to the proposed design for the Victoria Cross and her opinion that the inscription should be changed from 'for <u>the</u> Brave' to 'for valour', 5 January 1856

RA VIC/MAIN/E/6/71

Transcript of Queen Victoria's memorandum

The Queen returns the Drawings for the "Victoria Cross" she has marked the one she approves with a X, she thinks however that it might be a trifle smaller. The Motto would be better "for valour" than "for <u>the</u> Brave" as this would lead to the inference that only those are deemed brave who have got the cross.

W. Castle. Jan: 5 1856.

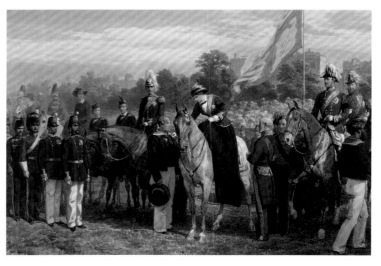

RIGHT *George Housman Thomas (1824–68)*, Queen Victoria distributing the first Victoria Crosses, *1857. Watercolour over bodycolour and pencil RCIN 916806*

THE ANGLO-ZULU WAR

The British Empire had several colonies in southern Africa, bordered by a number of settlements of Boers (Dutch-speaking colonists) and native African kingdoms such as that of the Zulus. The discovery of diamonds near the Vaal river, which ran through Boer territory, led to increased British interest in the area, and an attempt to organise a federation of British and Boer territories in 1875, similar to the scheme used in the formation of Canada. Sir Henry Bartle Frere, appointed High Commissioner of Southern Africa, believed that this plan was endangered by the threat posed by the Kingdom of the Zulus, who were themselves weary of Boer and British encroachments into their territory. Despite the reluctance of the British government to start another colonial war, Frere issued King Cetshwayo with an ultimatum on 11 December 1878, demanding that the Zulu army be disbanded and the Zulus accept the appointment of a British representative. Cetshwayo did not respond, so on 11 January 1879 a British force under the command of Lieutenant-General Lord Chelmsford invaded Zululand, although without the authorisation of the British government.

Leaving behind a small garrison of troops at the field station of Rorke's Drift, Chelmsford ordered his Army to march to Isandlwana, where they pitched camp on 20 January. He divided his force in two, leaving a smaller contingent to defend the camp and taking his remaining troops to find the main Zulu army. However, the Zulus outmanoeuvred him by moving behind his position, and at approximately 8 am on 22 January they attacked the British camp at Isandlwana, the resulting battle ending in a resounding victory for the Zulu army. Despite receiving numerous messages that the Zulus had been sighted near Isandlwana early in the morning, it was not until mid-afternoon that Chelmsford became convinced of the severity of the situation and took his force back to the camp, where it arrived after sundown, long after the battle had finished.

Meanwhile, soon after midday on 22 January, two survivors from Isandlwana managed to reach Rorke's Drift, bringing news of the defeat. After a meeting between the station's officers, Lieutenant (later Major) John Chard (1847–97), Lieutenant Gonville Bromhead (1845–91) and Acting Assistant Commissary James Dalton (1833–87), it was agreed that the garrison must stay and fight, so preparations were made to fortify the station. At approximately 4.30 pm the Zulu army was sighted and made the first of many assaults, the last of which occurred at about 2 am the next morning. The Zulus came close to overwhelming the small garrison force, but despite being heavily outnumbered (roughly 25 to 1) the British troops successfully repelled the attack. As a result of this heroic defence, many honours and decorations were awarded to the defenders of Rorke's Drift, including 11 Victoria Crosses.

Queen Victoria again took a personal interest in the progress of the war and was kept informed of events such as the defence of Rorke's Drift. Upon their return, she summoned Major Chard, Lieutenant Bromhead and other officers to Balmoral to recount the actions of 22 and 23 January. So keen was the Queen's interest that she requested a written account of Chard's experiences (p. 159). In a letter written on 21 February 1880, Captain Fleetwood Edwards, Assistant Private Secretary to Queen Victoria, forwarded a copy of this account of Rorke's Drift to the Queen. Edwards described it as 'a simple Soldierlike account of very gallant deeds, & a thrilling record of a terrible night's work', and observed that Chard 'deeply feels the honor Your Majesty confers upon him in wishing to have a narrative written by him'.

ABOVE Major John Chard, VC, RE, *1878–9. Albumen print, hand-coloured photograph RCIN 2501026*

Major John Chard's account of the Battle of Rorke's Drift on the night of 22 January 1879, with accompanying sketches

RA VIC/MAIN/O/46

1. Oscarberg. 2. Rocks and Caves occupied by Zulus. 3. Cattle Kraal. 4. Camp of B Co 24th. 5. Well built Kraal. 6. Mealie sack Wall. 7. 2 Heaps of Mealies in sacks. 8. Comm.t Store. 9. Cook House. 10. 2 Ovens. 11. 2 Wagons. 12. Wall of Biscuit Boxes. 13. Hospital. 14. Wall 5 ft. 15. Garden.

Transcript (part) of Major Chard's account

… Attack commenced 4-30 p.m.

See sketches (1) and (2)

We had not completed a wall two boxes high, when, about 4-30 p.m., Hitch cried out that the enemy was in sight, and we saw them, apparently 500 or 600 in number, come around the hill to our south (the Oscarberg) and advance at a run against our south wall.

Private Dunbar 24th

We opened fire on them, between five & six hundred yards, at first a little wild, but only for a shot or two, a chief on horseback was dropped by Private Dunbar 24th, the men were quite steady, and the Zulus began to fall very thick.

However it did not seem to stop them at all, although they took advantage of the cover, and ran stooping with their faces near the ground. It seemed as if nothing would stop them, and they rushed on in spite of their heavy loss, to within 50

Zulus checked

yards of the wall, when they were taken in flank by the fire from the end wall of the store building, and met with such a heavy direct fire from the mealie wall, and Hospital at the same time, that they were checked as if by magic.

1st Assault

They occupied the Cook house ovens, banks, and other cover, but the greater number, without stopping, moved to their left around the Hospital, and made a rush at the end of the Hospital and at our N.W. line of mealie bags.

There was a short but desperate struggle, during which Mr Dalton shot a Zulu, who was in the act of assegaing a corpl of the Army Hospital Corps, the muzzle of whose rifle he had seized, and with Lieut Bromhead and many of the men behaved with great gallantry …

Pen and brush sketch depicting the British camp and the surrounding landscape.

1: Sketch showing the layout of the mission station of Rorke's Drift, and the direction of the first advance by the Zulus.

2: Sketch depicting the first check of the Zulus' assault on the station. The red dots denote the position of the British soldiers, while the black dots represent the Zulu army.

18.

Private Dunbar 24th, the men were quite steady, and the Zulus began to fall very thick – However it did not seem to stop them at all, although they took advantage of the cover, and ran stooping with their faces near the ground. It seemed as if nothing would stop them, and they rushed on in spite of their heavy loss, to within 50 yards of the wall, when they were taken in flank *Zulus checked* by the fire from the end wall of the store building, and met with such a heavy direct fire from the mealie wall, and Hospital at the same time, that they were checked as if by magic –

They occupied the cook house ovens, banks, and other cover, but the greater number, without stopping, moved to their left around the Hospital, and made a rush at the end of *1st Assault* the Hospital and at our N.W. line of mealie bags –

There was a short but des=
:perate struggle, during which

This sketch is chiefly from memory, and therefore may not be quite correct – but it will give a fairly accurate impression of the relative positions of the Houses, Oscarberg, Drift &c –

Sketch showing the 1st Check of the Zulus and their 1st Assault. About 4.30 p.m. Zulus ••• British ••• Bush Green –

3 and 4: Sketches showing a series of attacks made by the Zulus, resulting in their breaching the defences of the Hospital.

5: Sketch showing that by nightfall the Zulus had completely surrounded the station, and that, with the Hospital on fire, the British soldiers had retreated to the Commissariat Store.

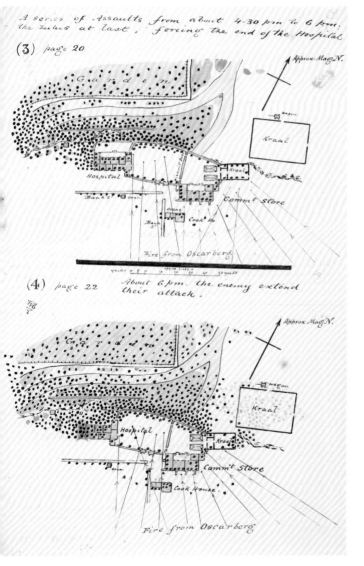

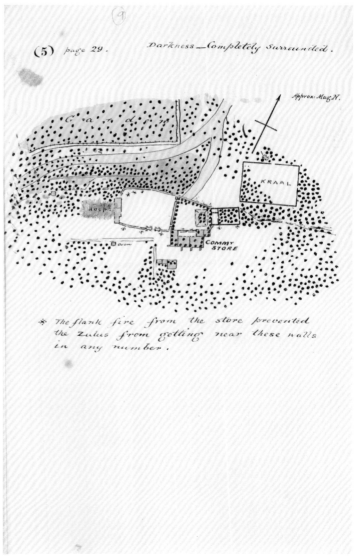

THE FIRST WORLD WAR _____

During a visit to Sarajevo on 28 June 1914 Archduke Franz Ferdinand, the heir to the Austro-Hungarian throne, was assassinated by a Serbian nationalist, an action that provided the catalyst for the outbreak of what was to become a truly global war, extending into almost every continent. While most of the fighting was on the Western and Eastern Fronts, battles were also fought in the Balkans, the Mediterranean, parts of Asia (including Gallipoli and the Dardenelles) and Africa. Moreover, it was not only on land that war was fought; naval warfare took place in many theatres, principally in the North Sea where Britain's Navy blockaded the entrance to the English Channel and the North Sea, effectively cutting Germany off from overseas trade and resources. The smaller German navy occasionally attempted to lure small sections of the British fleet into battles in the hope of weakening it enough to allow them to attack allied shipping and possibly break the blockade, as was the case during the Battle of Jutland. The war saw many innovations in mechanical warfare, with the invention of the tank and the transition in the use of aeroplanes from air reconnaissance to effective fighting machines.

During the course of the war, as Head of State King George V was kept informed of events by the Prime Minister and other members of the government. In addition, he requested that his generals and admirals 'from time to time write to me quite freely & tell me how matters are progressing.' Both the King and the Queen toured factories and hospitals, in Britain and in France, and saw for themselves the conditions for the armed forces.

Throughout the war the King and Queen sent messages, of encouragement or condolence, including Christmas cards in 1914, to members of the British armed forces (including Indian and Colonial), messages of welcome to recently returned prisoners of war, and condolences to the next of kin of those killed in action. Queen Mary worked tirelessly for charities and welfare services, including Queen Mary's Needlework Guild, of which she was patron, and which supplied hundreds of thousands of garments to the troops overseas.

The Prince of Wales and his younger brother Prince Albert (the future King George VI) both served in the British armed forces during the war (pp. 164–5). Their sister Princess Mary visited hospitals and welfare organisations with her mother, and inaugurated the Princess Mary's Sailors' and Soldiers' Christmas Fund, to which the public was invited to donate, so that a gift might be sent to all men wearing the King's uniform on Christmas Day 1914. In 1918 she enrolled on a nursing course and went to work at Great Ormond Street Hospital.

In 1917 King George V commanded that arrangements be made for overseas troops to visit the State Apartments at Windsor Castle, which had been closed to the public since the beginning of the war. Later in the year the privilege was extended to wounded British troops, and also to officers of the United States army passing through London. Naturally, the Royal Household was not immune to the effects of the war and several hundred of its members served in the armed forces.

Although the Armistice, signed at 11 am on 11 November 1918, brought the military campaign to an end, the precise terms of the various peace treaties between the combatant countries were finalised later. The best known of these, the Treaty of Versailles, concerned the settlement for the German Empire; its harsh terms became a contributing factor towards the advent of the Second World War.

Description by the Prince of Wales (later King Edward VIII and ultimately Duke of Windsor) in his diary in September 1916 of a demonstration of 'land submarines' (tanks), which he saw when serving in the British Army in France, and sketches he drew of them for his father, King George V

RA EDW/PRIV/DIARY/1916: 1 September and RA GV/PRIV/AA59B

These 'land ships' (mistakenly called 'land submarines' by the Prince) were built by Fosters of Lincoln under the guidance of the War Cabinet's 'Landships Committee', headed by the First Lord of the Admiralty, Winston Churchill. He had been shown Colonel Ernest Swinton's proposal for an armoured trench-crossing vehicle, which had been disregarded previously by senior staff in the British Army, whereas Churchill saw its potential. The machines were developed in secret, under the codename by which they would become universally known, 'tanks'. They fell into two categories, 'male' tanks, which were armed with naval cannons and machine guns, and 'female' tanks, which carried only machine guns.

Tanks were first deployed on 15 September 1916 during the Battle of Flers-Courcelette, part of the Somme campaign, although with mixed results as many broke down or became bogged down in the shell holes of the churned battlefield. However, where they were used effectively, the British Army made substantial gains.

Upon the outbreak of the First World War, the Prince of Wales was keen to join the armed forces, but as he was heir apparent it was difficult to find him a suitable position. To his great disappointment, he was not permitted to serve on the front line, because of concerns that the nation's morale would be severely damaged should the Prince come to harm. As a result the Prince was posted to the General Staff Office and served in Belgium, France, Italy and Egypt, gaining praise for his wartime service, especially for his lack of ceremony and his concern for the troops.

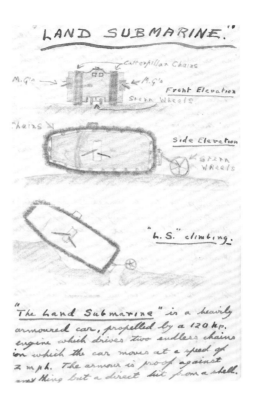

Transcript of the Prince of Wales's diary entry for 1 September 1916

… we motored via Amiens, St Vast, St Ouen & Domquer [Domqueur] to Yvrencheux to see these "Tanks" which is the code word for these new land submarines which are heavily armoured cars propelled by 120 H.P. engines which drive not wheels but those caterpillar chains to enable them to surmount any obstacle such as trenches, sunken rds etc. We left the car on the Yvrencheux – Oreux [Oneux] rd. & walked W. across fields to just S. of Gapennes where these "tanks" were operating with infantry, attacking!! … We wandered about watching these trials for about 2 hrs. & I went inside a "tank" at the end of which there are males & females; the males carry 2 6pdrs [pounders] & M.G's & the females M.G's!! They only do 2 m.p.h. but are silent. They are proof against schrapnell, bullets, bombs in fact any thing but a direct hit from a shell & each DIV. will have 6 to assault the trenches behind the 1st line of infantry & in front of the 2nd line!! They are good toys but I have'nt much faith in their success tho. their crews of 1 off. [officer] & 7 O.R. are d-d brave men!! …

Account by Prince Albert (the future King George VI) of the Battle of Jutland in 1916, in which he served as a Sub-Lieutenant on board HMS *Collingwood*

RA PS/PSO/GV/C/Q/832/366

During the course of the First World War the main British naval fleet was divided into two sections, a smaller Battlecruiser Force commanded by Admiral David Beatty (1871–1936), and the larger Grand Fleet under the command of Admiral John Jellicoe (1859–1935) stationed at Scapa Flow (Orkney islands). In May 1916 the German naval commander Admiral Reinhard Scheer (1863–1928) planned to attack British merchant shipping routes to Norway in an attempt to provoke both fleets into battle, hoping to destroy Beatty's force before Jellicoe's fleet arrived. However, British code-breakers intercepted the German transmissions and both British fleets put to sea early. On 31 May the two forces met near Jutland, Denmark, where fighting ensued with heavy losses on both sides: the British lost 14 ships and over 6,000 men, and the Germans lost 11 ships and over 2,500 men. The Battle of Jutland was the only large-scale clash of battleships during the war and the German navy never seriously challenged British control of the North Sea again.

Prince Albert fought in the Battle of Jutland and remains the only British Sovereign to have seen action in battle since William IV.

Transcript of Prince Albert's account

… We went to "Action Stations" at 4.30 p.m. and saw the Battle Cruisers in action ahead of us on the starboard bow. Some of the other cruisers were firing on the port bow. As we came up the "Lion" leading our Battle Cruisers, appeared to be on fire the port side of the forecastle, but it was not serious. …As far as one could see only 2 German Battle Squadrons and all their Battle Cruisers were out. The "Colossus" leading the 6th division with the "Collingwood" her next astern were nearest the enemy. The whole Fleet deployed at 5.0 and opened out. We opened fire at 5.37 p.m. on some

German light cruisers. The "Collingwood"'s second salvo hit one of them which set her on fire, and sank after two more salvoes were fired into her …

I was in A turret and watched most of the action through one of the trainers telescopes, as we were firing by Director, when the turret is trained in the working chamber and not in the gun house. At the commencement I was sitting on the top of A turret and had a very good view of the proceedings. I was up there during a lull, when a German ship started firing at us, and one salvo "straddled" us. We at once returned the fire. I was distinctly startled and jumped down the hole in the top of the turret like a shot rabbit!! I didn't try the experience again …

**Letter from Field Marshal Sir Douglas
Haig (1861–1928), Commander-in-Chief
of the British Expeditionary Force, to
King George V on 9 April 1917, reporting
on the latest events from the Western
Front, including the success of the Battle
of Vimy Ridge**

RA PS/PSO/GV/C/Q /832/137

GENERAL HEADQUARTERS,

BRITISH ARMIES IN FRANCE.

Monday
9 April 17.

Sir.

I beg to report that during the past 2 weeks,
I have visited all the Corps & Divisions
operating in the open country between
Arras and St Quentin. - I covered most
of the ground on horseback, partly because
the Enemy had blown up large craters at
the main cross roads and so motoring
was not always possible, and partly
because it was quicker to ride across
country which is mostly all grass land
now. - Your Majesty will be pleased
to hear that I found the troops everywhere
in the most splendid spirits and
looking the picture of health. - The
marching ~~the~~ ~~for~~, and the joy

Transcript of letter from Field Marshal Haig

Monday
9 April 17.

Sir,

I beg to report that during the past 2 weeks I have
visited all the Corps & Divisions operating in the
open country between Arras and St Quentin. I
covered most of the ground on horseback, partly
because the enemy had blown up large craters at
the main cross roads and so motoring was not always
possible, and partly because it was quicker to ride
across country which is mostly all grass land now.
Your Majesty will be pleased to hear that I found
the troops everywhere in the most splendid spirits
and looking the picture of health. The marching,
and the joy of operating in the open at last, and
above all, the fact that the Army was advancing,
made everyone happy! There was ample cover too
in the villages, although nearly all the houses have
been pulled down. Indeed I was surprised and of
course highly pleased to find the men were able to
get such good shelter, for the weather on the whole
was very bad – much rain and sometimes snow.
The change to open warfare has especially benefitted
the Australians: indeed they seem 50 per cent more
efficient now, than when they were in the trenches
– I spent a day with them last week in the Country
East & N.E of Bapaume.

It is sad to see the havoc wrought by the
Germans in the latter town, as well as in Péronne.
In neither town did there appear to be a house
with a whole roof left standing. Besides destroying
buildings, I saw nice furniture which had been
hacked about with axes, and beautifully bound
books all mutilated in the most wanton fashion.

Nearly every village, except 2 or 3 where
refugees had been collected, were treated in the
same fashion. But the village houses are, in this
part of France, mostly made of beams & mud
plaster; a few are of simple brick thickness: so their
destruction is not such a very serious matter as that
of the fine old houses of Péronne. The cutting down
of the fruit trees is however a serious loss.

The capture of the Bois d'Holnon (about 4 miles
West of St Quentin) was skilfully carried out by the
IVth Corps under General Woollcombe. The wood
stands on rising ground with long open slopes
towards the West. The position was thus very
strong, and most difficult to capture by direct attack
from the West. Gen. Woollcombe therefore arranged
to turn it. One Divn (the 32nd) under Shute was
sent to take the village & then the wood of Savy
(on the S. and S.E respectively of Holnon Wood)
and then work northwards on the Eastside of the
enemy's position. At the same time the 61st Divn
under Gen. Colin Mackenzie took Maissemy village
and worked Southwards to join hands with Shute.
These operations were most successful: the enemy
was forced from his position with the loss of some
prisoners, while our losses were very small indeed.

During this movement Gen. Shute also took
possession of l'Épine de Dallon (about 2000 yds
from the S.W. exit of St Quentin). This point was
of considerable importance: it was then some 3
miles in front of the French left flank which was
at the time held up near Roupy village. The French
were thus well supported by Your Majesty's troops,
and all grounds of complaint as to their flank being
uncovered by the British, removed!

I am writing this at Heuchin (near St Pol) while
the Battle for Vimy Ridge etc is going on. Everyone
is so busy today that I have managed to get a leisure
hour for writing a letter! I came here last night so as
to be near the Hd Qrs of Gens Horne & Allenby. Four
Divns of Canadians in the 1st Army are attacking the
Vimy Ridge; while the 3rd Army, with ten Divisions
in front line, is attacking astride the Scarpe.

The attack was launched at 5.30 a.m. and has
progressed most satisfactorily. Indeed at the time
of writing (3 p.m.) the several lines have been
captured according to the time table – and a large
number of prisoners have been taken; probably
10,000 when all are counted! Our success is already
the largest obtained in this front in one day.

With my humble duty, I have the honour to be,
Your Majesty's Obedt Servant
Douglas Haig

THE SECOND WORLD WAR ─────────────

In the 1930s, resentful at Germany's treatment by the international community after the First World War, Hitler began to mobilise the country's armed forces and to extend Germany's borders, in his efforts to provide *Lebensraum* (living space) for a united German people. The British government opted for a policy of appeasement towards Hitler, but he continued his plans, annexing Austria in 1938, occupying Czechoslovakia in March 1939 and invading Poland on 1 September that same year. As Britain and France had signed treaties to protect Poland, this act of aggression prompted them to declare war on Germany on 3 September 1939.

The German army swept across Western Europe the following spring, forcing the evacuation of the British Expeditionary Force from Dunkirk. That summer, the RAF's victory in the Battle of Britain forced Hitler to abandon his invasion plans for Britain. He resorted instead to strategic bombing of Britain's industrial areas and big cities.

Throughout this period of great menace to the country, King George VI developed a close working relationship with Winston Churchill, which rapidly evolved into a friendship of mutual admiration (p. 173). The King and Queen remained in London, only returning to Windsor Castle in the evenings. They undertook numerous visits to bomb-damaged areas, munitions factories and hospitals, and their high public profile and apparently indefatigable determination secured their place as symbols of national resistance. Buckingham Palace received several direct hits during the bombing raids and Their Majesties narrowly avoided injury on a few occasions (p. 170).

As in the First World War, the King and Queen sent messages of support to their peoples, including Christmas cards to the armed forces in 1939, thanks to those families who had taken in evacuated children and a certificate for members of the Home Guard when it was stood down in November 1944. In addition, the Royal Family made use of the relatively new medium of radio, broadcasting at moments of

significance – including the outbreak of war, and a message from the young Princesses, Elizabeth and Margaret, to the children of the Empire in October 1940. They spent the majority of the conflict at Windsor Castle, where they took part in pantomimes in aid of war charities. Princess Elizabeth later joined the Auxiliary Transport Service (ATS), training as a driver and mechanic.

During the war the King visited the Allied troops in France, North Africa, Malta, Italy, Belgium, the Netherlands and Luxembourg, while two of his brothers served in the armed forces: the Duke of Gloucester in the Army and the Duke of Kent in the RAF; the latter was killed in a flying accident in August 1942.

On 6 June 1944, a combined Allied army stormed the beaches of Normandy on 'D-Day'. The fighting continued in Europe until the following spring, when on 8 May 1945 the German High Command surrendered, Hitler having committed suicide a few days earlier. In the ensuing celebrations for VE (Victory in Europe) Day in London, the Royal Family appeared many times on the balcony of Buckingham Palace and the two Princesses mingled anonymously with the crowds outside.

The fighting in the Pacific continued until 15 August, when the Japanese army surrendered following the use of atomic bombs. In his broadcast that evening, King George VI expressed the relief that all felt: 'The war is over. You know, I think, that those four words have for the Queen and myself the same significance, simple yet immense, that they have for you ... From the bottom of my heart I thank my Peoples for all they have done, not only for themselves but for mankind.'

OPPOSITE *King George VI, Queen Elizabeth and Prime Minister Winston Churchill inspect bomb damage at the rear of Buckingham Palace, 13 September 1940. RCIN 2941134*

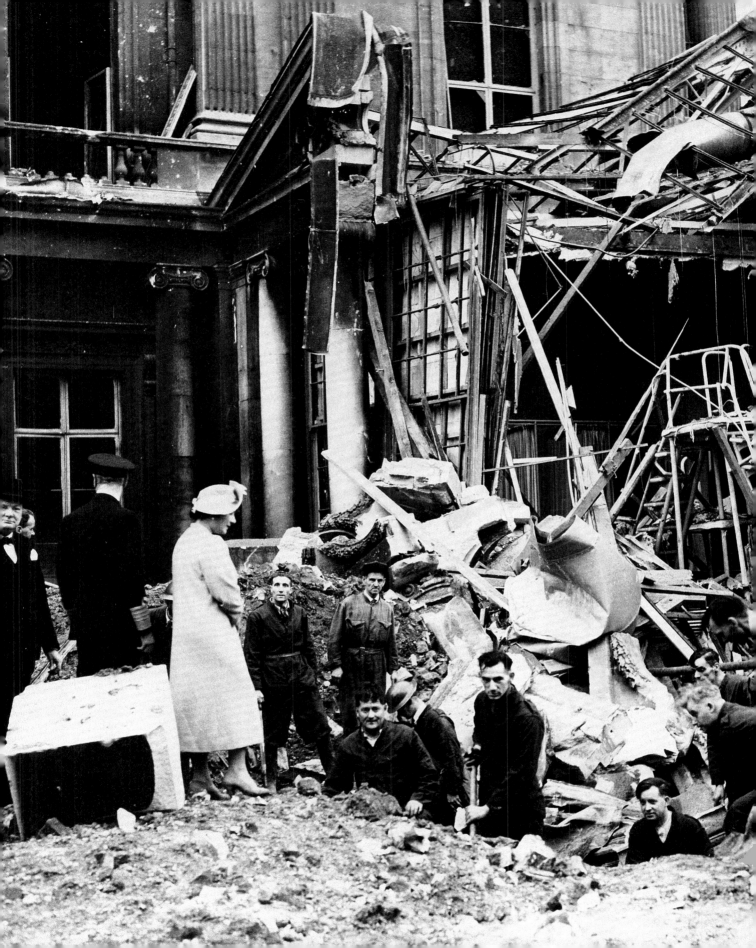

Letter from Queen Elizabeth to Queen Mary describing the bombing of Buckingham Palace on 13 September 1940, and her visit with the King to the East End of London later that day, and photographs of bomb damage sustained by Buckingham Palace, September 1940

RA QM/PRIV/CC12/135 and RA QM/PRIV/CC62/160, 163 and 181

Buckingham Palace was bombed nine times during the course of the Second World War. The raids caused considerable damage to the Chapel and resulted in the destruction of the Northern Lodge, where a policeman was killed by flying debris. In August 1944 a V1 rocket, or 'flying bomb', landed in the grounds of the Palace, shattering windows and destroying trees. The King and Queen had been present in the Palace during a number of these air raids, including the one described so vividly in this letter. The King wrote to Queen Mary the next day, adding: 'The aircraft was seen flying along the Mall before dropping the bombs … It was most certainly a direct attack on B.P. to demolish it.'

RIGHT, FROM TOP *The Palace forecourt, looking towards the front façade; the forecourt looking towards the Victoria Memorial; the north side of Buckingham Palace, September 1940.*

BELOW *Note in King George VI's handwriting, on the back of the bottom photograph.*

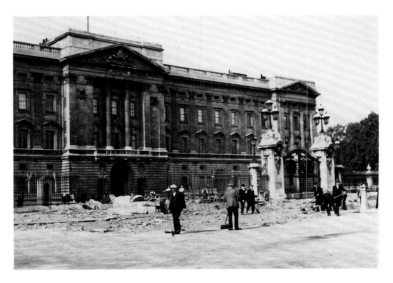

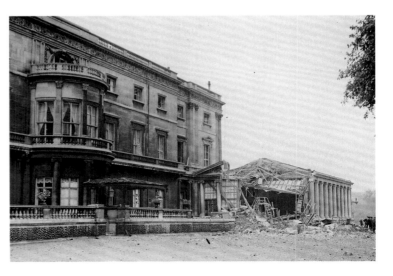

WINDSOR CASTLE

It all happened so quickly, that we had only time to look foolishly at each other, when the scream hurtled past us, and exploded with a tremendous crash in the quadrangle –

I saw a great column of smoke & earth thrown up into the air, and then we all ducked like

WINDSOR CASTLE

lightening into the corridor – There was another tremendous explosion, and we & our 2 pages who were outside the door, remained for a moment or two in the corridor away from the staircase, in case of flying glass. It is curious how one's instinct works at those moments of great danger,

Transcript of Queen Elizabeth's letter

September 13th 1940

My Darling Mama

I hardly know how to begin to tell you of the horrible attack on Buckingham Palace this morning.

Bertie & I arrived there at about ¼ to 11, and he & I went up to our poor windowless rooms to collect a few odds and ends – I must tell you that there was a "Red" warning on, and I went into the little room opposite B's room, to see if he was coming down to the shelter – He asked me to take an eyelash out of his eye, and while I was battling with this task, Alec came into the room with a batch of papers in his hand. At this moment we heard the unmistakable whirr-whirr of a german plane – We said "ah a german", and before anything else could be said, there was the noise of aircraft diving at great speed, and then the scream of a bomb – It all happened so quickly, that we had only time to look foolishly at each other, when the scream hurtled past us, and exploded with a tremendous crash in the quadrangle –

I saw a great column of smoke & earth thrown up into the air, and then we all ducked like lightening into the corridor – There was another tremendous explosion, and we & our 2 pages who were outside the door, remained for a moment or two in the corridor away from the staircase, in case of flying glass. It is curious how one's instinct works at those moments of great danger, as quite without thinking, the urge was to get away from the windows. Everybody remained wonderfully calm, and we went down to the shelter – I went along to see if the housemaids were alright, and found them busy in their various shelters – Then came a cry for "bandages", and the first aid party, who had been

training for over a year, rose magnificently to the occasion, and treated the 3 poor casualties calmly and correctly –

They, poor men, were working below the Chapel, and how they survived I don't know – Their whole workshop was a shambles, for the bomb had gone bang through the floor above them. My knees trembled a little bit for a minute or two after the explosions! But we both feel quite well today, tho' just a bit tired. I <u>was</u> so pleased with the behaviour of our servants. They were really magnificent. I went along to the kitchen which, as you will remember has a glass roof. I found the chef bustling about, and when I asked him if he was alright, he replied cheerfully that there had been un petit quelque chose dans le coin, un petit bruit, with a broad smile – The petit quelque chose was the bomb on the Chapel just next door! He was perfectly unmoved, and took the opportunity to tell me of his unshakable conviction that France will rise again!

We lunched down in our shelter, and luckily at about 1.30 the all-clear sounded, so we were able to set out on our tour of East and West Ham – The damage there is ghastly. I really felt as if I was walking in a dead city, when we walked down a little empty street – All the houses evacuated,

and yet through the broken windows one saw all the poor little possessions, photographs, beds, just as they were left. At the end of the street is a school which was hit, and collapsed on the top of 500 people waiting to be evacuated – about 200 are still under the ruins. It does affect me seeing this terrible and senseless destruction – I think that really I mind it much more than being bombed myself. The people are marvellous, and full of fight. One could not imagine that life <u>could</u> become so terrible. We <u>must</u> win in the end.

Darling Mama, I do hope that you will let me come & stay a day or two later – It is so sad being parted, as this War has parted famillies.

With my love, and prayers for your safety,
ever darling Mama your loving daughter in law
Elizabeth

P.S. Dear old B.P is <u>still standing</u>, and that is the main thing.

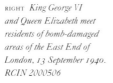

RIGHT *King George VI and Queen Elizabeth meet residents of bomb-damaged areas of the East End of London, 13 September 1940. RCIN 2000506*

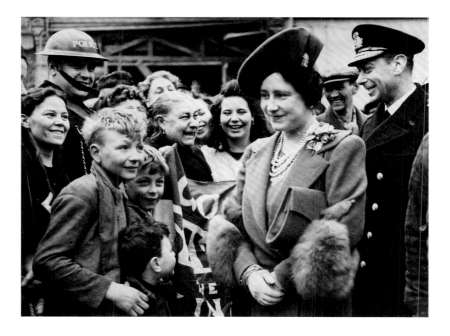

Letter from the Prime Minister, Winston Churchill, to King George VI, expressing his gratitude for Their Majesties' support during his first few months as war leader, 5 January 1941

RA PS/PSO/GVI/C/069/07

Transcript of Winston Churchill's letter

5. January 1941

Sir,

I am honoured by Yr Majesty's most gracious letter. The kindness with wh Yr Majesty & the Queen have treated me since I became First Lord & still more since I became Prime Minister have been a continuous source of strength & encouragement during the vicissitudes of this fierce struggle for life. I have already served Yr Majesty's Father, & Grandfather for a good many years as a Minister of the Crown, & my father & grandfather served Queen Victoria; but Yr Majesty's treatment of me has been intimate & generous to a degree that I had never deemed possible.

Indeed Sir we have passed through days & weeks as trying and as momentous as any in the long history of the English Monarchy, & even now there stretches before us a long, forbidding road. I have greatly been cheered by our weekly luncheons in poor old bomb-battered Buckingham Palace, & to feel that in Yr Majesty & the Queen there flames the spirit that will never be daunted by peril, nor wearied by unrelenting toil. This war has drawn the Throne & the people more closely together than was ever before recorded, & Yr Majesties are more beloved by all classes & conditions than any of the princes of the past. I am indeed proud that it shd have fallen to my lot & duty to stand at Yr Majesty's side as First Minister in such a climax of the British story, & it is not without good & sure hope and confidence in the future that I sign myself 'on Bardia day', while the gallant Australians are gathering another twenty thousand Italian prisoners,

Yr Majesty's faithful & devoted
servant & subject
Winston S. Churchill

ABOVE LEFT *Yousuf Karsh (1908–2002)*, Winston Churchill, *1941. Bromide print National Portrait Gallery, London*

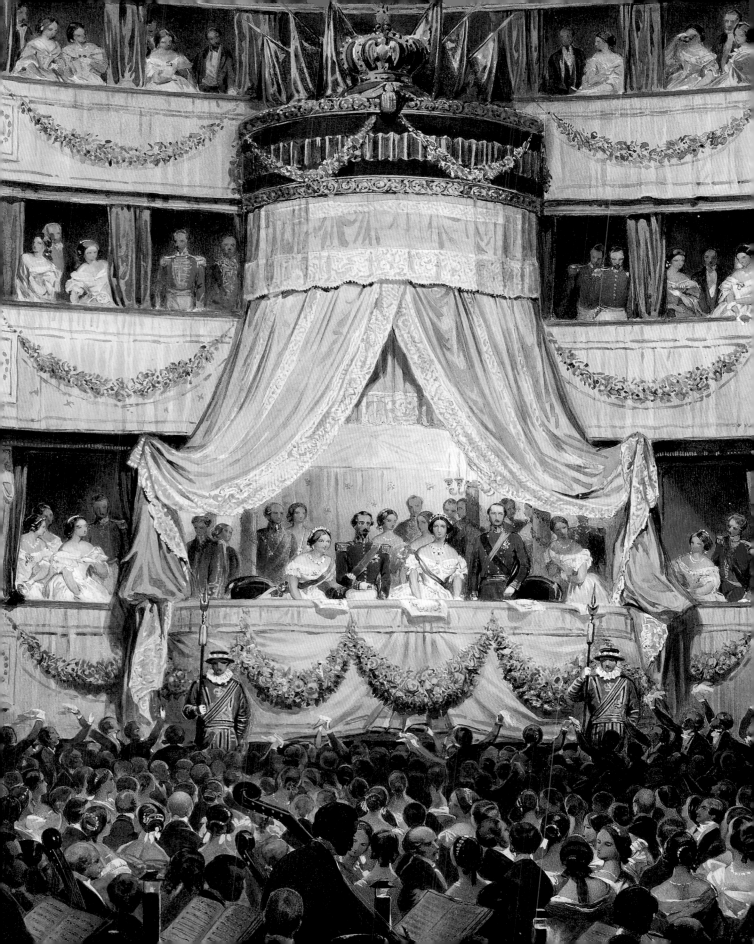

SEVEN ——————— ARTS & SCIENCES

'As commander of the British Antarctic Expedition [I] beg respectfully to inform His Majesty that the expedition hoisted Her Majesty's Union Jack ninety-seven miles from the South Pole ...'

——————— TELEGRAM FROM ERNEST SHACKLETON, 25 MARCH 1909

INTRODUCTION

The education of royal children has always included aspects of the arts, such as drawing and music, and many of them have proved talented; but several Royal Family members have shown a great personal interest in, and aptitude for, the sciences as well, which has resulted in a more personal engagement with scientific developments. The eighteenth and nineteenth centuries witnessed enormous advances in the various branches of science, for which the support of important patrons could be crucial; that of the Sovereign, not surprisingly, was above all to be desired, whether for scientific or artistic endeavours.

George III, for example, founded the Royal Academy of Arts in 1768; he studied architecture and showed some aptitude at it. But he was also greatly interested in developments in astronomy (p. 178), and fascinated by scientific instruments and clocks: he wrote notes on the mechanical aspects of successfully taking apart and reassembling a watch. Prince Albert, consort of Queen Victoria, was highly cultured and knowledgeable about art, so that his involvement in such projects as the rebuilding of the Palace of Westminster proved invaluable (p. 179); but his many interests also included the fledgling science of photography, numerous examples of which subsequently formed the basis of the Royal Photograph Collection.

The visual arts, music and poetry have often contributed to the celebration of royal occasions. A decorated silk programme, for example, was produced to commemorate a command performance during the French State Visit to Britain in 1855 (p. 181), and the Poet Laureate may be called upon to produce verses for his royal patron on specific occasions. However, there are also instances when this royal patronage may have a more personal aspect, as in the friendship between Queen Elizabeth The Queen Mother and the poet Ted Hughes (p. 187).

In view of the shock and grief caused by the premature death of Prince Albert in 1861, it is not surprising that efforts were made to create a fitting national monument to him. The Albert Memorial reflected the breadth of his interests, incorporating work by the best artists and images celebrating famous painters and poets, as well as statues representing manufacturing and engineering (pp. 182–3).

The twentieth century saw scientific exploration reach previously unknown areas of the planet, and lands hitherto uncharted came to bear royal names; just as Shackleton requested permission to name part of Antarctica after Queen Alexandra in 1909 (p. 184), so another part of that continent was named Queen Elizabeth Land in commemoration of the 2012 Diamond Jubilee.

Members of the Royal Family lend support to the arts and sciences through visits to cultural and scientific establishments and in the patronage of specific institutions, and even of expeditions (p. 178), as documented, naturally enough, throughout the Royal Archives. Their personal interests and abilities in these spheres can also be traced in their papers in the Royal Archives, and in their correspondence with men of letters and scientists.

PAGE 174 *James Roberts (c.1800–67)*, The Queen visiting Covent Garden with the Emperor and Empress of the French, 19 April 1855 *(detail), 1855. Watercolour RCIN 920055*

OPPOSITE *Christopher Pinchbeck (1710–83), Sir William Chambers (1723–96) and others,* Astronomical clock, *1768. Tortoiseshell, oak, gilt bronze, silver, brass, steel and enamel. This four-sided clock, with elements designed by George III, has a planisphere as one of its faces (pictured here), reflecting the King's active interest in astronomy (p. 178). RCIN 2821*

The Passage of Venus over the Sun's Disk will happen on the third of June 1769.

Morally speaking, None now living will see the same Phænomenon again; which will only happen again in 1874, and again 2004.

At Richmond.

It is to be presumed that the Planet Venus will be seen compleatly entered as a black Spot on the Top of the Sun's Disk, at about 23 Minutes and a Half Past Seven in the Evening.

Whence if the Weather is favorable the Observation may last distinct for about One Hour and two Thirds of an Hour, till Sunset.

Immersion.
7H. 23 Min. and about a Half Evening.

Venus at Sun-Set will be seen about thus far advanced on Sun's Disk.

1 Hour 15 Minutes and about a Half in the Morning.

Emersion.

Whereby Venus will take up about 5 Hours & 52 Minutes in Passing thro' that Line of the Sun's Disk, could We in that Place viz: Richmond see the whole Transit of Venus.

ABOVE *This memorandum estimates what was likely to be visible of the planet's progress from Richmond.*

Memorandum by George III on the forthcoming transit of the planet Venus across the face of the Sun, n.d. [1769]

RA GEO/MAIN/895

The transit of Venus is a rare but predictable astronomical event, occurring in a pattern repeated every 243 years, with pairs of transits eight years apart. They are important events because when Venus, the Earth and the Sun are in a straight line, it is possible to measure the scale of the solar system by determining the distance of the Earth from the Sun. A transit occurred on 6 June 1761, and its 'pair' was due to occur on 3–4 June 1769.

George III had a great interest in science; his education had included physics, chemistry and natural and experimental philosophy, and a number of the scientific instruments he collected are now kept in the Science Museum. His fascination with astronomy led to his patronage of William Herschel (1738–1822) in the 1780s and to his commissioning an observatory at Richmond, London, in time for the transit of Venus in 1769; the building still stands in the Old Deer Park. In addition, the King contributed £4,000 to fund the Royal Society's expeditions, including that of Captain James Cook (1728–79) to Tahiti, enabling astronomers to view the transit from various points around the globe. The King stayed up to watch the event with a small group including the instrument makers John Cuff (1708–92) and Jeremiah Sisson (1720–83) and the clockmaker Benjamin Vulliamy (1747–1811).

This document, which appears to be in the handwriting of the King himself, is, therefore, a record of a very unusual astronomical event, and indicative of the scientific interests of a Sovereign better known for the illness which blighted his later years.

Memorandum by Prince Albert proposing the scheme of interior decoration for the new Palace of Westminster, 1845

RA VIC/MAIN/F/30/35

When the old Palace of Westminster burned down in 1834, the opportunity arose to build a new home for the House of Lords and the House of Commons. The architect Charles (later Sir Charles) Barry (1795–1860) was appointed to design the new building in 1836, but it was not until 1841 that consideration was given to its decoration. A Royal Commission was appointed for the purpose by the Prime Minister, Sir Robert Peel, and, knowing of Prince Albert's great interest in art, he asked the Prince to be its chairman. The Commission intended to decorate the new building with art of the highest quality, having regard to the 'beneficial and elevating effect of the fine arts upon a people' and also to the patronage that might stimulate trade and manufacture.

As head of this Fine Arts Commission, Prince Albert carried the main responsibility for the decorative scheme, and in this memorandum he suggests suitable subjects for the paintings in the various rooms, including 'representations of the greatest military & naval achievements or … other memorable events in our History'. Competitions were held for the designs and also to test the artists' ability to paint frescoes, the painting style initially chosen. Prince Albert admired this technique, which was being used to great effect in Germany; but in England it was ultimately found to be unsuitable. Progress with the decoration proved slow and the Prince, who died in 1861, did not live to see its completion. However, it was through his influence that Daniel Maclise (1806–70) was persuaded to paint *The Meeting of Wellington and Blücher* (1861) and *The Death of Nelson* (1863–5), which still adorn the Palace of Westminster today.

Prince Albert's interests and abilities were wide-ranging, and Queen Victoria came to rely on his advice in both political and cultural matters. His achievements included the Great Exhibition of 1851. While no separate archive for Prince Albert has survived, some of his correspondence can be found among the Queen's papers, including memoranda and letters by him covering subjects such as foreign affairs, medals, the Church and education. The Prince's involvement and influence in the life of his adopted country, and his abilities and taste, are demonstrated by this document.

ticular Epochs in the History of the Constitution. It contains 8 pannels of equal size & these might be filled with the following subjects.—

1. Alfred giving Laws
2. The Signing of the Magna Charta
3. The Reformation (some event under Henry VIII or Elizabeth prominent in its history.)
4. Cromwell dissolving Parliament.
5. The Restoration. King Charles II landing.
6. Entrance of William III. into London.
7. George III surrounded by his great Ministers meeting Parliament. (perhaps the Closure of the Session of 1793, England alone withstanding the progress of Revolution)
8. The Passing of the Reform Bill.

A.

Transcript (part) of Prince Albert's memorandum

The most difficult subject perhaps, which this Commission has to consider & report upon to the Queen, is the selection of proper Subjects for paintings which are to adorn the Walls of the chief Halls in the new Palace. It is required, that they should at the same time record the chief events of British History, that they should be in harmony with & serve to indicate the peculiar Character of the several parts of the Edifice in which they may be placed, & should afford to the Artist ample scope for the Exhibition of his skill in the <u>highest</u> branch of the Art …

The choice of subjects should be appropriate to the purpose to which this apartment is to be applied & to the name which it bears. In the pannels of the <u>Royal Gallery</u> might be suitably placed the representations of the greatest military & naval achievements or of other memorable events in our History specially connected like them with the excercise of the Royal Prerogative … <u>In the oblong Centre Pannels</u> might be placed the battles of Trafalgar & Waterloo, the most memorable of the naval & military achievements of the last war, the one terminating the struggle at sea, the other laying the foundations of that Peace which Europe has ever since enjoyed …

<u>The three pannels over the Door leading to the</u> <u>Victoria Hall</u> might contain:

the Centre pannel Queen Victoria surrounded by the sovereigns of Europe who come to prove to her their respect for her person & their readiness to cooperate with her in the maintenance of general Peace:

the pannel at the left the signing of the Treaty of Nanking & that on the right the submission of Afghan Chiefs …

<u>St Stephen's Hall</u> containing the Statues of the distinguished patriots, members of the House of Commons & being on the site of the old House of Commons might be adorned with paintings commemorating the particular Epochs in the History of the Constitution. It contains 8 pannels of equal size & these might be filled with the following subjects.

1. Alfred giving Laws
2. The Signing of the Magna Charta
3. The Reformation (some event under Henry VIII or Elizabeth prominent in its history.)
4. Cromwell dissolving Parliament.
5. The Restoration. King Charles's II landing.
6. Entrance of William III into London.
7. George III surrounded by his great Ministers meeting Parliament. (perhaps the Closure of the Session of 1793, England alone withstanding the progress of Revolution)
8. The Passing of the Reform Bill.
A.

BELOW *Daniel Maclise (1806–70)*, The Death of Nelson *(detail of the lower deck of the* Victory*), 1863–5. Waterglass Houses of Parliament, London*

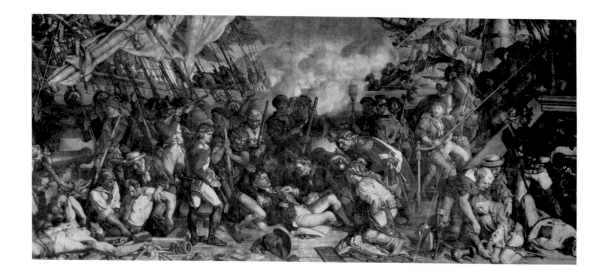

Decorated silk programme for the Command Performance of *Fidelio* at the Royal Italian Opera, Covent Garden, 19 April 1855

RA F&V/PLAYS/DECPROG/1855.0419

In 1855 England and her ally France were engaged in war against Russia in the Crimea. Dissatisfaction with the war's progress prompted the French Emperor, Napoleon III (1808–73), to propose to go to the Crimea in person, a suggestion that greatly alarmed the politicians. The French and British governments therefore suggested to Queen Victoria that she should invite the Emperor and Empress to pay a State Visit to England, and endeavour to persuade the Emperor that his proposal was unwise. The invitation was accepted, and the Emperor and Empress of France visited England from 16 to 21 April 1855.

One of the events arranged to mark this important visit was a performance of Beethoven's opera *Fidelio* at Covent Garden on 19 April. The Royal Archives holds a number of play and concert programmes printed on silk, many of which are for State performances during visits from foreign royalties or Heads of State, together with some from Queen Victoria's own private and extensive play-going. This is the finest example, presumably specially produced to commemorate the imperial couple's visit in 1855.

From Queen Victoria's Journal, it appears that only the second act of the opera was given on this occasion. She said little about the performance, but did note that, on leading the Emperor in, 'The applause generally was very marked, & very marked for <u>him</u>.' The visit proved a great success, both personally and politically. Queen Victoria, who had been very sympathetic towards the previous French ruler, King Louis Philippe (who had died in exile in England in 1850), was charmed by Emperor Napoleon III and Empress Eugénie, and the Queen, Prince Albert and their two eldest children paid a return visit to Paris later the same year. More importantly, perhaps, from the political point of view, the Emperor never carried out his proposed visit to the Crimea.

ABOVE *James Roberts (c.1800 – 67),* The Queen visiting Covent Garden with the Emperor and Empress of the French, 19 April 1855, *1855. Watercolour RCIN 920055*

Letter from George Gilbert Scott to Lieutenant-General Charles Grey (Equerry and acting Private Secretary to Queen Victoria), 25 April 1864, describing his ideas and proposed sculptures for the National Memorial to Prince Albert, the Prince Consort; and sketches and elevations for the proposed monument

RA VIC/ADDH/2/798–9, 815 and 817

When Prince Albert died of suspected typhoid fever on 14 December 1861, at the age of just 42, Queen Victoria was plunged into deep grief. The nation also mourned, perhaps with some self-reproach as the Prince had not always been universally admired. A month after Prince Albert's death, a public meeting at the Mansion House in London resolved that a memorial 'of a monumental and national character' should be erected to him, its nature and design to be decided by the Queen.

Initially the Queen's preference was for an obelisk, with groups of statuary at its base; its position was to be in Hyde Park on the site of the 1851 Great Exhibition, in which the Prince had played such a prominent role. Difficulties in acquiring a suitable piece of granite, however, resulted in this plan being abandoned.

In June 1862 seven architects were asked to submit designs for the memorial to Prince Albert; those by the English gothic revival architect George Gilbert Scott (1811–78) were ultimately chosen. He had already been approached by Queen Victoria to convert the Wolsey Chapel in Windsor Castle into a memorial chapel for the Prince, and he later received a knighthood for his work on the Albert Memorial.

Although the different sculptors for the central figure of Prince Albert and the allegorical groups were chosen by the Queen, they were all required to follow Scott's basic design. In this letter the architect emphasises 'that unity of purpose which is so essential to the success of our common work',

BELOW LEFT & OPPOSITE
Scott's sketches and elevations for the proposed monument

BELOW RIGHT *Sir George Gilbert Scott (1811–78),* Design for the Memorial to the Prince Consort, Kensington Gardens, *1863. Watercolour* RCIN 921531

and describes the proposed designs for the groups depicting the continents. 'Europe' was ultimately sculpted by Patrick Macdowell (1799–1870), 'Asia' by J.H. Foley (1818–74), 'Africa' by William Theed (1804–91) and 'America' by John Bell (1811–95). Smaller sculptural groups represented the 'Industrial Arts': 'Agriculture', 'Manufactures', 'Engineering' and 'Commerce'.

This letter, and Scott's sketches of the ground plan and the various measurements of the sculptural groups, are among a substantial group of papers in the Royal Archives concerning the Memorial. This includes correspondence not only on the designs ultimately chosen for the Memorial but also on those rejected. This collection forms a particularly valuable and rich source for one of Britain's most famous monuments, a unique representative of High Victorian gothic.

Transcript (part) of Scott's letter

… I send you photographic representations of the <u>three</u> of each which were modelled (by Mr. Armstead) as portions of the general model of the memorial, and which are to my mind well grouped as far at least as regards their outline and dimensions as portions of the general design.

In these little models Europe is represented by Europa on the bull surrounded by representatives of the leading nations and races, as England and Germany for the Teutonic races, and France and Italy for those of latin origin. Asia is represented by a female figure on an Elephant – unveiling herself as alluding to the great position she took in the Exhibition of 1851, around her are figures illustrative of China Tartary and India. The latter intended to idealize the Ganges. Africa is represented by a female figure (perhaps representing ancient Egypt) on a lion, surrounded by a Nubian a Negress and figures intended to idealize the rivers Niger and the Nile. These, however, are only ideas which occurred in making the small model.

I also send a plan shewing the dimensions of the bases of the groups and some suggestions as to their height and outline.

These eight groups forming integral parts of my general design for the monument, it becomes essential to the success and perfection of that design that the several artists to whom they are committed should view them as in every sense portions of a great whole, and should, from the first, design them in harmony – the one with the others – and in unity with the 'whole conception of' the design. If this is not determinedly and loyally acted up to, the harmony of the monument and the unity of the design will inevitably be destroyed …

Telegram from Ernest Shackleton to King Edward VII, 25 March 1909, reporting on his achievements in the Antarctic and seeking permission to name a mountain range after Queen Alexandra

RA PPTO/PP/EVII/MAIN/D/31400

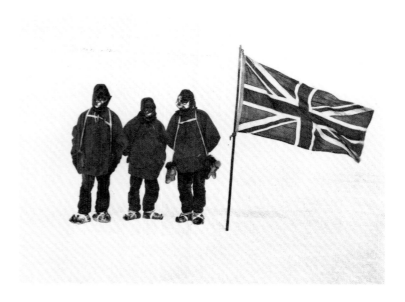

ABOVE *Eric Marshall (1879–1963)*, Adams, Wild and Shackleton beside the Union Jack at Furthest South, 9 January 1909 *RCIN 1124430*

The first quarter of the twentieth century witnessed a number of expeditions to the still largely unknown and unmapped continent of Antarctica. Among those who ventured on these perilous journeys were the British explorers Robert Falcon Scott (1868–1912) and Ernest Shackleton (1874–1922), both of whom became famous as a result of their adventures. Having been a member of Scott's 1901–04 Antarctic expedition (from which he had been sent home early on account of ill health), Shackleton in due course led his own explorations, and in the years 1907–09 returned to the Antarctic in search of the South Pole and the magnetic South Pole.

The Nimrod expedition (named after the ship Shackleton had acquired for the trip) left England on 7 August 1907; before its departure the ship was inspected by King Edward VII, Queen Alexandra, the Prince of Wales and other members of the royal family at Cowes. The King made Shackleton a Member of the Royal Victorian Order (MVO) and the Queen presented him with a Union Jack to carry to the South Pole.

The expedition met with mixed success. Although team members achieved the first successful ascent of Mount Erebus (an active volcano near the expedition hut) and passed the Furthest South set by Scott, by early 1909 they were in desperate straits. On 9 January a team of four, including Shackleton, planted Queen Alexandra's flag 97 miles (156 km) from the Pole, and thus set a new Furthest South record; but then they had to turn back, nearly starving to death on their return journey to the ship. Meanwhile, other

expedition members had managed to reach the South Magnetic Pole on 16 January; by March all parties were back on the *Nimrod*, which left for New Zealand on 9 March.

From Christchurch, Shackleton sent this telegram to inform the King of the expedition's achievements and to request permission to name a mountain range after the Queen. In his response the King sent his congratulations on 'the splendid result accomplished by your Expedition', and 'gladly' gave his assent to 'the new Range of Mountains in the far South' bearing the Queen's name: the Queen Alexandra Range, about 100 miles (160 km) long, is to be found in East Antarctica. After Shackleton's return to England, the King and Queen received him at Buckingham Palace on 12 July, when the King made him a Commander of the Victorian Order; it was probably on this occasion that Shackleton returned the Queen's flag, for it now hangs in Sandringham House.

For all its appearance, this frail-looking document is therefore part of the extraordinary history of Antarctic exploration.

Transcript of Shackleton's telegram

TRUST I AM IN ORDER IN ASKING YOU
TO CONVEY TO HIS MAJESTY THE
FOLLOWING MESSAGE I AS COMMANDER
OF THE BRITISH ANTARCTIC EXPEDITION
BEG RESPECTFULLY TO INFORM HIS
MAJESTY THAT THE [E]XPEDITION
HOISTED HER MAJESTY'S UNION JACK
NINETYSEVEN MILES [F]ROM THE
SOUTH POLE AND THE UNION JACK ON
THE SOUTH MAGNETIC POLE MAY I BE
PRIVILEDGED TO NAME A NEW RANGE
OF MOUNTAIN[S] IN THE FAR SOUTH
AFTER HER MAJESTY = SHACKLETON
CHRISTCHURCH NEW ZEALAND

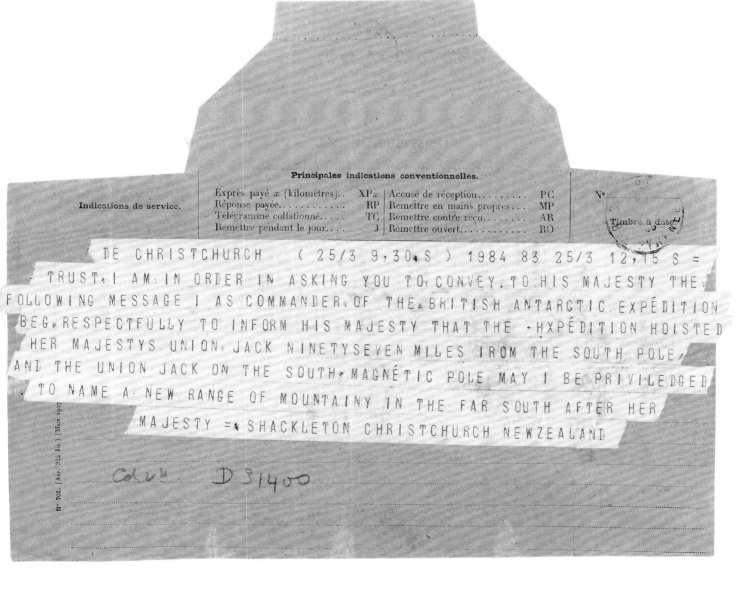

The Herbs Of Glen Gairn —— for His Majesty Queen Elizabeth The Queen Mother —— Birkhall

Miss Dimsdale! O Miss Dimsdale!
With radar or with hound,
By hook or crook, the mystery
'Miss Dimsdale' must be found.

 The rumours! O the rumours!
 Her behaviour so suspicious!
 A fox has been arrested for
 Miss Dimsdale in her fur!
 Some say she robbed a pram or carried
 Off against his wishes
 The American Evangelist
 Who worships only her.

Miss Dimsdale, O where is she?
She was here, and she was there,
But now we need to find her she has vanished
Into air.

 The Aberdeen Police are keen
 To be the lucky finder.
 Did she collapse the government
 By whispering to a spy?
 Or else abscond with all the Funds
 Of Global Babyminders?
 Or is she some great actress resting
 From the Public Eye?

Miss Dimsdale! O Miss Dimsdale!
Is she lost or on the run?
Or is there some huge prize she must
Be told that she has won?

Perhaps she is a character
Escaped out of some Drama
Left half-written when the writer
Won the lottery.
But she was glimpsed at Ballater
Sweeping in all her glamour
Going West. Then going East
Glimpsed at the Brig o' Dee.

Miss Dimsdale! O Miss Dimsdale!
By radar or with hound,
By hook or crook, the mystery
'Miss Dimsdale' must be found.

 So we went up the Gairn and asked
 The ringing rock to raise her.
 It rang so clear — and lo! there rose
 A spirit from the burn.
 The magic herbs dripped in her hands,
 But what seemed to amuse her
 Was our astonished and delighted
 Greeting: "O return

Miss Dimsdale! O Miss Dimsdale!
And turn your face to us,
Let us recognize you, please
Be less mysterious."

 She turned and was a sunburned Elf,
 A creature of the weather
 A bonny Scottish witch, her hair
 About her like a shawl.
 And she took our scone and sandwich
 With a smile like sun on heather
 And a gaze like a wild-cat's pondering
 The night-lights of Birkhall.

The Herbs of Glen Gairn, a poem by
**Ted Hughes, written in his own hand
and dedicated to Queen Elizabeth
The Queen Mother, May 1993**

RA QEQM/PRIV/PAL/HUGHES

Edward James 'Ted' Hughes (1930–98) was
appointed Poet Laureate in succession to Sir John
Betjeman in 1984, and held the position until his
death in 1998. The Poet Laureate is a member of
the Royal Household, and originally was expected
to compose odes or verse to mark such occasions as
the Sovereign's birthday. Nowadays the post has
become largely honorary, although the Poet
Laureate may still write commemorative verses
if they so wish. Among Hughes's work, for example,
are verses on the christening of Prince Henry in
1985 and on Queen Elizabeth's 90th birthday.

Queen Elizabeth The Queen Mother first met
Ted Hughes in 1987, when he spoke at the King's
Lynn Festival. Queen Elizabeth enjoyed reading
and liked poetry and she had drawn great comfort
from the anthology *A Book of Flowers* which Edith
Sitwell sent her after King George VI's death in
1952. She and Hughes became good friends,
exchanging correspondence, and he was a regular
guest at Queen Elizabeth's social gatherings. During
one of his visits to Birkhall (Queen Elizabeth's home
on the Balmoral estate in Deeside), Hughes and the
Queen Mother had seen a young woman collecting
moss near the place where they picnicked; they
decided she must be a 'Nymph of the Glen',
and from this flight of fancy Hughes created the
imaginary character and life of 'Miss Dimsdale' in
these verses. He sent the poem to Queen Elizabeth
in a letter dated 25 May 1993, writing 'A chance to
turn Miss Dimsdale and Mrs Skyross into propitious
and helpful figures was not to be neglected … The
enclosed rhymes are very slight. But they will <u>be</u> all
I hoped they might be, if they give Your Majesty
some pleasure, recalling those two strange ladies
who entertained us so much.' Queen Elizabeth was
delighted, and even extended the fiction by sending
him a letter (in her own hand) allegedly written by
Miss Dimsdale, thanking Hughes 'for finding me …
now I know who I am', and then by later writing to
suggest a marriage between Miss Dimsdale and the
Reverend Cedric Potter, another of Hughes's
imaginary characters.

As well as being an example of the work of one
of the twentieth century's leading literary figures,
this poem is a token of a special friendship, and
indicative of Queen Elizabeth's enjoyment of the
company of cultured individuals: among her other
friends were Osbert Sitwell, Benjamin Britten,
Noel Coward and Edward Seago. It is not surprising
that correspondence with men of letters may be
found among the papers in the Royal Archives,
but this poem shows a particularly personal interest
and engagement.

ABOVE *Bob Tulloch (b. 1950),*
Ted Hughes, *1999. Pencil*
RCIN 933520

ECLIPSE

London, Published Sept.ʳ 1, 1796, by Mefs.ʳˢ Stubbs High Street Marybone

EIGHT ———————— PASTIMES & PASSIONS

'I must say I have the greatest confidence in our driver – I poke him violently in the back at every corner to go gently & whenever a dog, child or anything else comes in our way! ...'

——————— LETTER FROM QUEEN ALEXANDRA TO GEORGE, PRINCE OF WALES, 28 JUNE 1901

INTRODUCTION

When not engaged on official business, members of the Royal Family have been able to indulge their enthusiasm for many varied leisure interests. Since medieval times they have taken part in outdoor pursuits such as hunting, horse-riding, angling (p. 198) and sailing. Many have been interested in the breeding of animals, including dogs, and particularly horses for racing. This began with the Duke of Cumberland in the eighteenth century (p. 192), carried on by George IV as Prince of Wales and then King Edward VII, also when Prince of Wales (p. 199), and continues today with the successful horse studs at Hampton Court and Sandringham belonging to Queen Elizabeth II. A love of gardening and landscaping has also been handed down through successive generations, and Kew Gardens, created by Augusta, Princess of Wales in the mid-eighteenth century, provides a lasting testimony to this royal pastime (p. 195).

Scientific and technological progress has frequently been embraced by members of the Royal Family. George III commissioned new scientific instruments for his private collection, which are now in the Science Museum, London. His commissions included hydraulic, pneumatic and mechanical instruments, chronometers, specialist equipment to facilitate his interest in astronomy (p. 178), and even lightning conductors. A hundred years later Prince Albert became an early supporter of photography, Queen Alexandra became an enthusiastic and talented amateur photographer, and in modern times photography has been one of the Duke of York's main hobbies. In addition, King Edward VII and Queen Alexandra were particularly keen adopters of the newly invented motor car in the late 1800s and early 1900s (p. 200).

Other leisure activities enjoyed by past monarchs and their families have included sketching and painting, needlework, stamp collecting and reading – King George V kept a detailed list of the hundreds of books he read over a 46-year period (p. 201). Cultural pastimes such as visits to the theatre, opera and concerts have also been a staple part of royal life over the centuries; Queen Victoria in particular was a keen patron of the arts, and her collection of playbills provides a fascinating insight into the world of nineteenth-century theatre (p. 196).

These pastimes and passions, and more, are well documented in the innumerable letters, diaries, accounts and souvenir items held by the Royal Archives, which reveal details of the leisure time enjoyed by members of the Royal Family away from the formalities of their public lives.

PAGE 188 *After George Stubbs (1724–1806), Eclipse (detail), 1796. Print* RCIN 502095

OPPOSITE *Johan Jacob Schalch (1723–89), The Gardens at Kew (detail), c.1760. Oil on canvas. This view was commissioned by Augusta, Princess of Wales, in 1759, and shows part of her gardens at Kew, with a small temple in the distance (p. 195).* RCIN 403517

Register of mares owned by the Duke of Cumberland, 1761–2, and a list of the Duke's horses, 1 May 1764

RA CP/MAIN/70/151, 156

The strong association between the Royal Family and the breeding and racing of horses is exemplified by Prince William Augustus, Duke of Cumberland, son of George II and Queen Caroline.

The Duke is perhaps best known for his role in suppressing the Jacobite uprising at Culloden in 1746 (p. 143); but he was also one of the leading figures in British horse racing. From his youth he enjoyed frequent hunting meets in the Royal Parks; his love of horses and hunting developed into a passion for horse racing and breeding at his own stud at Cranborne Lodge in Windsor Great Park. He was frequently present at race meetings at Newmarket and Ascot as an owner, breeder and, indeed, gambler. The Duke had revived the Ascot races following their decline after the death of Queen Anne (who had founded the Ascot Racecourse in 1711), and he was one of the founding members of the Jockey Club in 1750, thereby playing a significant role in the regulation and management of horse racing.

This register of mares owned by the Duke of Cumberland in 1762 is one of the oldest documents in the Royal Archives reflecting the Royal Family's interest in horses. It also details the covering stallions and their offspring. Of particular significance are the mare Spiletta and the stallion Marske, who would be the sire and dam of the foal Eclipse, born on 1 April 1764, who, though unnamed, is shown in the list of the Duke's horses (opposite). Following the Duke's death in October 1765, Eclipse was sold on and later became one of the greatest horses in racing history. He started and won 18 races in a career that began in May 1769 and ended less than eighteen months later; he was just too good and his undefeated record meant that spectators were not betting on rival horses. Eclipse was retired to stud in 1771 and died in 1789; he, Matchem and Herod (the latter also bred by the Duke of Cumberland) are widely regarded as the foundation sires of the modern thoroughbred racehorse.

Suckers.

	Stones	Pounds	Miles	Guineas	Forfeit
Maske, out of Spilletta a Chestnut Colt, with a bald Face, & the off hind Leg, white up to the Hock. 1st Sp: M: 68. ag.t the D: of Grafton's Colt, by Doctor. L: Rock.ms Colt by the Godolphin Hunter; Lord Boling's. Colt, by Damascus; L: Gower's Colt, by Sweepstake L: Orford Colt, by Feather; Mr Shafto's Colt, by his Hunter —	8	10	4	each 100	P P +

55600

Plaisterer's work done for Her Royall Highness

Princess Dowager of Wales

in her Gardens Kew &c. F. Engleheart

1769 — Temple of Bellona £ . s . d

yds

138 .. washing stoping and Whiting — — — — — a ½p · 0 - 4 · 9

10·0 do .. to plain Mouldings — — — — a ¾ · 0 · 0 · 5

133·8 do. to Enricht cornice &c. — — — a 1 · 0 · 11 · 3½

5/3 ... do ... Portico do — — — — a 1½p · 0 · 0 · 8

Moresque Temple.

April 21 — 2 Plaic. & Labourer 6 days Ea. repairing out side ⎫
5 hods fine Stuff 5 do Course 4 do finishing 1 hundd ⎬ ·· 3 · 5 · 6
Plaister Lathe & Nails &c. — ⎭

Gothic Cathedral.

28 .. Plaic. & Lab. 1 day Ea. repairing out side 1 hod Lime & ⎫
hair 1 do finishing & 1 bagg of Plaister — — — ⎬ ·· 0 · 10 · 0

Temple of the Sun.

29 — Plaict. & Lab. 5 days Ea. repairing out side cornice 3 ⎫
hods fine Stuff 3 baggs of Plaister ⎬ ·· 1 · 14 · 0

May · 8 · — Greenhouse.

Plaic. & Lab. 1 day Ea. making good outside 1 hod Stucco ⎫
finishing 1 bagg of Plaister — ⎬ ·· 0 · 9 · 4

15 · — Plaic. Lab & boy 3 days Ea. repairing Mosque · 4 Bundles ⎫
Lathe & Nails 64 hods Course Stuff 14 do finishing 5 do ⎬ 7 · 3 · 2
@ fine Stuff 100 ½ Plaister ½ thousand 10 Nails — ⎭

22 — Plaic. & Labourer 5 days Ea. making good round windows ⎫
&c in do ½ hod fine Stuff 3 hods finishing 1 bagg of Plaister ⎬ 1 · 13 · 10

Temple of Bellona.

29 — Plaic. & Lab. 3 days & ½ Ea. making good read mouding &c ⎫ 2 · 16 · 4
12 hods Course Stuff 4 do finishing 2 do fine Stuff 3 baggs ⎬ ————————
Plaisters ½ thousd Nails 2 bundle Laths ⎭ £ 18 · 9 · 3½

Bill for work carried out on buildings in Kew Gardens for Augusta, Princess Dowager of Wales, by F. Engleheart, 1769

RA GEO/MAIN/55600

The royal estate at Kew was first leased in 1731 by Frederick, Prince of Wales (son of George II), and, following his marriage to Princess Augusta of Saxe-Gotha-Altenburg in 1736, the White House at Kew became a family retreat for the Prince and Princess and their seven children, including the future George III.

In the late 1740s the Prince of Wales turned his attention to the expansion of the estate and purchased over 70 additional acres (28 hectares), 32 acres (13 hectares) of which had been landscaped and planted by 1751. The Prince also embarked on a scheme to introduce exotic plants, ornamental buildings, statues and water features to the gardens. However, in March 1751 he was taken ill while supervising his workmen at Kew and 'Poor Fred', as he is often known, died on 20 March at the age of 44. His death was subsequently attributed to a burst abscess on a lung, caused by an old sporting injury.

Following her husband's death, Princess Augusta continued his work at Kew under the guidance of the botanists John Stuart, third Earl of Bute (1713–92), and the Reverend Stephen Hales (1677–1761). The gardens were extended and landscaped, and many distinctive garden buildings were built for the Princess, including the Orangery, the Chinese Pagoda and the Temple of Bellona, all of which can still be seen at Kew today. In 1759 Princess Augusta set aside about 10 acres (4 hectares) of her estate at Kew to create a Physic or Exotic Garden, managed by the gardener William Aiton (1731–93). The garden featured the Great Stove (since demolished), a large hothouse designed by Sir William Chambers (1723–96). By 1768 the botanical garden contained around 3,400 species: the Royal Archives has a number of bills for various seeds, plants and trees purchased by Princess Augusta for the garden.

The Princess Dowager of Wales died in 1772, but her patronage of the gardens at Kew, and the continuing interest of successive monarchs and their consorts, created the legacy of the Royal Botanic

Gardens, now one of the world's foremost sources of reference on botanical matters and home to an unsurpassed plant collection. Today, Kew Gardens also contributes to worldwide nature conservation through the research, propagation and seed storage of endangered species.

The Prince and Princess of Wales's passion for gardens is evident in subsequent generations of the Royal Family. Queen Victoria and Prince Albert created landscaped gardens at Osborne House and Balmoral, while King George VI and Queen Elizabeth transformed the gardens of Royal Lodge at Windsor and of Sandringham House. Today, the gardens at Highgrove, designed by Charles, Prince of Wales, are considered to be some of the most inspired and innovative in the country.

ABOVE *Jean-Étienne Liotard (1702–89), Augusta, Princess of Wales, 1754. Pastel on paper RCIN 400892*

OPPOSITE *This bill, dating from 1769, shows details of some of the plastering work undertaken by Francis Engleheart on a number of garden buildings, and is an example of one of the many bills for the Prince and Princess of Wales held by the Royal Archives.*

Queen Victoria's copy of the playbill for *The Frozen Deep*, featuring Charles Dickens, performed on 4 July 1857

RA F&V/PLAYS/PLAYBILLS

Two of Queen Victoria's great passions were opera and the theatre, and from girlhood until the deaths of her mother, the Duchess of Kent, and her husband, Prince Albert, in 1861, she enjoyed attending performances and plays regularly. Some years later she began to invite theatrical companies to perform privately at Windsor Castle, but did not venture again to public performances. Queen Victoria's enthusiasm for this particular pastime is reflected in the large collection of playbills and texts she collected during her theatre-going years, now in the Royal Archives.

This example of a playbill from the collection relates to a production of *The Frozen Deep* by Wilkie Collins (1824–89), a story based loosely on the ill-fated 1845 Franklin expedition to discover the Northwest Passage across the Arctic Ocean. The play began life as an amateur theatrical, directed by and featuring the author Charles Dickens (1812–70), and it was decided that a special performance with non-professional actors, including Dickens, should be staged at the Royal Gallery of Illustration in Regent Street, London, on 4 July 1857. Dickens personally invited the Queen to the performance, and she attended with her four eldest children and other guests. She later recorded in her Journal that the play was:

> *most interesting, intensely dramatic, & most touching & moving, at the end. The Play was admirably acted by Charles Dickens, (whose representation of Richard Wardour, was beyond all praise & not to be surpassed) … There was charming scenery & almost constant accompaniment of music, which adds so much to the effect of a Melodrama. We were all kept in breathless suspense, & much impressed.*

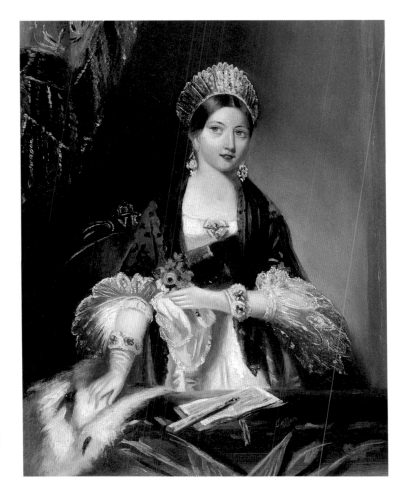

Between the performance of *The Frozen Deep* and the farce that was to follow, Queen Victoria sent for Charles Dickens, but he begged to be excused. Dickens recalled some years later in a letter to Arthur Helps (Secretary to the Privy Council), 'I was already dressed for the farce in a ridiculous wig and dressing gown, and felt, not being a professional actor, that there would be something incongruous in my so presenting myself for the first time before the Queen and the late Prince Consort'. Queen Victoria did not meet Charles Dickens in person until March 1870, only three months before his death. After he died on 9 June, Queen Victoria noted that 'He is a very great loss. He had a large, loving mind & the strongest sympathy with the poorer Classes. He felt sure that a better feeling – & much g[rea]ter union of Classes wld take place in time. And I pray earnestly it may.'

ABOVE *Edward Thomas Parris (1793–1873)*, Queen Victoria at the Drury Lane Theatre, November 1837, *c.1837. Oil on panel RCIN 405577*

Pitrick —

GALLERY OF ILLUSTRATION,

REGENT STREET.

STRICTLY PRIVATE REPRESENTATION.

UNDER THE MANAGEMENT OF MR. CHARLES DICKENS.

On Saturday evening, July 4th, 1857, AT 9 O'CLOCK, will be presented

AN ENTIRELY NEW

ROMANTIC DRAMA, IN THREE ACTS, BY MR. WILKIE COLLINS,

CALLED

THE FROZEN DEEP.

PERFORMED BY THE AMATEUR COMPANY OF LADIES AND GENTLEMEN WHO
ORIGINALLY REPRESENTED IT, IN PRIVATE.

THE OVERTURE COMPOSED EXPRESSLY FOR THIS PIECE BY MR. FRANCESCO BERGER.

The Dresses by MESSRS. NATHAN, *of Titchbourne Street, Haymarket.* Perruquier, MR. WILSON, *of the Strand.*

CAPTAIN EBSWORTH, *of The Sea Mew* . . .	MR. EDWARD PIGOTT.
CAPTAIN HELDING, *of The Wanderer*	MR. ALFRED DICKENS.
LIEUTENANT CRAYFORD	MR. MARK LEMON.
FRANK ALDERSLEY	MR. WILKIE COLLINS.
RICHARD WARDOUR	MR. CHARLES DICKENS.
LIEUTENANT STEVENTON	MR. YOUNG CHARLES.
JOHN WANT, *Ship's Cook*	MR. AUGUSTUS EGG.
BATESON } *Two of The Sea Mew's People* . . .	{ MR. SHIRLEY BROOKS.
DARKER }	{ MR. FREDERICK EVANS.

(OFFICERS AND CREWS OF THE SEA MEW AND WANDERER.)

MRS. STEVENTON	MISS HELEN.
ROSE EBSWORTH	MISS KATE.
LUCY CRAYFORD	MISS HOGARTH.
CLARA BURNHAM	MISS MARY.
NURSE ESTHER	MRS. FRANCIS.
MAID	MISS MARLEY.

THE SCENERY AND SCENIC EFFECTS OF THE FIRST ACT, BY MR. TELBIN.
THE SCENERY AND SCENIC EFFECTS OF THE SECOND AND THIRD ACTS, BY **Mr. STANFIELD, R.A.**
ASSISTED BY MR. DANSON.
THE ACT-DROP, ALSO BY **Mr. STANFIELD, R.A.**

To Conclude with the Farce, in One Act.

TWO O'CLOCK IN THE MORNING.

MR. SNOBBINGTON	MR. CHARLES DICKENS.
THE STRANGER	MR. MARK LEMON.

Musical Composer and Conductor of the Orchestra, **Mr. FRANCESCO BERGER,**
WHO WILL PRESIDE AT THE PIANO.

Prince Alfred's game book, recording fish caught in the river Alten in Norway, with sketches by Oswald Walters Brierly, July and August 1864

RA VIC/ADDA20/1768

The Royal Family's love of country pursuits is exemplified by this game book belonging to Prince Alfred, later Duke of Edinburgh, fourth child and second son of Queen Victoria and Prince Albert.

In July 1864, at the age of 19, Prince Alfred was serving on the ship HMS *Racoon* during its cruise to Norway. As part of the cruise, Prince Alfred visited the sixth Duke of Roxburghe at his fishing quarters on the river Alta (Alten) in Norway. The Duke had leased a 25-mile (40-km) stretch of the river since 1862 and with its rapid streams, succession of pools and size and quantity of fish, the Alta provided some of the best salmon fishing in the world. The Prince was a keen fisherman and records in this game book details of the fish he caught in streams around Sandia and Raipas, locations near the Alten. In a letter to his mother on 11 August, Prince Alfred wrote that the sport 'has been very good & I have caught a great many salmon the largest 24lbs weight half a pound heavier than any I have ever caught before'.

The marine painter Oswald Walters Brierly (1817–94) accompanied the Prince on board HMS *Racoon* in order to capture scenes from the cruise, and his work included these two pencil-and-wash sketches of the encampments at Raipas and Sandia. The remaining pages of the game book, which begins in 1863 and includes entries up until the late 1890s, record details of the various shoots of game animals and birds (including deer, wild boar, rabbits, partridges and pheasants) in which Prince Alfred took part. The shoots took place in various locations around Britain and also during overseas visits made during the Prince's naval career. After 1893 the book records details of shoots in Germany, where he resided after succeeding to the dukedom of Saxe-Coburg and Gotha.

RAIPAS

SANDIA

ABOVE *These sketches were included in Prince Alfred's game book: it is very unusual to see artwork of this nature in such a volume.*

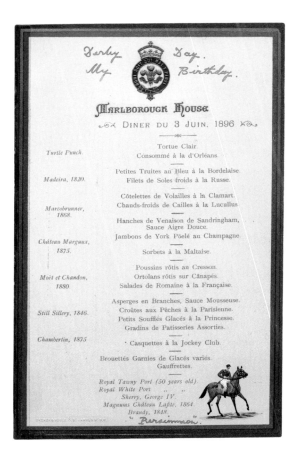

The Prince of Wales's racehorse won the Epsom Derby, 3 June 1896: Prince George's race card with note of his lottery win, and Marlborough House dinner menu

RA GV/PRIV/GVD/1896

Albert Edward, Prince of Wales (later King Edward VII), continued the royal tradition of owning and training racehorses begun by his Georgian forebears. One of his greatest successes was Persimmon, which he had bred at his stud at Sandringham, Norfolk, in 1893. This bay horse began his racing career in 1895 and in June 1896 became the first royal-owned winner of the Epsom Derby for over a century. Later that year, Persimmon won the St Leger and the Jockey Club Stakes, and in 1897 went on to win the Eclipse Stakes and the Ascot Gold Cup. This last win was not repeated by a royal horse until 2013, when Estimate became the first ever horse owned by a reigning monarch, Queen Elizabeth II, to win the Ascot Gold Cup. Persimmon was retired to stud towards the end of 1897, and his statue still stands at Sandringham as testament to one of the most successful royal racehorses of all time.

George, Duke of York (later King George V), attended the Derby on 3 June 1896, his 31st birthday, and recorded the exciting win of his father's horse in his diary: 'it was a splendid victory & it was only won by a head, Papa led "Persimmon" in, he got a tremendous ovation, I never saw such a sight & I never heard such cheering. I won £300 on the race.'

ABOVE LEFT *Kept with the diary is the menu, illustrated with a horse and jockey, for the dinner held at Marlborough House that evening. This annual Derby Day dinner, hosted by the Prince of Wales for his friends and colleagues in the 'turf' set', was a highlight of the racing calendar.*

ABOVE RIGHT *On the race card for the event, which is still kept inside his diary for that year, the Duke noted 'I Drew this [Persimmon] in the lottery in the stand'.*

Letter from Queen Alexandra to her son, George, Duke of York, in which she describes motoring on the Sandringham estate, 28 June 1901

RA GV/PRIV/AA32/30

The association between the Royal Family and motoring first began with Albert Edward, Prince of Wales, in the mid-1890s. The Prince was keen to try one of the new 'horseless carriages' exhibited by the burgeoning automobile industry at the Imperial Institute in May 1896, and his growing enthusiasm for motoring resulted in an order for his first car, a Daimler, in 1900. The following year the Prince came to the throne as King Edward VII and, during the nine years of his reign, he added several new cars to the Royal Mews, including additional Daimlers, two Mercedes and a Renault.

Queen Alexandra shared her husband's interest in motoring and as early as 1901 kept a two-seater Columbia electric car at the Sandringham estate. The Queen also expressed an interest in learning to drive in April of that year, when her lady-in-waiting, Miss Charlotte Knollys, wrote to Paris Singer (at that time a leading member of the Automobile Club of Great Britain) that 'the Queen as well as myself will be most grateful for some instruction in driving'. Miss Knollys had just acquired her own runabout at Sandringham with Singer's help.

In this letter, written in the same year, to 'her own darling Georgie boy', the future King George V, Queen Alexandra describes her delight at motoring at 50 miles per hour around Sandringham and her own particular method of controlling her driver.

Transcript (part) of Queen Alexandra's letter

… We had a charming week or ten days at Sandringham which was in great beauty at that moment … We had a splendid Motor Car down there & I did enjoy being driven about in the cool of the evening at <u>50.</u> miles!! an hour! when <u>nothing</u> in the way – of course only! – & I must say I have the greatest confidence in our driver – I poke him violently in the back at every <u>corner</u> to go gently & whenever a <u>dog</u> <u>child</u> or anything else comes in our way! …

List of books read by King George V between 1890 and 1936

RA GV/PRIV/AA7/46

Contrary to his popular image, King George V was an avid reader. This book list, kept between May 1890 and the King's death in January 1936, shows that he read over a thousand books in just under 46 years. This was no mean achievement, particularly if one takes into account the King's many official duties and other leisure pursuits, which included sailing, shooting and stamp collecting.

The books read by the King included biographies and memoirs of royal and public figures and accounts of war, both from the official perspective, such as *The Truth about Jutland* by J.E.T. Harper, but more often from a personal viewpoint: the list includes renowned works such as *All Quiet on the Western Front* by Erich Maria Remarque, *Goodbye to All That* by Robert Graves and Ernest Hemingway's *A Farewell to Arms.* The King also enjoyed books on sport, such as the reminiscences of horse trainer Charles Morton, *My Sixty Years of the Turf*, and books on travel and adventure, including *The Fight for*

Everest 1924 by Lieutenant-Colonel Edward Norton, who led the expedition.

Among the many books read by King George V, however, are also a wide variety of works of fiction, including *The Thirty-Nine Steps* by John Buchan, *Uncle Tom's Cabin* by Harriet Beecher Stowe and *The Hound of the Baskervilles* by Arthur Conan Doyle. Rather surprising, perhaps, is the inclusion of the novel *Lady Chatterley's Lover* by D.H. Lawrence, first published privately in Italy in 1928. An unexpurgated edition of this controversial novel was not published in Britain until 1960; however, the King obtained a copy in 1933 through John Colville, son of Lady Cynthia Colville, lady-in-waiting to Queen Mary.

BELOW *These two pages from his reading list illustrate the King's varied literary tastes, and also suggest that he was keen to read new publications: many of the books on these pages were published in 1933.*

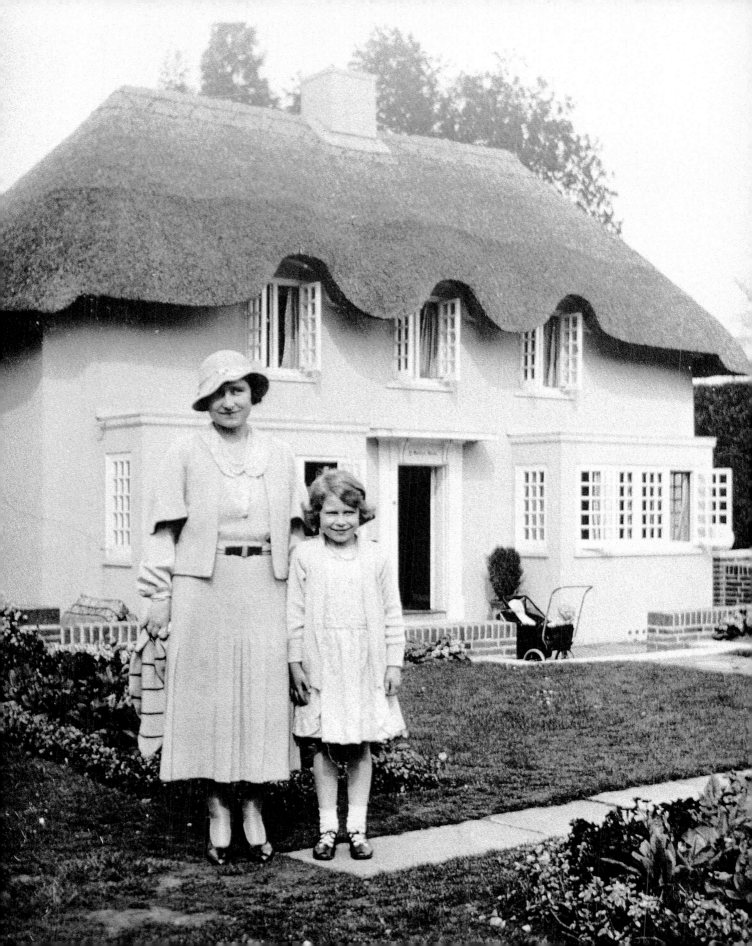

NINE —————— FAMILY LIFE

'I need not tell you that since we left, all my thoughts have been
with you at Windsor, and that your image fills my whole soul.
Even in my dreams I never imagined that I should find so much
love on earth ...'

————— LETTER FROM PRINCE ALBERT TO QUEEN VICTORIA,
15 NOVEMBER 1839

ROYAL CHILDHOOD

Royal childhood can be regarded as something of a paradox; although past generations of younger members of the royal family have enjoyed an extremely privileged existence, these princes and princesses have also been constrained by their royal status, because of the expectations and attitudes of their elders and also of society in general. The Royal Archives contains a multitude of letters, journals and documents which shed light on the lives and experiences of royal children over the last three hundred years; it is particularly fascinating to see the youthful writings of those who have gone on to accede to the throne as Sovereign. The documents which reflect the upbringing and education of Princess Victoria, later Queen, are a case in point. As a young girl, the isolated Princess had to adhere to a strict code of conduct and a regimented education (p. 209), yet it is still possible to see her true character through her childhood drawings and writings (pp. 208, 210). The separation of sons from their parents is also a recurring theme in royal childhood, as illustrated by the naval log of Prince Alfred (p. 213), the second son of Queen Victoria, whose youth was cut short by his entry into the Navy at only 11 years old.

The situation is somewhat different for modern royal children; young princes and princesses attend school rather than having lessons with private tutors and governesses, and they mix freely with other children. Those of recent generations have also chosen their own career paths, although the association with the armed forces still remains strong.

There is no doubt that children of royal parents enjoyed experiences unattainable to the population at large. For example, Albert Edward, Prince of Wales and eldest son of Queen Victoria, attended lectures by the scientist Michael Faraday at 15 years old and at 20 travelled extensively through Europe and the Middle East, with no expense spared (pp. 214–5). Yet perhaps most touching are the emotional aspects of these documents and the insight they offer into the parent and child relationships within the Royal Family. The baby books lovingly kept by Queen Mary (p. 216), the deeds to the beloved Welsh Cottage (p. 219) and the letter written by the young Bonnie Prince Charlie to his father in 1728 (p. 206) are indeed treasures of royal childhood.

PAGE 202 *Princess Victoria (1868–1935), Duchess of York and Princess Elizabeth standing in front of Y Bwthyn Bach, 1933. Gelatin silver print* RCIN 2304996

OPPOSITE *Richard Westall (1765–1836), Queen Victoria when a Girl (detail), 1830. Oil on canvas* RCIN 400135

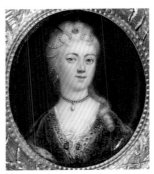

Letter written by the young Prince Charles Edward Stuart to his father, Prince James Francis Edward Stuart, 4 May 1728

RA SP/MAIN/115/161

This letter was penned by the seven-year-old Prince Charles Edward Stuart, who later became known as the 'Young Pretender' or, more commonly, as 'Bonnie Prince Charlie' (p. 143). Writing to his father, Prince James Francis Edward Stuart, the 'Old Pretender', from Palazzo Muti, the Stuart residence in Rome, the young Prince seems to be responding to a reprimand for upsetting his mother, Princess (Maria) Clementina. At this time, Prince James and his wife were in the midst of a brief reconciliation after Princess Clementina's two-year stay in a convent. She was pregnant at some point in 1728 (although she later lost the child) and Prince Charles's promise to 'be very Dutifull to Mamma, and not jump too near her', may be connected to his mother's health during her pregnancy. Princess Clementina suffered from nervousness and depression, compounded by physical ill-health exacerbated by her devotion to prayer and fasting;

her state of mind and body led to estrangement from her husband and perhaps to her premature death in 1735 at the age of 32.

Prince James was devoted to his son and heir, who from an early age displayed both intelligence and a propensity for disobedience. Prince Charles Edward particularly excelled in outdoor pursuits such as riding, tennis and shooting, and also demonstrated an aptitude for languages and dancing. His privileged lifestyle did not prevent his developing somewhat wayward behaviour, which was perhaps partly a result of his unsettled family life, and he often took his frustrations out on his parents and tutors. These traits followed him into adulthood: as eventual leader of the Jacobites his changeable personality was undoubtedly a drawback in his mission to restore his father to the British throne.

This letter, written by the young 'Bonnie Prince Charlie', is one of the thousands of the exiled Stuarts' documents, which now form a substantial collection in the Royal Archives. The Stuart Papers not only reflect the efforts made by the Jacobites to reclaim the throne for the Stuart royal line, but also the private and domestic lives of two generations of this family.

Dear Papa

I thank you mightily for your kind letter: I shall strive to obey you in all things. I will be very Dutifull to Mamma, and not jump too near her. I shall be much obliged to the Cardinal for his animals. I long to see you soon and in good health. I am

Dear Papa
your most Dutifull and affectionate
Son
Charles P.

Princess Victoria's paper dolls, *c*.1830

RA VIC/MAIN/Z/124

Princess Victoria's childhood was spent under the shadow of the 'Kensington System', a regime devised by her mother, the Duchess of Kent, and the Duchess's adviser, Sir John Conroy. The system essentially meant constant surveillance and observation of the young Princess. The regime was designed to protect her, but also to keep her under the strict control of the Duchess and Sir John, with a view to enhancing their own power when the Princess became Queen. Princess Victoria was thus supervised at all times by her mother, her governess Baroness Lehzen or one of her tutors. She was also kept away from Court and permitted to mix with very few other children.

As a consequence, Queen Victoria's childhood was rather lonely and far from carefree. However, as a girl she did find some consolation in a number of leisure pursuits, including painting, horse riding, visits to the theatre and playing with her beloved dogs and birds. The Princess also enjoyed playing with her collection of over 130 tiny wooden dolls, and she referred to them in her Journal on a number of occasions. Princess Victoria named her dolls, made clothes for them and meticulously kept their details in an inventory; remarkably, the dolls still survive today in the collections at Kensington Palace. The dolls were also the subject of paintings by Baroness Lehzen and the young Princess, as well as some painted by her half-sister, Princess Feodora of Leiningen, and the daughter of Sir John Conroy, Victoire. These colourful paper dolls were carefully cut out and pasted in two volumes, now held by the Royal Archives.

BELOW *This page from one of the volumes of Princess Victoria's paper dolls shows three dolls made by Lehzen and one, 'Lady Maria' (second from right), painted by the Princess herself.*

Distribution of the Day for The Princess Victoria. As it was in the year 1833.

Hours	Monday	Tuesday	Wednesday	Thursday	Friday	Saturday
From 9. To ½ past 9.	Putting down Expence. The Dean. Scriptural reading, (The old Testament)	from the preceding days, and writing the Journal. Psalms for the following Sunday read and explain.		Lessons for the following Sunday read and explained	Epistle and Gospel for the following Sunday read and explained	
	Scripture reading. (The New Testament)					
To 11.	English History.	Ancient History.	English History.	Ancient History.	History and Composition in English.	Repetition of the Lessons said in the Week.
To ½ past 11.	Latin.	Geography and Astronomy.	Latin.	General Knowledge Marshall's and Bingley	General Knowledge Blackstone & Clarendon.	
12.						
To 1.	Walking, — or occupations according to The Princess' own choice					
To 2.	Luncheon					
To 3.	Repetition for Monsieur Grandineau. Mr Westall, Drawing Lesson.	Repetition for Monsieur Grandineau. and Latin, for the Dean.	Repetition for Mr Steward. and History for the Dean.	Repetition for Monsieur Grandineau. and Mr Barez.	Repetition for The Dean. History Geography and General Knowledge.	Learning the Catechism by heart. Mr Westall Drawing Lesson.
To 4.	Repetition for Mr Steward.	Mr Steward, Writing and Arithmetic.	Monsieur Grandineau. French Lesson.	Mr Steward. Writing and Arithmetic.	Mr Barez. German Lesson.	Repetition for The Dean. Latin.
To 5.	Mr Sale. Music Lesson.	Monsieur Grandineau French Lesson.	Madame Bourdin. Dancing Lesson.	Madame Bourdin. Dancing Lesson.	Monsieur Grandineau French Lesson.	Mr Sale. Music Lesson.
To 6.		Music for ¾ of an hour.			Music for ¾ of an hour.	

N.B. On the last Friday of every Month, a religious repetition — to begin with the attendance of that morning, — after which, in the time Mss, Blackstone and Clarendon, — omitting Poetry and Composition.

Timetable of Princess Victoria's lessons, 1833

RA VIC/MAIN/M/5/43

Princess Victoria's formal education began at the age of four under the supervision of her Principal Master, the Reverend George Davys (1780–1864). By the age of 11 the Princess was spending most of her waking hours engaged in lessons, and was being taught by a number of different tutors who were specialists in their subjects. This was intended to ensure that she had the best education that her mother could possibly provide.

Princess Victoria was intelligent and quick to learn, and her aptitude for study was reflected in examinations by the Bishops of London and Lincoln arranged for her by the Duchess of Kent in 1830. The Bishops reported that the 11-year-old Princess 'displayed an accurate knowledge of the most important features of Scripture, History and … Christian religion … as well as an acquaintance with the chronology and principal facts of English History remarkable in so young a person'. The Duchess went further in seeking approval for her daughter's education by asking the opinion of the Archbishop of Canterbury, who assessed the Princess personally. He reported that the cultivation of her intellect, talent, and religious and moral principles was 'conducted with so much care and success, as to render any alteration of the system undesirable'.

As this timetable from 1833 shows, the Princess's school day began at 9 am, when she spent half an hour writing her Journal and recording her expenses from the previous day. She was then given religious instruction, followed by lessons in history, geography, Latin or general knowledge. A couple of hours were spent walking or engaged in another occupation chosen by the Princess, with a short break for luncheon. Her afternoons involved a wide variety of lessons, including French with Monsieur Grandineau, German with Mr Barez, writing and arithmetic with Mr Steward and music with Mr Sale. A notable omission from the timetable is any kind of scientific instruction, as this subject was not then considered necessary for girls. Any spare hours in the day were spent by the Princess in drawing and dancing lessons, pursuits in which the she particularly excelled and that she would enjoy for many years to come.

Princess Victoria's self-portrait sketch after her illness in Ramsgate, November 1835

RA VIC/MAIN/M/5/85

Between 1832 and 1835 the young Princess Victoria embarked on a series of tours of England and Wales. These 'Royal Progresses' were designed by the Duchess of Kent and Sir John Conroy to acquaint Princess Victoria with her future kingdom, and to allow her prospective subjects to see her in person.

In 1835 a lengthy tour of the north Midlands and east of England was planned, much to the disapproval of William IV, who objected to the Royal Progresses and appealed unsuccessfully to Princess Victoria to abandon the forthcoming tour. Despite the Princess's attempts to persuade her mother that they should not go, the tour went ahead at the beginning of August, and quickly proved to be physically and mentally exhausting for Princess Victoria. She soon began to suffer with fatigue, backache, headaches and loss of appetite, and following the end of the tour and the party's arrival in Ramsgate on 29 September the Princess was feeling very unwell. No doctor was called, as her mother believed she was exaggerating her symptoms. But on 7 October, after bidding farewell to her aunt and uncle, King Leopold I and Queen Louise of the Belgians, at Dover following their week-long stay in Ramsgate, Princess Victoria took a serious turn for the worse. In her Journal that day she wrote 'I felt so ill and wretched that I did not leave my room for the rest of the evening'. That was to be her last Journal entry for over three weeks. The nature of the illness that caused Princess Victoria to be incapacitated for such a long time is unclear; it may have been typhoid, tonsillitis, or perhaps a physical reaction to the emotional strain she had been put under by her overbearing guardians and the strenuous tour of England. Regardless of the cause, however, her recovery took many weeks; she did not leave Ramsgate until mid-January 1836.

During her convalescence the Princess sketched this self-portrait in pencil, which bears the caption 'Victoria. Drawn by herself after Her illness at Ramsgate in the Months of October & November 1835'.

Queen Victoria was a talented artist and her skills in both drawing and painting are evident in the hundreds of sketches, portraits and landscapes she produced over her lifetime, which are now part of the Royal Collection.

Notes by Albert Edward, Prince of Wales, on lectures given by the scientist Professor Michael Faraday, 1856–7

RA VIC/ADD A5/470E

Queen Victoria and Prince Albert were strong advocates of a good education for all of their children, and they were both heavily involved in overseeing lesson timetables and selecting tutors and governesses for the young princes and princesses. Prince Albert in particular was extremely interested in science, championing the cause of scientific and technological research and discovery, and he ensured that science was among the lessons taken by his sons.

As part of their studies, the Prince of Wales (later King Edward VII) and his next brother, Prince Alfred, attended a number of lectures given by the eminent scientist Professor Michael Faraday (1791–1867). The lectures took place in the Royal Institution in London from December 1856 to January 1857, and focused on Professor Faraday's area of expertise, the study of electromagnetism and electrochemistry. Professor Faraday first discovered electromagnetic induction in 1831, through experiments that led to his invention of the world's first electric transformer and electric generator. His pioneering work in both electromagnetic induction and electrochemistry still form the basis of modern electrical technology.

The Prince of Wales made detailed notes during the lectures, which he later wrote up with accompanying illustrations, presumably under the watchful eye of his tutor. Bills from the Prince's accounts show that scientific apparatus was purchased for him: in 1858, for example, an electrometer, electrophorus, insulated brass conductor and shellac rod were bought in order to enable him to carry out experiments.

has something to do with electricity.

He had also a live flounder on some zinc foil, & he laid a half crown on its back, & the flounder remained quite quiet, but when he touched the half crown, & the zinc foil, at the same time, it jumped about. We now return to the plates of Zinc & Copper, which are used in great numbers, & are called the Voltaic Battery & was invented by an Italian, called Volta. With this battery all the

Prince Alfred's midshipman's log for the steamship HMS *St George*, 1861–2

RA VIC/ADDA20/1767

Prince Alfred, known as 'Affie' by his family, the second son of Queen Victoria and Prince Albert, was born on 6 August 1844 at Windsor Castle. The Prince had his heart set on a naval career from a young age, and at only 11 years old was sent away from home to begin his preparation for the Navy. Two years later, in August 1858, Prince Alfred passed his naval entrance examinations with very high marks, and was ordered to report to his first ship, the frigate HMS *Euryalus*. The young cadet spent the next 14 months aboard this ship, mostly sailing in the Mediterranean. After a brief return to England, during which he passed his midshipman's exams with flying colours, he again boarded HMS *Euryalus* for a much longer journey to Cape Town. The ship arrived at its destination in July 1860, and the Prince paid the first ever royal visit to South Africa, where he was greeted with a rapturous reception.

He returned home in November and in early January joined the steamship HMS *St George*, which was bound for North America and the West Indies. As part of his role as midshipman, Prince Alfred kept a detailed log of his time aboard HMS *St George* between October 1861 and July 1862. The log includes such information as the ship's course, wind speed and direction, weather and other details of life and work at sea, in addition to sketches of some of the ship's destinations.

Prince Alfred, who was created Duke of Edinburgh in 1866, and succeeded to the dukedom of Saxe-Coburg and Gotha in 1893, pursued a highly successful naval career after his time as midshipman aboard HMS *St George*, rising through the naval hierarchy until he was appointed to the highest rank, Admiral of the Fleet, in 1893. The experiences of Prince Alfred in the Navy reflect the strong connection between the royal family and the armed forces, which dates back over centuries and is still very much in evidence today.

ABOVE *William Lake Price (1810–96)*, Prince Alfred in naval uniform, *August 1858* RCIN 2900141

LEFT *These pages from the log book record the arrival of HMS* St George *in Havana harbour in Cuba on 23 January 1862 and the ship's subsequent course for Bermuda. The sketch of Moro Castle was made by Prince Alfred himself.*

The Prince of Wales's journal of his travels in the Middle East, 1862

RA VIC/MAIN/EVIID /1862: March

In 1861 Queen Victoria and Prince Albert decided that their eldest son, Albert Edward, Prince of Wales (later King Edward VII), should undertake a tour of the Middle East and Egypt, with stops in various European cities en route. Such a tour would offer benefits of an educational, cultural and political nature, while the planned visits to European and Middle Eastern rulers would also provide diplomatic training for the 20-year-old heir to the throne.

The death of Prince Albert in December 1861 did not stop the Prince of Wales's tour from proceeding, for Queen Victoria was adamant that her late husband's wishes should be followed to the letter. The Prince finally left Dover on 6 February 1862 for the five-month-long tour. He was accompanied by, amongst others, his governor, Major-General Robert Bruce, Robert Meade, who was to act as adviser during the tour, and the Reverend Arthur Stanley, who had previously spent time in the Holy Land and Egypt, and was persuaded by Queen Victoria to join the royal party as guide.

The entourage was also joined by the photographer Francis Bedford (1816–94), who had been commissioned by the Queen to document the tour.

Following stops in Italy and Greece, the royal party sailed to Alexandria before heading further south into Egypt by way of the river Nile. The tour continued to the Holy Land and sites in Syria and modern-day Lebanon, before travelling home via Constantinople, Athens, Malta, Marseilles and Paris. This extended tour provided the Prince of Wales with opportunities to experience new peoples and cultures, to see ancient ruins and tombs he had previously only read about in books, and to indulge his interests in outdoor pursuits and the collecting of antiquities. The tour was the start of the Prince's lifelong love of travel, and he would return to the Middle East in 1869.

The Prince of Wales kept a detailed journal of his travels in the Middle East, and in these extracts, from 4 and 5 March, he records seeing the Pyramids of Giza in Egypt. This is one of only a few diaries kept by the Prince of Wales, all of which date from his youth, when the writing of such journals was considered by his parents and tutors to be an important part of his education.

ABOVE *Francis Bedford (1816–94),* The Prince of Wales and group at the Pyramids, Giza, *5 March 1862. Francis Bedford took a substantial number of photographs of the Middle East and Egypt, which were exhibited on the party's return to England. These photographs captured the imagination of the public in the 1860s, as they still do to this day.*
RCIN 2700867

Transcript of the Prince of Wales's journal

March 4th

After breakfast Teesdale & I rode all through the different Bazaars in the Town, & I made a few purchases. At 1.30. P.M. We embarked in a steamer, that i.e. Teesdale & I have a boat to ourselves wh. is towed to a steamer with the rest of the party, & we take our meals there, & there is another steamer for the servants; all this the Viceroy has been gracious enough to provide for us. Mr. Calvert, the Consul at Cairo, joined our party. We stopped at Ghizeh, a small village, where the Viceroy has a private residence; he was there & received us very kindly & showed us, a rifle wh. M. Minié, who is now in his service had invented. M. Minié (whom I had seen at Vincennes in 1855) was there & showed it. We then proceeded on dromedaries, (not at all an unpleasant mode of conveyance) to the celebrated Pyramids of Ghizeh. They quite exceeded my expectations, & are certainly wonderful mementoes of our forefathers. We visited the "Sphynx" just before sunset, wh. is also very curious & interesting. We had a charming little encampment just below the Pyramids where we slept for the night.

March 5th

At 5.30. before the sun rose we started to ascend the first & principal Pyramid (there are three) the ascent is rather tedious & difficult, but you are rewarded by a fine view on the top. At 10.30. we returned to Ghize by dromedaries, & embarked on board our boats at 1. P.M. for Thebes. Mr. Calvert took leave of us there & Mr. Colquhoon, (the Consul General for Egypt) accompanies us, also Habib Effendi, a young gentleman who the Viceroy has appointed to attend on us, he is a nice fellow & speaks English. We steamed till about 4, then we landed with our guns at Benisouef & I shot a quail & 2 white bitterns; at 5.30. we steamed again & stopped at 7.30. Teesdale & I, who are living on the small boat wh. is towed, went on board the steamer for dinner, & we remained at anchor for the night.

Baby's Souvenir album for Prince Albert (the future King George VI), kept by his mother, Queen Mary, 1895–1916

RA QM/PRIV/CC118/2

King George V and Queen Mary had six children: Prince Edward (later King Edward VIII), Prince Albert (later King George VI), Princess Mary, Prince Henry, Prince George and Prince John.

Like many mothers, Queen Mary kept souvenir albums for her children. The commercially produced albums were of the same design and format, featuring illustrations by the American artist Frances Brundage (1854–1937). They included pages on which Queen Mary could record significant information about her children's lives, from their first months through to their teenage years. The album allowed space for details such as the baby's first word, first steps and first day at school, in addition to room for items such as photographs and a lock of hair. Pages for recording the weight and height of the growing child, photographs taken at various ages, and the child's signature from the age of eight through to 21, also gave the opportunity to observe how the child had developed over time.

This souvenir album was kept by Queen Mary for Prince Albert, who was born on 14 December 1895 at York Cottage, Sandringham. As the Prince was growing up he was very close to his mother; this bond remained strong through his adult years (p. 249).

OPPOSITE *These particular pages from the souvenir album record Prince Albert's birth weight, his first outing and feature a series of photographs of him.*

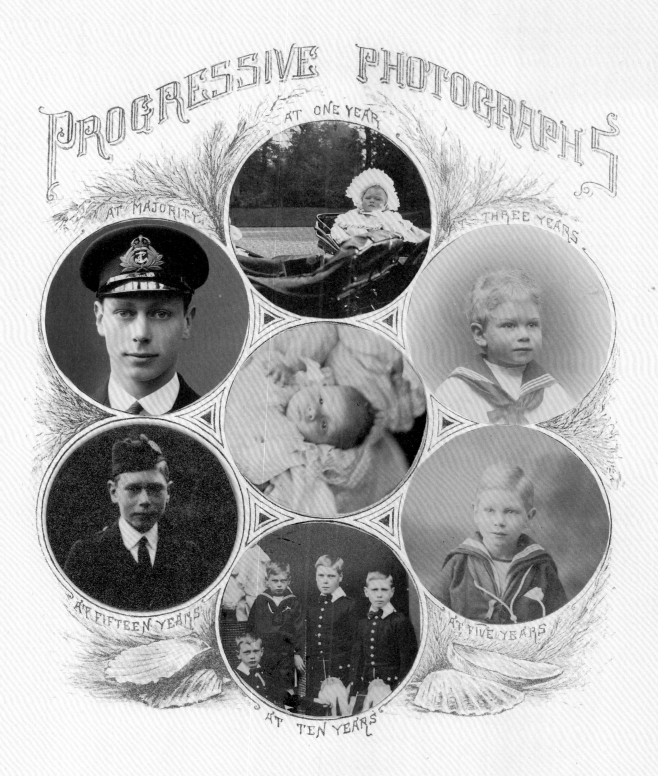

PROGRESSIVE PHOTOGRAPHS

AT ONE YEAR

AT MAJORITY

AT THREE YEARS

AT FIFTEEN YEARS

AT FIVE YEARS

AT TEN YEARS

53

Deed of Gift and inventory for Y Bwthyn Bach, Princess Elizabeth's miniature Welsh cottage, 1931

RA GVI/PRIV/RES

To mark the occasion of the sixth birthday of Princess Elizabeth (later Queen Elizabeth II) in 1932, during the visit of her parents, the Duke and Duchess of York, to Wales in March of that year the Welsh people presented them with the gift of a fully equipped Welsh cottage, complete with thatched roof and latticed windows. The cottage was called 'Y Bwthyn Bach', which translates from the Welsh as 'The Small House'. Once installed in the grounds of their family home, Royal Lodge in Windsor Great Park, the cottage became a favourite haunt of Princess Elizabeth and her younger sister, Princess Margaret.

The playhouse consists of four rooms, two up and two down, with a tiny hall and landing, and is large enough to accommodate anyone up to about 4 ft (1.2 m) tall. Like Queen Mary's Dolls' House, all the furniture and fittings were made exactly to scale and were commissioned from skilled craftsmen. The parlour contains an armchair, bookcase and working wireless and reading lamp, while the small kitchen, where the Princesses would entertain guests to tea, has a cooker, refrigerator, running hot and cold water, and a Welsh dresser laden with blue china. The cottage also has a working bathroom with towels embroidered with the initial 'E', and a bedroom decorated in blue and white. The cottage even has its own deed box, containing this Deed of Gift and an inventory of all the craftsmen and suppliers who helped to create the miniature house.

Y Bwthyn Bach has been enjoyed by subsequent generations of royal children and is still in the private grounds of Royal Lodge, surrounded by its own small lawns and flower beds.

Column 1.	Column 2.	Column 1.	Column 2.
W. T. Copeland & Sons, 14-18 Holborn, London, E.C.1.	China	Mess.rs Ellams Duplicating Co. 10 Kings Street, London	Duplicator
Cardiff Gas Light & Coke Co., Ltd. Bute Terrace, Cardiff Manufactured by:— Mess.rs John Wright & Co. Essex Works, Aston, Birmingham.	Gas Stove and Boiler.	Made by:— Mess.rs Express Hemstitching Co. Ltd. 15 Castle Arcade, Cardiff. Materials by:— Mess.rs Turnbull & Stockdale Ltd. Roselank Print Works, Ramsbottom, Manchester.	Curtains
Cross Bros. Ltd. St. Mary Street, Cardiff	Glass and Kitchen Equipment.	Mess.rs Thomas French & Sons, Chester Road Mills, Manchester, S.W.	Ruflette Curtain Tapes.
Mess.rs T. J. & Oscar Daniel, Old Mill, Llanfoythyd, n.r Cowbridge	Thatching.	Mess.rs Electrolux Ltd. 153-155, Regent Street, London.	Refrigerator
Mess.rs Down & Son, 221, High Street, Swansea.	Two Easy Chairs	Mess.rs The Educational Supply Association, Ltd. Escuan House, 171, 181, High Holborn, London, W.C.1	Kitchen Furniture
M.r Gomer Davies, Llanhennog Rectory, Caerleon, Mon.	Glass Flower Decorations.		

This Deed of Gift

is made the Seventh day of November One thousand nine hundred and thirty one **Between** Robert Gerard Hill Snook Lord Mayor of the City of Cardiff (hereinafter called "the Assignor") of the one part and Her Royal Highness Princess Elizabeth of York (hereinafter called "the Donee") of the other part.

Whereas the persons enumerated in the first column of the Schedule hereunder written have out of their deep and abiding love and affection for the Donee being desirous of making a gift to the Donee of such chattels as are specified opposite the names in the second column hereto have delivered them over to the Assignor on trust that he should execute this deed of gift in manner following.

Now this Deed Witnesseth that in consideration of the premises the Assignor as Trustee hereby assigns to the Donee those chattels specifically mentioned in the second column of the Schedule hereto **To Hold** the same unto the Donee absolutely.

DOMESTIC LIFE _____

Behind the closed doors of royal residences through the ages, the numerous staff of the Royal Household have worked tirelessly to ensure the smooth running of the domestic life of the Sovereign and the royal family. Numerous records survive in the Royal Archives, particularly from the reign of Queen Victoria onwards, which provide detailed information about the vast domestic operation required to meet the everyday needs of the royal family and the royal residences.

The memoranda, correspondence and financial papers generated by the various departments of the Royal Household, the structure of which has changed relatively little through the centuries, shed light on royal life 'behind the scenes'. The names of members of the Royal Household and their roles are kept in volumes known as Establishment Books, the oldest of which date back to the sixteenth century; the Establishment Book for the Household of Princess Elizabeth (later Elizabeth I) from 1551–2 is a particularly fine example (p. 223).

The many volumes of accounts and bills held in the Royal Archives, dating from the reign of George III through to the twentieth century, record the payments of salaries to staff, as well as purchases of such items as food, clothing, works of art, musical instruments and armour. Here they are represented by Queen Charlotte's personal accounts from the last quarter of the eighteenth century; many pages of this beautifully kept volume record the expenses of the Queen's younger sons and daughters (p. 224).

The interest displayed by Sovereigns and, more often, their consorts, in domestic record-keeping is also evident in the collections held by the Royal Archives. The diary of Queen Charlotte, consort of George III, from 1789 (p. 226), records the minutiae of domestic life in Windsor Castle. Over a hundred years later, Queen Mary recognised the importance of keeping records by ensuring that her dresser listed the clothes and jewellery she wore on special occasions in a dedicated volume (p. 232).

Personal records kept by lower-ranking members of the Household are rather rare; however, among the few interesting examples that survive is the recipe book of Mildred Nicholls, a kitchen maid during the reign of King Edward VII (p. 230). The desserts and cakes made by Mildred in the kitchens would have been included on the illustrated menu cards produced for royal banquets and dinners (p. 229).

RIGHT The Kitchen at Windsor Castle *(detail)*, *1878*
RCIN 2100721

The House.
Of the right excellent Princes the
ladie Elizabeth her grace.

Thaccompte Of
Thomas Parry Esquier.

The said Thomas Parry esquire

The remayne
with the prest of the
laste yere.

Summa
Elizabeth

The Remayne

The Prest

Household accounts of Princess Elizabeth at Hatfield, 1551–2

RA EB/EB/34

The Royal Archives holds relatively few items from the Tudor period, and this account book from the early 1550s is one of its treasures. The volume relates to the Household of Princess Elizabeth, who would later become Elizabeth I. 'The Virgin Queen', as she was known because of her refusal to marry, reigned from 1558 until her death at Richmond Palace on 24 March 1603; her 45-year reign is considered to be one of the most glorious in English history. During this first Elizabethan era, a secure Church of England was established, political administration and foreign policies were consolidated, the arts flourished, a new world was discovered by explorers such as Sir Francis Drake and Sir Walter Raleigh, and an invading Spanish armada was vanquished. Elizabeth I, the last Tudor monarch, ruled over a golden age and was a revered and popular Sovereign.

As Princess, Elizabeth spent her youth at Hatfield Palace in Hertfordshire. The Palace, of which only a small part still exists near the present Hatfield House, had been built by the Bishop of Ely in 1497, but was seized by Henry VIII, who used it as a home for his children. It was while living there in 1558 that Princess Elizabeth heard of her accession to the throne following the death of her half-sister, Mary I.

This account book, with its beautifully illuminated frontispiece, dates from Princess Elizabeth's residence at Hatfield Palace in the years 1551–2. Every page bears her signature and that of her chamberlain, Sir Walter Buckler.

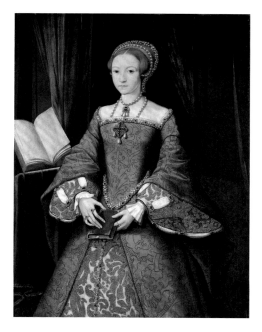

		Grand Total		
Brought over		38,307	8	2

Money paid upon Warrants directing the Payment of Bills Attested by Lady Charlotte Finch Governess & Mrs Martha Caroline Goldsworthy Sub Governess to Their Royal Highnesses the Younger Princes & Princesses.

The said Accountant hath also issued and paid upon Her Majesty's Account & Service for Work done and Goods delivered by several Creditors & Artificers for the Service of the Royal Nursery upon Bills Examined Allowed and Signed by Lady Charlotte Finch Governess & Mrs Martha Caroline Goldsworthy Sub Governess to Their Royal Highnesses the Younger Princes & Princesses in pursuance of several Warrants under Her Majesty's Royal Sign Manual for the Payment thereof as is here after particularly Expressed Vizt.

Person's Names	Professions &c	Total paid each Person					
Messrs Kings	Mercers	1605	4	7½			
Elizabeth Gordon	Milliner	1315	15	8½			
Jean Baptist Suardy	Hair Dresser	729	9	6			
Emelia Pohl	Milliner	468	14	4			
Alice More	Staymaker	342	6	1			
Elizabeth Beauvais	Milliner	312	17	1			
John Sparkes	Laceman	290	4	7			
Enoch Hodgkinson	Linen Draper	278	11	–			
William Wallis	Haberdasher	269	1	4			
Mary Mackenzie	Mantuamaker	196	1	6			
Edward Webb	Musick Master	189	13	6			
Maria Elizth Rhelingen (Necessary Woman)	Disbursements	169	15	2			
James Kennedy	Shoemaker	166	8	6			
Robert Bond	Glover	131	9	1			
John Beckett	Hosier	128	13	6			
Elizabeth Snow	Milliner	116	12	8			
John Grieve	Shoemaker	115	19	6			
Thomas Roe	Linen Draper	111		3			
Flamand &Co	Staymakers	76	4	4			
Sarah Clarke	Haberdasher	75	8	8			
T. Ungerland	Habit maker	74	6	–			
Carried over		7163	16	7	38,307	8	2

66892

Persons Names

Butler &Co
John Taylor
C. Phillips
M. Scholey
Ibbetson &Co
Angelica Charlior
Ann Wrighte
Peter Wright
Joseph Clayton
Bi Cole
John Alexr Gresse (Drawing M
James Webb
William Roome
Urania Devins
Thomas Davies
John Martinnant
William Werndly
Margaret Williams
Hartley &Co
Timothy Sheldrake
J. Heseltine
Willerton &Co

In all the sai
paid unto the several Creditor
Majesty's Service as by the
acknowleding the Receipt tho

Money

The said Accountan
and Service several Sums of M
in any of the aforegoing Artic
Sign Manual directing the

ofessions &c°	Total paid each Person	Grand Total
Brought over	7163 16 7	38,307 8 2
...shers	65 18 2	
...ker	59 6 6	
...r	52 . 4	
...raper	34 13 .	
	32 16 6	
...r	26 11 3	
...ker	24 . .	
...r	23 14 ..	
...ker	23 4 7	
...r	22 3 6	
...ments	19 19 6	
...ker	19 2 6	
...erer	17 3 .	
...ress	11 16 .	
	11 14 ..	
...ther	10 17 ..	
...ker	9 16 6	
...s	8 18 ..	
...rapers	5 5 .	
...ker	4 14 6	
...raper	3 7 6	
	1 6 6	

...Money by this Accountant issued and ...k done and Goods delivered for Her ...said several Persons or their Assigns ...nunt to the Sum of 7651 17 5

...rants not comprehended ...going Articles.

...and paid upon Her Majesty's Account ...Mathias for Disbursements not comprehended ...Warrants under Her Majesty's Royal ...mounting to the Sum of 6464 10 11

Carried over 52,423 16 6

Account book for Queen Charlotte, 1777–93

RA GEO/MAIN/36836–36948

Queen Charlotte was the wife of George III and mother of his 15 children; the first, George, Prince of Wales (later George IV), was born a year after their marriage in 1761.

The Queen's account book, which covers the years 1777–93, contains details of payments made to members of her Household and to individuals who provided services for her children, such as wet-nurses and hairdressers, language and music teachers. The accounts also refer to goods provided for Queen Charlotte herself and for the younger princes and princesses – clothing, shoes, perfume, hats, toys and so forth – although sadly there is no detailed information about the clothing and accessories purchased by the Queen for her own use.

As shown by these pages from May 1785, the accounts of the royal nursery were kept by the children's governess, Lady Charlotte Finch (1725–1813), and their sub-governess, Mrs Martha Caroline Goldsworthy. All these expenses were paid from Queen Charlotte's own funds and were approved by her secretary and comptroller, Richard Howard, later fourth Earl of Effingham (1748–1816). At this period it was customary for the costs incurred by the royal nursery to be met by the Queen, apart from the expenses of the heir to the throne – in this case the Prince of Wales – who had his own separate account.

The Queen's account book is just one of many such volumes and boxes of bills accumulated by the royal family in the Georgian era. The accounts of George IV are particularly substantial and reflect his love of fine things and his extravagant lifestyle (p. 62).

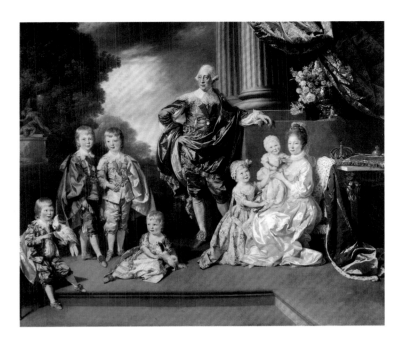

Queen Charlotte's diary, 28 October to 31 December 1789

RA GEO/ADD43/2

ABOVE *Johan Zoffany
(1733/4 –1810)*, George III,
Queen Charlotte and their
Six Eldest Children, *1770.
Oil on canvas
RCIN 400501*

Very few volumes of Queen Charlotte's diary have
survived in the Royal Archives, and therefore the
nine remaining, rather plain-looking notebooks,
dating from the years 1789 and 1794, are indeed
archival treasures. As consort of George III and
mother of a large family, Queen Charlotte led a busy
domestic life often under strain from her husband's
illness. Yet she remained interested in many subjects,
including the arts, music, botany and the theatre.

As these are the only eighteenth-century royal
diaries to survive in the Royal Archives, the
notebooks provide a unique record of Georgian
life from the perspective of a member of the royal
family. The entries record the public life of the
Queen, such as her theatre visits, stays in country
houses and dinners with aristocratic families. But
often more fascinating are her descriptions of the
minutiae of domestic life. They perfectly exemplify
the quiet and simple country-house life enjoyed
by the royal couple and their children, and not
the extravagant and ostentatious lifestyle that
one would perhaps expect of the King and Queen
of Great Britain.

d with the K.ᵗ till
Lady Mary Howe
n the Music began
dy Courtown came
versi the K.ᵗ my-
ce who came today
tired at ii.

ᵇʳ 1789. We break
y went a Hunting
t to Paint again
Princesses came off
went to Dress &
came & read to me
came. The K.ᵗ &
& staid below till

& then all went up Stairs the Music begun & the
Younger Princesses & Lᵈy Courtown came at &
we drank Tea, & play'd at Reversi with the K.ᵗ
Lᵈy Holderness & Major Price. the others work'd
we parted ¼ after 10 Supp'd & retired at ii
 very damp all Day.

Windsor Wednesday the 25th q ᵇʳ 1789. We
breakfasted at 9. ½ past 9. The K.ᵗ sent off for
London the Princesses walk'd & at ii we all
went paint again. at 12. I went with Lᵈies
Holderness & Courtown to the Spinning School
& returned by one then went to Dress. at 2
M. Guiffardiere read to me till 4. then we went
to Dinner drank Caffe & staid together till 6
then I went to play upon the Harpsichord till
the K.ᵗ came. at & the Younger Princesses & Lᵈy

ABOVE *The entries from the Queen's diary illustrated here, from 24 and 25 November 1789, were written while the royal family was residing at Windsor Castle and contain details of the daily routine and leisure pursuits they enjoyed, such as the King going 'a hunting', the Queen playing her harpsichord and joining the young princesses in a game of 'Reversi'.*

Queen Victoria's Christmas Day menu, 1899

RA F&V/PRFF/MAIN/1899

Christmas was a very special time for Queen Victoria, Prince Albert and their children, and their celebrations included many traditions familiar to us now. The exchanging of Christmas cards, a lavish meal, gifts for the poor, decorated Christmas trees (a custom introduced to Britain by George III's wife, Queen Charlotte) and tables laden with presents were just some of these royal festive traditions. On Christmas Eve in 1832 the 13-year-old Princess Victoria recorded in her Journal that 'there were two large round tables on which were placed two trees hung with lights and sugar ornaments. All the presents being placed round the tree. I had one table for myself.' By 1850, now having her own family to celebrate with, Queen Victoria's Christmas had become a splendid occasion: the apartments at Windsor were decorated with large Christmas trees suspended from the ceiling, tables were heavy with presents for her children and gifts for members of the Royal Household, and spectacular present tables were assembled for the Queen and Prince Albert.

Writing again in her Journal, Queen Victoria described the scene on Christmas Eve in 1850, when 'my beloved Albert first took me to my tree & table, covered by such numberless gifts, really too much, too magnificent'. The presents she received included a watercolour by Edward Corbould (1815–1905), oil paintings by John Callcott Horsley (1817–1903) and Emma Richards (1825–1912), four bronzes, and a bracelet designed by Prince Albert which included a miniature of their daughter Princess Louise. This exchange of presents and unveiling of the tree on Christmas Eve was a continuation of the German tradition in which Christmas celebrations begin on 24 December.

Following the death of Prince Albert in 1861, Queen Victoria spent her Christmases more quietly at Osborne House on the Isle of Wight; however, in 1899 she broke with tradition to celebrate Christmas at Windsor Castle, where she presided over a festive evening dinner for 31 guests and 19 family members. This beautifully decorated menu, one of many in the Royal Archives dating back to the nineteenth century, shows the wide variety of dishes enjoyed at this festive dinner.

OPPOSITE *The menu includes many traditional dishes still enjoyed at Christmas today, including turkey, mince pies and plum pudding.*

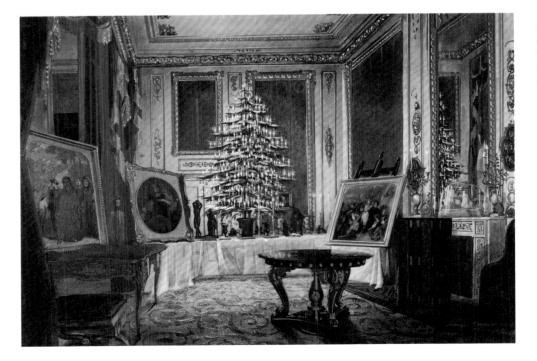

LEFT *James Roberts (c.1800–67),* The Queen's Christmas tree at Windsor Castle, *1850. Watercolour RCIN 919812*

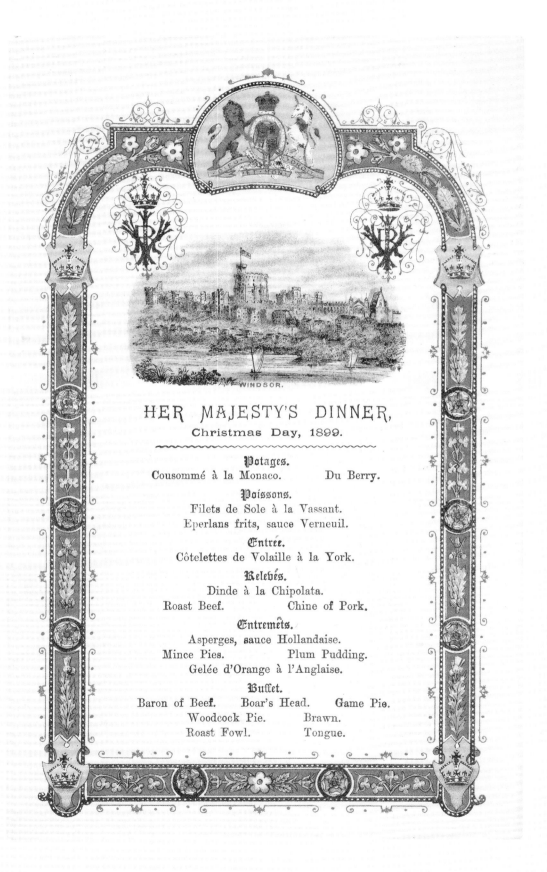

HER MAJESTY'S DINNER,
Christmas Day, 1899.

Potages.
Cousommé à la Monaco. Du Berry.

Poissons.
Filets de Sole à la Vassant.
Eperlans frits, sauce Verneuil.

Entrée.
Côtelettes de Volaille à la York.

Relevés.
Dinde à la Chipolata.
Roast Beef. Chine of Pork.

Entremets.
Asperges, sauce Hollandaise.
Mince Pies. Plum Pudding.
Gelée d'Orange à l'Anglaise.

Buffet.
Baron of Beef. Boar's Head. Game Pie.
Woodcock Pie. Brawn.
Roast Fowl. Tongue.

The Royals plum pudding

12	lb	Flour (Sifted) 1½ lb
6	"	Lisbon Sugar 12 ℔
8	"	Raisins (Stoned)
8	"	Currants 1
6	"	Beef. Chopped fine 12℔
10	"	Beef Suet " " 10 6½
30		Eggs.

Salt Mixed Spice Cinnamon
Grated Nutmegs

Mix all together and boil
about 8 or 9 hours.
Boil for about 2 or 3
hours the day wanted

Servants Plum Pudding.

40	lbs	Beef Suet	1 ½
40	lbs	Flour	1 ½
25	lbs	Raisins	10 ℔
25	lbs	Currants	10 ℔ & Sal
20	lbs	Lisbon Sugar.	½ Su
14	lbs	Peel.	6 ℔
¾	lbs	each of Grated Cinnamon	lb
3		nutmegs G: allspice.	

2 tablespoons salt.

60 Eggs. milk. Beer. Black
Jack. mincemeat ½ inch
℔ Chopped Apples larger
cinnamon
½ Currants ½ Raisins allspice
6 ℔ Sal ½ Suet ½ Sugar
2 ℔ Peel Rind + Juce
Orange + Lemon

ABOVE *These particular pages
from the book show recipes
for the royal and servants'
versions of plum pudding
– both requiring large numbers
of eggs.*

Recipe book of Mildred Nicholls, kitchen maid, 1908–19

RA VIC/ADDC31

For centuries the Royal Household has played a major role in supporting the Sovereign and the Royal Family in both the public and the private spheres. However, relatively few records survive in the Royal Archives that reflect the lives of members of the Royal Household, and this is particularly the case for those who worked below stairs.

This recipe book is an unusual item in that it shows the work of a kitchen maid, Mildred Nicholls. Mildred entered royal service in 1908, during the reign of King Edward VII; her first position was seventh kitchen maid, and by 1913 she was working as third kitchen maid. As was typical for women in service at this time, Mildred left the Royal Household when she married in 1919. Staff records for this period in the Royal Archives rarely give details of the backgrounds and previous service of those employed in the Royal Household, but census returns show that Mildred Nicholls was born in Mayfair, London, in 1887.

The royal kitchens were divided into subsections specialising in different aspects of food preparation, such as the confectionery, bakery and pastry departments. This well-used book contains numerous handwritten recipes for cakes and puddings that Mildred would have cooked for the royal family and the Royal Household in her role as a pastry kitchen maid. The names of the recipes in the book are mostly in French; this long-standing tradition is associated with the fact that the top chefs were generally from France. The dishes include regal dishes such as 'Pouding Soufflé à la Royale', 'King's Wafers' and 'Soufflé Glaces Leopold', in addition to the more traditional Swiss roll and Chester cake. Two favourites of Queen Alexandra are included: a Danish pudding, 'Rodgröd', made with currants and raspberries; and, tucked inside the book, a recipe for Bath buns, bearing the note 'The Queen's Recipe ... Sent down Sunday Jan 2. 1910'.

RIGHT The Kitchen at Windsor Castle, *1878*
RCIN 2100721

Queen Mary's dress book, 1911–13

RA QM/PRIV/CC58/162

Queen Mary, consort of King George V, was an assiduous diarist, letter-writer and record-keeper, and her papers comprise a significant part of the Royal Archives. Amongst them is a small series of volumes in which are documented details of the clothes and jewellery she wore on public occasions including official engagements, military reviews, garden parties, visits to Royal Ascot, Court functions and overseas visits. Records of clothes worn by members of the Royal Family are very unusual in the Royal Archives and these volumes therefore provide a valuable insight.

Queen Mary developed a personal style over the years and was often to be seen in outfits in her favourite shade of pale blue. She liked fine materials and accessories, and photographs of the Queen wearing her beloved toque hats and long skirts are a familiar sight; she certainly did not approve of the fashion for shorter hemlines after the First World War.

Examples of the attire worn by Queen Mary listed in these volumes include a turquoise blue silk gown, a straw hat with shaded roses and a turquoise necklace worn on a visit to the Women and Children's Hospital at Bruntsfield, Edinburgh, on 18 July 1911. To a children's fête held in Old Bombay Exhibition Grounds on 4 December that year, as part of the Delhi Durbar, the Queen wore a chiffon gown patterned with hollyhocks, with a mauve and grey feather hat.

A number of Queen Mary's items of clothing, including her Coronation gown, still survive today in the Court Dress Collection at Kensington Palace.

LEFT Queen Mary: study for the Coronation picture, c.1911
RCIN 2808099

OPPOSITE *The pages from the dress book shown here record the gowns Queen Mary wore on 22, 23 and 24 June 1911 for various engagements held in celebration of the Coronation on 22 June. The handwriting is that of the Queen's dresser, who was responsible for the care of the Queen's clothes and jewellery.*

June 22nd
Dinner

23rd
Drive Through London

23rd
Dinner
Foreign Office

24th
Leave London for the Yacht
Naval review.

clasps . with V.A. in diamonds
on clasps

Pink & silver brocade gown
Diamond comb ruby & diamond
collar, large uncut ruby
necklace arranged on bodice
with diamond drop added

White pompadour satin gown
cream hat with shaded blue
feathers, sapphire brooch, 2 rows
of cream pearls
Orders, the Garter & 3 family orders

Sapphire blue & gold gown
Young ladies pearl & diamond
tiara, pearl collar with ladies
pearl & diamond necklace
under, pearl & diamond stomacher
large round pearl brooch
3 family orders

Navy blue serge coat & skirt
Blue flower hat, Sapphire Anchor brooch

FAMILY RELATIONSHIPS _____

As with all families, the relationships between members of the royal family over the last three hundred years, particularly between husband and wife and parent and child, have had their difficulties. The nature and characteristics of these relationships and the feelings and emotions they provoked are evident in the handwritten lines of the many thousands of private letters exchanged between members of the royal family, which now form a very important part of the Royal Archives. This correspondence was not intended for anyone other than the recipient and, therefore, the letters offer a unique, and for the most part honest and truthful, perspective into royal marriage and royal parenthood away from the public gaze. These personal letters can be found throughout the many collections held by the Archives, and it is possible to see both continuity and change in the nature of royal relationships over the centuries.

Many royal marriages were true love affairs; as their letters testify, Queen Victoria and Prince Albert were devoted to each other from the time of their second meeting in 1839 (p. 242) and they remained so until his premature death in 1861. The marriage of Queen Victoria's granddaughter Princess Alix of Hesse to Tsar Nicholas II in 1894, is another example of a real love match (p. 244). Yet many royal marriages in earlier times were not founded on love and affection, but were instead political and diplomatic arrangements, often used as a means of strengthening Britain's ties with foreign nations. In the case of George III and Queen Charlotte, who did not meet each other face to face until their wedding day in 1761, the arrangement worked well, and they enjoyed a long and happy marriage until the deterioration of the King's health (p. 236). In distinct contrast, the arranged marriages of Princess Caroline Matilda to King Christian VII of Denmark in 1766 and of Princess Caroline of Brunswick to the Prince of Wales in 1795 ended very badly: Queen Caroline Matilda died in exile, estranged from her children

(p. 238); while George IV and Queen Caroline's disastrous marriage led to the latter dramatically 'standing trial' for adultery (p. 240). Not all royal relationships were officially recognised; some of the Georgian princes in particular were notorious for their womanising ways, and George IV, as Prince of Wales, even 'married' one mistress, Mrs Fitzherbert, in an illegal ceremony (p. 236).

The bonds between royal parents and children are also apparent in the many personal letters in the Royal Archives. After his marriage to Lady Elizabeth Bowes-Lyon, the Duke of York wrote movingly to his mother, Queen Mary, expressing his love and gratitude to her (p. 248), while the 100th birthday telegram sent by Queen Elizabeth II to her mother, the Queen Mother, in 2000, is a truly unique document embracing both filial affection and monarchical tradition (p. 250). Such treasures provide an incomparable insight into the private lives of members of the royal family, and it is a remarkable privilege to be able to read their thoughts and feelings in their own words.

OPPOSITE *Laurits Regner Tuxen (1853–1927)*, The Marriage of Nicholas II, Tsar of Russia, 26th November 1894 *(detail)*, *1895–6. Oil on canvas RCIN 404465*

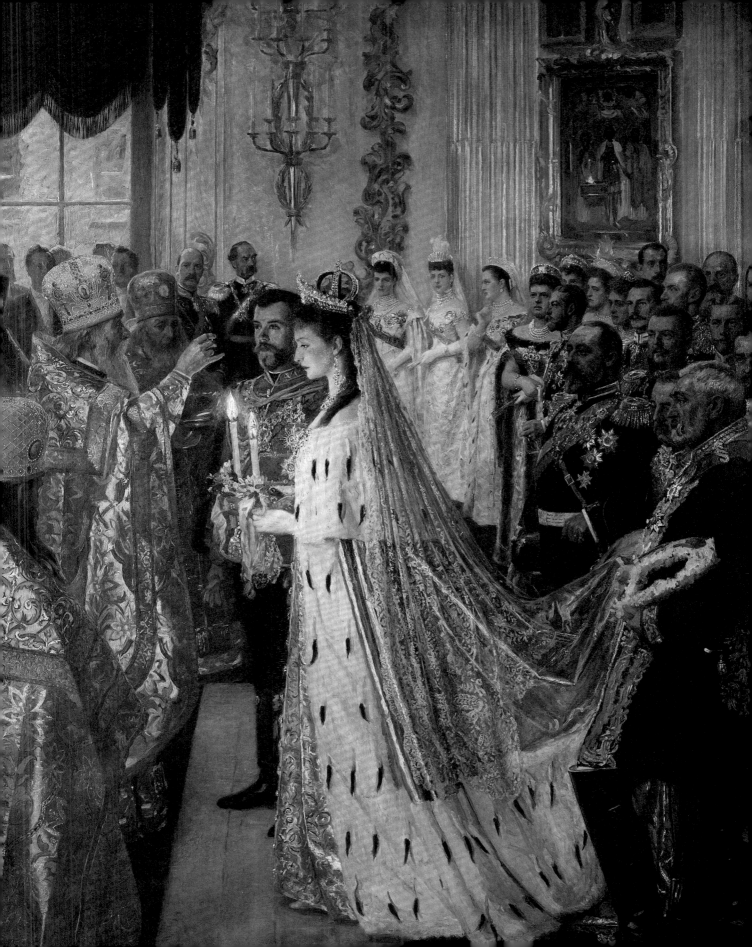

Letter from Queen Charlotte to George III, 26 April 1778

RA GEO/MAIN/36352–4

Following his accession to the throne in 1760, the 22-year-old George III began his search for a wife among the princesses of continental Europe. He sent agents to Germany, who made secret enquiries as to the suitability of the princesses there, and Princess Charlotte of Mecklenburg-Strelitz, then aged 17, was the most highly recommended. The King agreed with the choice, as did the Princess's widowed mother, and their marriage took place in the evening of 8 September 1761 at St James's Palace. The couple had met for the very first time that afternoon, when Princess Charlotte arrived in London from Germany. Just two weeks later, on 22 September, the King and Queen were crowned at Westminster Abbey.

Despite the unsentimental manner in which their marriage was arranged, George III and Queen Charlotte proved to be a very compatible couple, and they enjoyed a happy domestic life (p. 226), sharing many interests, including the arts, books and music.

In April 1778, when George III was away on his yacht HMY *Royal Charlotte*, Queen Charlotte wrote this letter to him providing news of family life at the Queen's House in London (later rebuilt as Buckingham Palace, p. 51). As the couple spent much of their time together, relatively little correspondence between Queen Charlotte and George III survives in the Royal Archives, and therefore this letter provides a fascinating insight into their affectionate relationship and the close bond they shared with their children. The phrases used in the letter also reflect the fact that the Queen was not a native speaker of the English language; indeed, when she arrived in England in 1761 she could not speak any English at all, yet she learnt the language quickly and remarkably well.

The Queen closes her letter by anticipating the homecoming of 'him who is ever dear to me', an affectionate reference to the King himself.

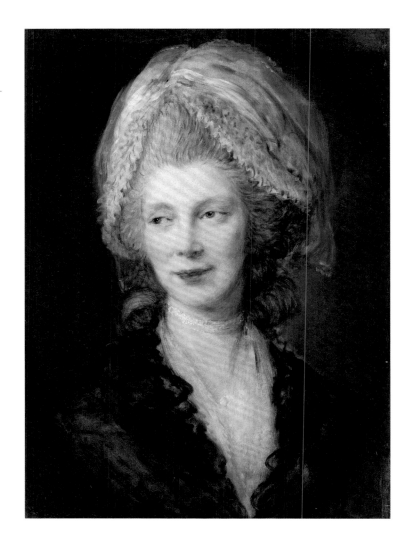

ABOVE *Thomas Gainsborough (1727–88),* Queen Charlotte, *1782. Oil on canvas RCiN 401007*

OPPOSITE *'Dear little Minny', to whom Queen Charlotte refers in the letter as being anxious for her papa to return home, was the pet name of their daughter Princess Mary, who had just turned two years old.*

36352 - 3

Sir. A Thousand thanks unto You for Your very
kind and affectionate letter which arrived
last Night by a quarter past Ten just after
My Commerce party was broke up. it hath
served me as supper and is to keep me com-
pany at Breakfast this morning when
that hours comes, where j shall have an
opportunity to rejoice all the little people
with Your Kindness to them. Dear little
Minny remains quite Uneasy about not
finding You any where in the House, every
Coach she sees is Papa a coming and no-
thing satisfies her hardly but sitting at the
Window to door for You.

The Duke of Mountague brought

Last letter from Queen Caroline Matilda of Denmark to her brother, George III, before being sent into exile, 24 May 1772

RA GEO/MAIN/52315

Queen Caroline Matilda of Denmark (1751–75) was the youngest daughter of Frederick, Prince of Wales, who died before her birth in 1751. At the age of only 15 Princess Caroline Matilda travelled to Copenhagen to marry the recently crowned King Christian VII in a ceremony that took place on 8 November 1766.

Their marriage, arranged to strenghten the ties between Britain and Denmark, was unhappy from the beginning; although the couple had a child, the future Frederick VI, in January 1768, Christian VII's lengthy absences, scandalous sexual behaviour and episodes of severe mental illness left Queen Caroline Matilda increasingly lonely and isolated. In 1770 she began an affair with Johan Friedrich Struensee (1737–72), who had joined the King's household as physician and rose to power as a minister in the government. In July 1771 Caroline Matilda gave birth to a daughter, widely suspected to have been fathered by Struensee.

By December 1770 Struensee had taken control of the Danish government and began to issue social and political reforms with increasing zeal. His enemies grew and in January 1772 both Struensee and the Queen were arrested in a plot instigated by Queen Dowager Juliana Maria (1729–96), the King's stepmother. Three months later the marriage of Queen Caroline Matilda and Christian VII was dissolved by divorce and Struensee was executed for the crime of *lèse-majesté*.

George III sent a diplomat to negotiate his sister's release and the Danes agreed to deport her to Celle in Hanover, part of George III's German territories. Queen Caroline Matilda was forced to leave her four-year-old son and baby daughter behind. In this last, poignant letter to her brother before her departure from Denmark she thanks him for his efforts on her behalf and writes movingly of parting from her children. Sadly, her desire to be reunited with her son and daughter remained unfulfilled, for she died in exile in Celle only three years later.

Transcript of Queen Caroline Matilda's letter

Dear Brother,

I suppose that this will be the last letter that You will receive from me in Denmark. I have the consolation in leaving this contry to know that my Children are in good health, Louisa has had the measels, and I have not been well, but we are now both recover'd. I do not think it impossible that I may some time or other see them again. I am affraid they will spoil my Son, as it is their interest that he should be as easy to govern as his Father is. receive again my sincerest thanks for Your kind behaviour to me in my misfortunes, and Believe Dearest Brother that I shall never cease to be

Your most affectionate Sister
Caroline Mathilda.
Cronenburg May 24th 1772.

ABOVE *Francis Cotes (1726–70),* Princess Louisa and Princess Caroline *(detail of Princess Caroline), 1767. Oil on canvas* RCIN 404334

'Certificate' for the marriage of George, Prince of Wales, and Mrs Maria Fitzherbert, 15 December 1785

RA GEO/MAIN/50210

George, Prince of Wales (later Prince Regent and George IV), displayed a lack of restraint in many areas of his life. From his extravagant purchases of works of art to his consumption of the finest food and drink, the Prince of Wales was not a man of moderation, and his love of women was no exception. From young adulthood he enjoyed the company of beautiful mistresses, embarking on several affairs with courtesans, actresses and aristocratic ladies.

Maria Fitzherbert, a twice-widowed Roman Catholic who was six years older than the Prince of Wales, was the first woman to be the subject of his total infatuation. The couple met in early 1784 in London, when the Prince was 21 years old. He quickly became determined to marry her, despite her unsuitability and the considerable obstacles of the Royal Marriages Act of 1772, which did not allow any member of the royal family to marry without the King's consent, and the Act of Settlement of 1701, which excluded those married to Roman Catholics from acceding to the throne. Nevertheless, the Prince of Wales finally persuaded Mrs Fitzherbert to enter into marriage with him, and the ceremony was held in great secrecy in her drawing room at Park Street, London, on 15 December 1785. The illegal service was conducted by an Anglican priest who was let out of Fleet prison for the purpose. The Prince of Wales wrote this certificate himself, bearing the words 'We the undersigned do witness yt [that] George Augustus Frederick Prince of Wales was married unto Marie Fitzherbert this 15th. of December 1785'. It was then signed by the couple and their two witnesses, her brother, John Smythe, and her uncle, Henry Errington, and kept safely by Mrs Fitzherbert.

Following the ceremony, the couple maintained separate establishments and were rarely seen in public together, although their relationship lasted until 1794, when the Prince broke it off. The pair did drift back together a decade later, but were thereafter estranged – although at the time of his death in 1830 George IV was found to be wearing around his neck a locket bearing a miniature of Mrs Fitzherbert.

Following Maria Fitzherbert's death in 1837, this extraordinary document was deposited in the vaults of a London bank; it was eventually placed in the Royal Archives during the reign of King Edward VII.

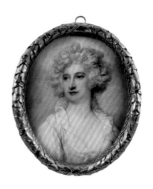

BELOW *The names of the two witnesses to the marriage were cut out by Mrs Fitzherbert herself in 1820, for fear the certificate would be used as evidence during the trial of Queen Caroline (p. 241).*

ABOVE *Richard Cosway (1742–1821), Mary Anne Fitzherbert, 1785–90. Watercolour on ivory laid on card*
RCIN 420928

The 'trial' of Queen Caroline for adultery: witness statement regarding 'Bathing on Board the Polacre' and 'The Queen's Narrative', 1820

RA GEO/BOX/13/83 and RA GEO/BOX/10/5/27

Princess Caroline of Brunswick-Wolfenbüttel (1768–1821) married George, Prince of Wales, on 8 April 1795 in the Chapel Royal at St James's Palace. The Prince's father, George III, was adamant that his wayward son should settle down and produce an heir to the throne, and had chosen Princess Caroline, daughter of his favourite sister, Princess Augusta, as a suitable bride. From the day of the wedding itself the marriage appeared to be ill-fated. Commentators quickly remarked on Princess Caroline's lack of manners, etiquette and personal hygiene, while the Prince, who was illegally married to Mrs Fitzherbert (p. 239) and was in the throes of a love affair with Lady Jersey, had begun drinking after meeting his future wife for the first time earlier in the day, and was drunk throughout the ceremony. Having spent their wedding night together, the couple had a child, Princess Charlotte Augusta, born exactly nine months later on 7 January 1796. After the birth and despite the Princess's attempts to maintain an amicable relationship, relations between the Prince and Princess soured to such an extent that a separation was inevitable. The Princess of Wales left Carlton House and made her home in Blackheath, but, as a result of the intervention of George III, was still permitted contact with her daughter.

In the ensuing years the Princess's alleged love affairs and illegitimate pregnancies were the source of a great deal of gossip, to the extent that an official and secret commission was set up in 1806 to look into the rumours. The 'Delicate Investigation', which did not remain secret for long, found no substance to the allegations of pregnancy, but advised that the Princess be warned about her conduct. However, to the fury of the Prince of Wales, the commission did not recommend that she be excluded from Court. With the decline of George III's mental health in 1811, Caroline lost her only real ally in the royal family. Her husband,

by now Prince Regent, began to restrict access to her daughter even further and prohibited his wife from attending Court. By now a virtual social outcast, the Princess decided to leave England in 1813 and headed for exile in Europe. Her behaviour during her travels was regarded as scandalous: it was widely believed that she and her Italian servant, Bartolomeo Pergami, who had quickly risen through the ranks of her entourage, were lovers. The Prince Regent sent spies to gather proof of his wife's

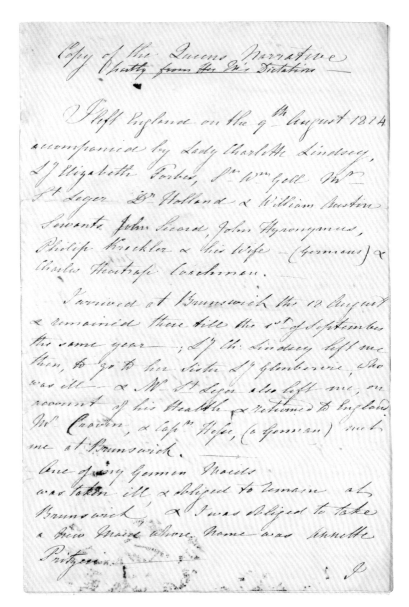

ABOVE *In an attempt to defend herself, Queen Caroline wrote this narrative of events for the hearing from her perspective, naturally portraying herself as blameless. The records in the Royal Archives relating to Queen Caroline's trial amount to thousands of documents, all bearing testimony to this extraordinary episode in royal history.*

Bathing on Board the Polacre

Maiocchi

Examination	Cross Examination	Lords
Do you remember whether the Princess bathed on board the Vessel? I remember it Where was the Bath prepared? In the Cabin of H.R.H. Who assisted her at the Bath The first time I carried the water into the Bath & then Bart[?] Pergami came down and put his hand into the bath to see the Temperature of the Water then he went up Stairs & hand H.R. Highness down – after which the door was shut and B. Pergami & Her Royal Highness remained alone in the Cabin. Do you remember whether this bathing took place more than once? I remember it has been more than once.	Were you ever yourself in the room in the Vessel where the Princess used to dine? Yes. How many doors were in that room? I do not remember Do you not know that there were two rooms which entered out of that inside? This I do not remember Has not the Bath when taken always in the Dining Room itself? Not in the Dining room but in the room next to it What do you mean by the Room next to it? A small room.	You have stated that when on board the Polacre you saw Pergami hand down the Princess to the place prepared for the Bath? I did Did you see Pergami & the Princess enter the Cabinet in which the Bath was prepared? I did You have stated that you handed down two Buckets of water to Pergami for the Bath and that Pergami received them? I carried two pails of water to the door of the Bath & Pergami came out & took one of the Pails I do not know whether it was hot or cold. Did you see the Princess when Pergami took the Pails from you

ABOVE *This report of a witness examination regarding the alleged presence of Pergami while Caroline bathed aboard ship during her Mediterranean cruise of 1816 is one of several such witness statements.*

RIGHT *Printed propaganda surrounding Queen Caroline's trial, 1820*
RA GEO/BOX/13/75

The following is a literal Copy
OF A
PLACARD,
Posted on one of the Pillars of the Market Cross, last night,
BY A
Rev. Young Partridge,
IN COMPANY WITH A
National Schoolmaster.

"ADULTERY TRIUMPHANT."
"ILLUMINATION IN HONOR OF AN ADULTERESS."
"Light up your windows; shout, long live the Queen!
"Than whom a greater whore was never seen."

The Original may be seen at JACKSON's Shop, Bridge Street, where an Address to Her Majesty is now lying for the Signatures of every Male and Female who feel for injured innocence.

JACKSON, PRINTER. BOSTON.

ABOVE *Sir Thomas Lawrence (1769–1830),* Caroline, Princess of Wales, and Princess Charlotte *(detail of the Princess of Wales), 1801. Oil on canvas* RCIN 407292

adultery and, on his accession to the throne as George IV in 1820, was determined to divorce her, a determination intensified by Caroline's return to London in June as Queen. George IV persuaded Parliament to introduce a Bill to strip the Queen of her title and dissolve the marriage, and what was effectively a public 'trial' of the Queen began. Witnesses were called to Westminster to attest to the adultery committed by Queen Caroline with Pergami, and the evidence was read out during the reading of the Bill.

The Bill was passed by the House of Lords but was not put to the House of Commons for fear it would be rejected, thanks to the considerable body of public support amassed for Queen Caroline during her trial. She accepted an allowance of £50,000 to leave the country, but not long after the coronation of George IV on 20 July 1821, to which she was famously refused admission, she succumbed to a short illness and died on 7 August. The body of Queen Caroline, whose life had been marred by marriage to a man who did not love or even like her, was returned to Brunswick to be buried beside that of her father.

Letter from Prince Albert to Queen Victoria, written during their engagement, 15 November 1839

RA VIC/MAIN/Z/296/24

Princess Victoria met her first cousin, Prince Albert, for the first time when he travelled to England from Coburg, Germany, with his father and brother on the occasion of her 17th birthday in May 1836. The Princess confided in her Journal on 18 May that she thought him 'extremely handsome … but the charm of his countenance is his expression, which is most delightful … full of goodness and sweetness and very clever and intelligent'. At the ball held in honour of Princess Victoria's birthday on 24 May, Prince Albert retired early and he remained in bed the whole of the following day, having danced only twice and 'turned as pale as ashes', according to the Princess's Journal. Despite this inauspicious start, the couple began to exchange letters; Prince Albert in particular was aware that their mutual uncle, King Leopold I of the Belgians, was strongly in favour of the Prince as a suitable husband for his niece.

After succeeding to the throne as Queen on 20 June 1837, Victoria was reluctant to lose her new-found independence and refused to rush into marriage. However, Prince Albert arrived with his brother Ernest for a second visit to England in the autumn of 1839, and Queen Victoria found them both 'grown and changed, and embellished. It was with some emotion that I beheld Albert – who is beautiful.' The couple's feelings for each other became apparent only days after Prince Albert's arrival. On 15 October Queen Victoria sent for Albert and said to him 'that it would make me too happy if he would consent to what I wanted (that he should marry me). We embraced each other over and over again, and he was so kind and so affectionate.'

The wedding was quickly planned for 10 February 1840, but it was necessary for Prince Albert to return to Coburg to settle his affairs beforehand. As the couple were apart for much of their engagement, they exchanged a number of loving letters during this time, including this example.

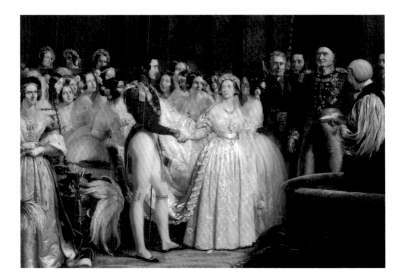

Translation of Prince Albert's letter

Dearest deeply loved Victoria.
According to your wish, and by the urging of my heart to talk to you and open my heart to you, I send these lines. We arrived safely at Calais, and Lord Alfred [Paget] is to re-cross in a ¼ of an hour, and will arrive at Windsor early tomorrow. The state of the tide and strong wind forced us to start at 2.30 in the morning, and we reached here at about 6 o'clock. Even then the Firebrand could not approach the quay, so that we decided to go ashore in a smaller boat. We both, Schenk, and all the servants were fearfully ill; I have hardly recovered yet.

I need not tell you that since we left, all my thoughts have been with you at Windsor, and that your image fills my whole soul. Even in my dreams I never imagined that I should find so much love on earth. How that moment shines for me still when I was close to you, with your hand in mine. Those days flew by so quickly, but our separation will fly equally so.

Ernest wishes me to say a thousand nice things to you.

With promises of unchanging love and devotion Your ever true Albert.

My best respects to dear Aunt and B[aroness] Lehzen

ABOVE *Sir George Hayter (1792–1871),* The Marriage of Queen Victoria, 10 February 1840, *1840–42. Oil on canvas RCIN 407165*

OPPOSITE *Penned in German, the Prince's native language, this particular letter was written during his return journey to England from Coburg.*

Theuerste innigst
geliebte Victorin.

Meinem Wunsche gemäß
und um dem drange mir
aus Herzens, mich mit dir
zu unterhalten, Luft zu machen,
sende ich dir diese Zeilen.
Wir sind glücklich in Calais
angelangt und L. Alfred wird
in einer ¼ Stunde wieder

Letter from Princess Elisabeth of Hesse to Queen Victoria reporting on the plans for the wedding of her sister, Princess Alix, to Tsar Nicholas II of Russia, 17 November 1894

RA VIC/MAIN/Z/274/25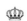

In April 1894, Princess Alix of Hesse (daughter of Queen Victoria and Prince Albert's second daughter, Princess Alice) became engaged to Nicholas, Tsarevitch of Russia. He was the maternal nephew of the Princess of Wales, wife of the future King Edward VII. The parentage of the betrothed couple provides a good example of the extent to which the British royal family was, and still is, intertwined with the royal houses of Europe through familial ties.

Queen Victoria was initially displeased at the prospect of her granddaughter marrying a member of the Romanov imperial family, partly because she had regarded Russia as an adversary since the Crimean War some forty years earlier. Princess Alix was motherless (Princess Alice having died in 1878 from diphtheria), so Queen Victoria felt particularly responsible for her granddaughter's happiness and well-being. She would have much preferred Princess Alix to marry the Duke of Clarence, her eldest British grandson and second in line to the throne; however, Alicky and Nicky, as they were known to their families, were clearly in love, and Queen Victoria gave the couple her blessing after they spent a happy summer with her at Windsor and Osborne following their engagement.

On 2 November 1894 Tsar Alexander III died and his son came to the throne as Tsar Nicholas II. Princess Alix was received into the Orthodox Church the following morning, and it was decided not to delay their wedding but to hold it shortly after the funeral. Writing to Queen Victoria on 17 November (5 November in the Russian calendar), Princess Elisabeth of Hesse, Princess Alix's older sister, informed her grandmother of the plans for the wedding, to be held at the Winter Palace in St Petersburg. Queen Victoria did not attend the wedding but recorded in her Journal that her thoughts were 'constantly with dear Alicky, whose wedding takes place today. I prayed most earnestly

for her, & felt so sad I could not be with her.' At Windsor that evening the Queen held a dinner in honour of the happy couple, during which the Russian national anthem was played, and she also proposed a toast to the health of Nicky and Alicky 'the Emperor and Empress of Russia, my dear Grandchildren'.

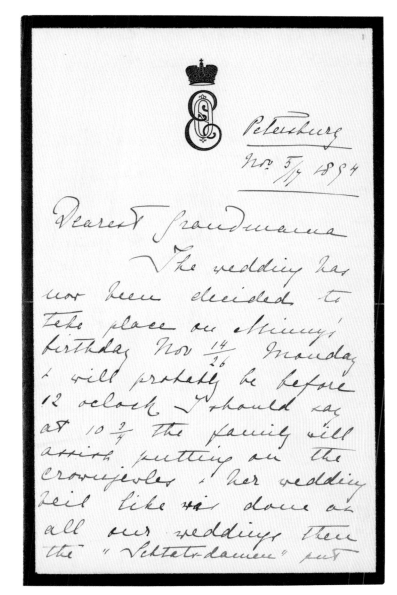

ABOVE & OPPOSITE
Of particular interest to Princess Elisabeth were the dress, jewels and hairstyle to be worn by the bride, and she included careful illustrations of these in her letter. She also referred to Nicholas II's mother, Tsaritsa Maria Feodorovna (called Minnie by her family), who was grieving following the death of her husband.

Transcript of Princess Elisabeth's letter

Petersburg
Nov. 5/17 1894
Dearest Grandmama

… the dress is in embroidered silver cloth Russian courtdress & very pretty[;] as bride she wears two curls[;] in old times only young girls had the right of having their hair hanging down – it looks very pretty & a pretty frame for the face – the complete bridaldress & splendours of diamonds & the velvet cloak (I must say the latter is heavy & would be much prettier without) A little myrtleblossom she adds on the dress & next to the wee crown

Although the complete costume is heavy yet the lovely diamonds suit everybody & Alix being tall will look perfectly lovely[.] I only saw Paul's wife & Xenia both short but even they oddly enough did not look crushed but both sweetly pretty[;] I think it is because all is white silver[,] shining like rays of electric light & the red cloak relieves the whole[,] although I would have preferred it to be white.

… They all are well[,] Minny keeps up wonderfully[,] in her fearful sorrow God helps her[,] she is so deeply religious & prays with such fervour it is beautiful & touching[;] oh if you only could have seen how she loved & nursed her husband[,] poor little thing she has got so thin & pale[,] only those immense dark eyes bigger than ever & oh so sad like a hunted deer – Alix is luckily well & not too tired[,] poor Nicky has no rest & looks thin & pale[,] poor Boy such lots to do[;] he & Minny both told me your kind lines had deeply touched them[;] nothing helps in such sorrow as kind true sympathy & your letters proved them what a loving motherly heart you have[,] God bless you darling Grandmama & help you …

I remain
Your loving "Own Child"

Ella

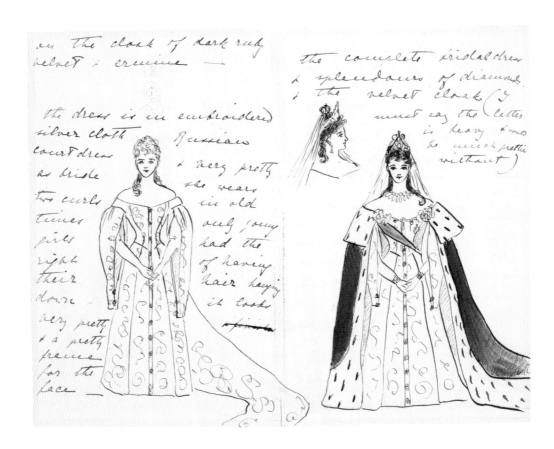

Letter from Queen Maud to her sister-in-law, Mary, Princess of Wales, on becoming Queen of Norway, 17 December 1905

RA QM/PRIV/CC45/285

Princess Maud (1869–1938) was the youngest daughter of King Edward VII and Queen Alexandra. She was a high-spirited child and her tomboyish ways and love of outdoor activities earned her the nickname 'Harry' from her family and friends. Growing up, she accompanied her mother on her annual visits to family in Denmark and on her cruises to Norway and the Mediterranean.

On 22 July 1896, at the private chapel at Buckingham Palace, Princess Maud married her first cousin, Prince Carl of Denmark. She had first met the Prince during one of her stays in Denmark, but she was not particularly happy living in her husband's native country permanently and stayed frequently at Appleton House on the Sandringham estate, a gift from her father. The couple had their only child, Prince Alexander, on 2 July 1903.

Their relatively quiet life changed forever when the newly independent Norway elected Prince Carl as their new King in November 1905. He took the name King Haakon VII, while his son became Prince Olav. In this animated letter to her sister-in-law 'May' (herself later to become Queen Mary), written after her arrival in their new country, the new Queen Maud of Norway could not contain her excitement at her unexpected change in circumstances.

This change marked a new era for Norwegian history, but also for the life of Queen Maud, who could no longer shy away from royal duties. King Haakon VII and Queen Maud were crowned at the cathedral in Trondheim on 22 June 1906, and the new Queen adapted herself to her new role with relative ease, learning the language, supporting charitable causes in her new country and bringing up her son as a Norwegian.

Transcript of Queen Maud's letter

Christiania
Dec: 17. 1905

Dearest May,

Behold! I am a Queen!!! Who wd have thought it?
& I am the very last person to be stuck on a throne!
I am actually getting accustomed to be called "Yr
Majesty!" & yet often pinch myself to feel if I am
not dreaming! We are very comfortably settled now,
at least we are trying our utmost to get our rooms as
we like. Some are really very fine, & nice big lofty
rooms & divine view fr [from] the windows, but
alas! & alack! the appaling taste there is, is not
to be believed, the papers, curtains, carpets &
furniture are something quite out of the common
& really I think those who chose all these things
must have been extraordinar[il]y clever to have
discovered such a collection of monstrosities!! The
sad part is the lack of money, & I doubt when we
can ever get these horrors changed. Luckily we
have had a lot of good furniture in Copenhagen so
have been able to put them about in our own rooms.
Our reception here was wonderful, & the people are
touching in their welcome, they crowd round the
Palace & we can never go out driving without being
cheered lustily. Little Olav gets tremendous
ovations all to himself, & all the different
schoolchildren fr the various towns have given him
toys, his nursery is full. He has 3 nice rooms all on
the Southside, we all live on the 2nd floor & have
an entire wing to ourselves. Oh! Dear, we have such
a lot to do, audiences & deputations almost every
day, & then we have had 2 big dinners, & 2
receptions, 2 Concerts a Gala performance at [the]
theatre, also 2 big balls, the Opening of Parliament,
2 new artists who wish to photograph us & draw us
etc. an awful bore! I beg to remark I chatter away in
my best Norwegian, & never cld speak Danish very
well as the accent is so ugly, but now just in
Norwegian I get the right accent & they are
delighted & think it alright! …

 Good-bye God bless you darling May, heaps
of love & every good wish for a happy Xmas
& New Year, from Yr devoted old Harry

ABOVE *Signed 'Downey', based
on a photograph by William
& Daniel Downey (active
1860–early 1900s)*, Maud,
Queen of Norway,
*1905–10. Watercolour
on ivory laid on card
RCIN 421080*

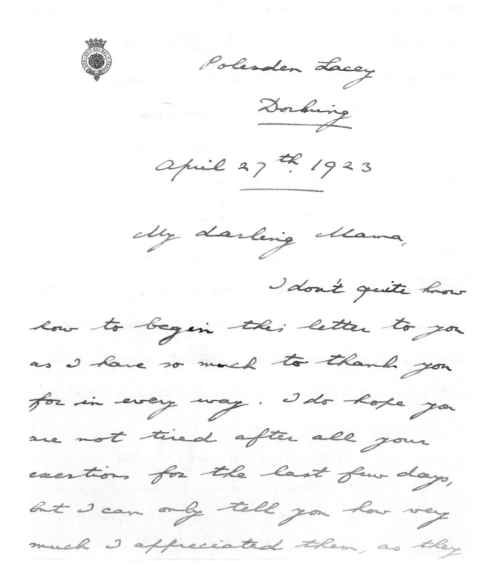

Polesden Lacey
Dorking

April 27th 1923

My darling Mama,

I don't quite know
how to begin this letter to you
as I have so much to thank you
for in every way. I do hope you
are not tired after all your
exertions for the last few days,
but I can only tell you how very
much I appreciated them, as they

Letter from Albert, Duke of York, to his mother, Queen Mary, after his wedding, 27 April 1923

RA QM/PRIV/CC11/40

Prince Albert, Duke of York (later King George VI), and Lady Elizabeth Bowes-Lyon, daughter of the fourteenth Earl of Strathmore and Kinghorne, first met as adults at a London dance in July 1920. The Prince was immediately captivated by the 19-year-old socialite, who had only recently come out into London society after a happy upbringing as one of a large and lively family; Lady Elizabeth, however, was reluctant to give up her carefree life for the restrictions of a royal marriage. With the support of his family, Prince Albert persisted with courting Lady Elizabeth and proposed to her, for what was at least the third time, at her parents' home in Hertfordshire, St Paul's Walden Bury, on 13 January 1923. On this occasion Lady Elizabeth's love for Prince Albert overcame her reservations and the next day she accepted his proposal.

The engagement signalled a change for the royal family, as it had been customary previously for British princes and princesses to marry members of foreign royal or princely families.

The couple were married just over three months later, on 26 April 1923, at Westminster Abbey. The Duke and Duchess of York then went to Polesden Lacey, near Dorking, Surrey, for their honeymoon, from where the Duke wrote this touching letter to his mother, Queen Mary, the following day. Mother and son maintained their close relationship in the ensuing years, as shown by the hundreds of letters exchanged between them, now kept in the Royal Archives.

Transcript of the Duke of York's letter

Polesden Lacey
Dorking

April 27th. 1923

My darling Mama,

I don't quite know how to begin this letter to you as I have so much to thank you for in every way. I do hope you are not tired after all your exertions for the last few days, but I can only tell you how very much I appreciated them, as they did so help to make a success of the arrangements. I trust you thought the actual ceremony went off well, as I am afraid I was very nervous about it until it was over. You were kindness itself in all the help you gave me in choosing the silver & the china which we needed at the beginning; all the more so as I had very little idea of what we did want never having thought much about those things before.

And now it is all over; the nervous strain & little worries which are bound to crop up on occasions such as these when one wants everybody to be satisfied & pleased. I do hope you & Papa were. Elizabeth & I were very thankful to arrive here

safely yesterday at 5.30. We were both very tired after all we had gone through & it is so pleasant & nice to be alone at last in this delicious spot where Mrs. Greville has made us very comfortable. Having nothing in particular to do is such a welcome change to what has passed & we really do need a rest.

I do hope you will not miss me very much, though I believe you will as I have stayed with you so much longer really than the brothers. I am very very happy now with my little darling so perhaps our parting yesterday was made easier for me but still I did feel a pang at leaving my home.

However we shall not be very far away from you at White Lodge. Darling Mama you know how much I thank you for all your kindness to me so with my very best love

I remain
Ever your very devoted boy
Bertie

100th birthday message from Queen Elizabeth II to Queen Elizabeth The Queen Mother, 4 August 2000

RA QEQM/PRIV/RF

Since 1917 at the earliest it has been customary for the Sovereign to send a message of congratulation to any British subject celebrating their 100th and 105th birthdays, and every year thereafter. Such messages were sent on rare occasions during the reign of King Edward VII but the practice became more regularised during the reign of King George V. The message was originally in the form of a telegram, but these were replaced by telemessages (a combination of telegram and letter) in 1982, and later, in 1999, by a card with a picture of Queen Elizabeth II and her signature in facsimile. The congratulatory card is a source of great pride

for the recipient. In 2012 alone, 7,059 cards were sent to individuals reaching their 100th or 105th birthday; a further 438 messages were sent on the occasion of people celebrating birthdays between the ages of 106 and 113. The cards are also sent to centenarians residing in Commonwealth countries, on the recommendation of their governors general.

On 4 August 2000, Queen Elizabeth The Queen Mother celebrated her 100th birthday; that morning a congratulatory card from her daughter, The Queen, was duly delivered to Clarence House. Inside the message read 'On your 100th Birthday all the family join with me in sending you our loving best wishes for this special day'. This 100th birthday message celebrates the grand age of a much-loved member of the Royal Family, and it is also a rare example of The Queen acting in both her roles as daughter and Sovereign.

OPPOSITE *The card was exactly the same as those sent to centenarians up and down the country, but includes a personal message written by The Queen and signed 'Lilibet', the pet name given to her by her parents.*

BELOW *Camera Press : London,* The Queen and Queen Elizabeth The Queen Mother waving on the balcony of Buckingham Palace on the occasion of the Queen Mother's 100th birthday, *4 August 2000* *RCIN 2999977*

ROYAL MAIL

BUCKINGHAM PALACE
LONDON SW1A 1AA

Her Majesty Queen Elizabeth The Queen Mother
Clarence House
St. James's
London
SW1A 1BA

On your 100th Birthday
all the family join with me
in sending you our loving
best wishes for this special day

Lilibet

INDEX

ACKNOWLEDGEMENTS

The authors' foremost acknowledgement is to their Royal Archives colleagues, past and present, for their work on cataloguing the collections in the Round Tower, thus enabling these treasures to be selected. Among these colleagues, special mention must be given to Lynne Beech, for the sheer physical work involved in gathering together this material, and Sheila de Bellaigue, for her German expertise and for making many improvements to the text. David Ryan, the Assistant Keeper of the Royal Archives, must also be thanked for his constant encouragement and support throughout this project.

This book could not have been written without the assistance of many previous Royal Collection publications, on which the authors have depended heavily. Royal Collection colleagues have also provided invaluable information and assistance: these have included Lisa Heighway and Alessandro Nasini in the Photograph Collection, Kate Heard in the Print Room, Bridget Wright and Emma Stuart in the Royal Library, Alan Donnithorne, Head of Paper Conservation, and Anne Griffiths in the Household of The Duke of Edinburgh. Beyond the Royal Household, thanks are also due to Eleanor Cracknell, formerly Assistant Archivist at St George's Chapel, for transcribing and translating the Latin deed, and to Marianne Tidcombe for information about the binding of Queen Alexandra's visitors book. The translation of Emperor Qianlong's edict is taken from *Annals and Memoirs of the Court of Peking*, by E. Backhouse and J.O.P. Bland, published in London in 1914, as reprinted in *The Lion and the Dragon* by Aubrey Singer, published in London in 1992.

The authors would also particularly like to thank Megan Gent, the Archives Conservator, for her expertise in preparing the items, and Eva Zielinska-Millar for photographing them so beautifully.

Finally, a special debt is owed to the publishing team, particularly Nina Chang and Jacky Colliss Harvey, who have greatly helped the authors during the production of this book.

PICTURE CREDITS

To find out more about the Royal Collection please visit our website
www.royalcollection.org.uk

Published by Royal Collection Trust / © Her Majesty Queen Elizabeth II 2014
York House, St James's Palace, London SW1A 1BQ

Text and reproductions of all items Royal Archives / © Her Majesty Queen
Elizabeth II 2014 and Royal Collection Trust / © Her Majesty Queen Elizabeth II 2014.

ISBN 978 1 909741 04 1
014835

British Library Cataloguing in Publication Data:
A catalogue record for this book is available from the British Library.

Design: Peter Dawson, www.gradedesign.com
Location photography: Valerie Malkin
Editorial project management: Nina Chang
Production: Debbie Wayment
Typeset in Caslon and printed on Tatami ivory 135gsm
Printed and bound by Studio Fasoli, Verona, Italy